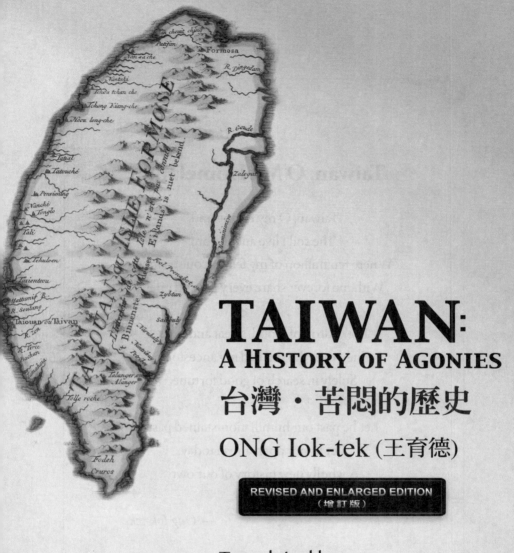

TAIWAN:
A HISTORY OF AGONIES

台灣・苦悶的歷史

ONG Iok-tek (王育德)

**REVISED AND ENLARGED EDITION
（增訂版）**

Translated by
SHIMAMURA Yasuharu
a.k.a. Nathan Shiga（島村 泰治）

Edited by
ONG Meiri（王明理）

Taiwan, O My Homeland

Taiwan, O my Homeland,
The soil I live and die on,
Where ten million of my fellow countrymen
With me forever share every joy and grief.

Every drop of blood, sweat and tears
Shed over the soil had my ancestors,
Solely in search of good fortune.

Let be past our humiliation-stained past
Let us pry open afresh today
A wholly new history of our own

— *Ong Iok-tek*

Preface[1]

Ng Chiau-tong (黃昭堂)

Professor Emeritus, Showa University, Japan (1932-2011)

Seventeen years having elapsed since the passing of Dr. *Ong Iok-tek*, I feel very much elated to see one of his major works thus published.

Hailed in Tainan, Dr. Ong devoted his entire life to the cause of Taiwan independence movement. He was a spiritual leader and the key man of the movement; it was under his auspices that "The Taiwan Youth", the predecessor of the World United Formosans for Independence, was inaugurated in 1960. At the height of the Chiang Kai-shek regime's white terror, Taiwan society was under the grossest of threats, academics being silenced and the Taiwanese populace disrespected and looked down upon as second-class citizens. Dr. Ong was convinced that only upon the establishment of their own nation could the Taiwanese ever free themselves of the misery. That conviction drove him to setting on the arduous road of advocating

[1] This preface was originally written for the Collection of Works of Dr. Ong Iok-tek in 2002 in Taiwan and the closing paragraph therein, in which the author expresses his words of gratitude to those who had contributed to have the collection published, is hereby omitted.

Taiwan independence.

The magazine *Taiwan Youth* was a ray of hope for the Taiwanese at that moment of time. A regularly published magazine of a rich variety of theses and contributions on political and cultural issues confronting Taiwan at that time, the *Taiwan Youth* targeted inspiring spiritual awareness of the Taiwanese. However, the task of promoting such political awareness was for him easier said than done.

Dr. Ong was still then a doctoral student at Tokyo University and concurrently a part-time adjunct instructor at the College of Commerce, Meiji University. Out of his meager income he covered the costs of several Taiwanese students helping him running the magazine. He had quite a heavy load of burdens to bear; while writing essays for the magazine and elsewhere, correcting manuscripts in Japanese, proofreading, printing, mailing, and all the other chores, he personally took part in raising money to keep the magazine going.

The *Taiwan Youth* was started in Tokyo, the capital of Japan, initially with Taiwanese supporters living in and around Tokyo. Gradually support started coming from Kobe, Osaka and other areas, and soon from the United States in increasing numbers from among the Taiwanese studying there. Later, "The Taiwan Youth" changed its name first to the "Society of Taiwan Youth", then to the "Taiwan Youth Independence Alliance" and, in 1970, as groups of movement for Taiwan independence mushrooming all over the world, it renamed itself again to the "Taiwan Independence Alliance", and eventually to the World United Formosans for Independence (WUFI). Dr. Ong was a man of foresight and inspiration. He held and will hold an immortal position in the history of Taiwan independence movement.

At Meiji University he became a full-time instructor and latter excelled himself to the posts of associate professor and finally full professor. He was in fact one of the first foreign professors at a time when Japanese universities were still reluctant to employ foreign professors. He taught Chinese Language and Chinese Studies successively at Tokyo University, Saitama University, Tokyo University of Foreign Studies, Tokyo University of Education, and Tokyo Metropolitan University. He was especially excited when invited to teach Taiwanese Language courses at Tokyo University of Foreign Studies and Tokyo Metropolitan University. He taught many students over altogether 27 years of his teaching career. As he aged he developed a heart complication but kept on working strenuously.

His love for his compatriots revealed itself in the issue of compensations for Japanese servicemen of Taiwanese ancestry and their dependents. Those people who had served, voluntarily or involuntarily, in the Japanese armed forces during World War II were living under the rule of the Chiang Kai-shek regime after the war. They were living in utter poverty and hardship in Taiwan, with no compensation whatsoever by the Japanese government. In 1975, Dr. Ong organized the "Council for Implementing Compensation for Ex-Japanese Soldiers of Taiwanese Ancestry" and directed activities for holding indoor meetings, street rallies etc., and filed law suits against the Japanese government at the Tokyo District Court and subsequently the High Court, and eventually the Supreme Court. That legal process took a decade, during which he fell ill. His selfless and tireless efforts rang the bell in the hearts of Japanese politicians and, in 1986, the Japanese Diet passed a resolution to compensate every serviceman, dead or severely wounded, two million Japanese

Yen. Though the amount itself was much smaller than Japanese servicemen's annuities, his efforts did pay off in compelling the Japanese government treasury to appropriate 600 billion in a special budget. The entire process of this campaign was duly recorded and compiled by a group of Japanese volunteers into a book. The Collection of Works of Dr. Ong Iok-tek does not include the book and, as it was not written solely by Dr. Ong. He had a number of articles to his credit in this nearly 1,000-page document, which he had later published.

During his lifetime Dr. Ong's publish a wide variety of works including academic articles, political commentaries, literature reviews, plays, and book reviews. His *Study on the Phonetics of the Ming Language* is among the best in its field. After his death, his teachers, students, relatives, and friends intended to publish this doctoral thesis. However, as they discovered many symbols that could not be proofread, they concluded to have included a copy of the original manuscript in the Collection of Works.

I studied with Dr. Ong at Tainan First High School. Later in the independence movement I served as the chairman of the Japanese Chapter of the Taiwan Independence Alliance. I vividly recall him then as a man of modesty and magnanimity. Senior as he was to me as my teacher, he was modest enough and magnanimous enough to seek instructions from me.

Preface
Taiwan and My Father

ONG MEIRI (王明理)

Daughter of Ong Iok-tek

This is a precise history of Taiwan written by a Taiwanese who loved his homeland most sincerely.

Fifty years have already elapsed since my father *Ong Iok-tek* (Wang Yu-te) published his *Taiwan: A History of Agonies* in Japan in 1964.

But even today this book is still read by the young Taiwanese and I am convinced that this book is worth reading for all who want to know what Taiwan is.

Originally this book consisted of seven chapters, the last eighth chapter "From 1960's to 1970's —1964~" being added when it was reprinted in 1970 by Ong Iok-tek himself.

During 45 years thereafter Taiwan has drastically changed. This time I have written a digest of the history of Taiwan after 1970 and put it after the last chapter.

And I have partially rewritten the chronological table as well.

Let me briefly trace my father's career.

Ong Iok-tek was a Taiwanese born in 1924 in Tainan (*Tai-lam*) known as a city of traditions under Japanese era. His family was very rich and his father was very enthusiastic for children's education. He and his elder brother *Ong Iok-lim* graduated from the Taihoku High School which was the most prestigious high school in Taiwan and entered the Tokyo University in Japan. His brother became a prosecutor, the first Taiwanese ever to assume the post of prosecutor in Japan.

After World War II, Chinese Kuomintang troops occupied Taiwan initially on behalf of the Allied forces and later kept occupying it illegally.

These newcome Chinese massacred a great number of Taiwanese during 228 Incident and thereafter. Ong Iok-lim was also killed. Ong Iok-tek was on the list, because, besides his work as the teacher of the Tainan First High School Ong had written plays and played as an actor at the theater in Tainan and criticized KMT Government in his plays. As an intimate colleague of his was arrested he decided to escape from Taiwan. In those days the Taiwanese were admitted to Hong Kong only with the Reentry Permit without visa or passport. He then flew to Hong Kong, wherein he figured he would work out some way to Japan. Three weeks afterwards, he found his way onto a freighter trafficking smuggled goods, landed at the Port of Shimonoseki and on he smuggled himself into Japan. But at that time he thought his escape was only temporary and wanted to come back to his homeland as soon as possible. But that he couldn't because the situation in Taiwan under martial law was getting worse.

He decided to call his wife and daughter (my sister) to Japan and started a new life in Japan.

He had lived in Japan since 1949 onward as a political refugee

till he passed away in 1985.

First of all Ong Iok-tek returned to his alma mater Tokyo University to devote himself in the study of the Taiwanese language. Under Japanese rule, the Taiwanese were given education in Japanese and later in 1945 onwards under Chinese rule in Chinese. Ong decided to study Taiwanese for fear that the Taiwanese would eventually lose their mother tongue. For a decade thereafter till he completed his doctoral course he studied under a leading philologist of the time Prof. Hattori Shiro and pursued his own study of Taiwanese. In 1957, as if to have a gravestone engraved, he published *Frequently Used Taiwanese Vocabulary*. For years afterwards, he kept up as a philologist his studies of the Taiwanese language. His accomplishments were published after his death in volumes of *Historical Study of Taiwanese Phonetics* (1987).

He worked as a professor of Meiji University and also gave many lectures in other universities. He taught Taiwanese at Tokyo University of Foreign Studies; that was in fact the first course ever offered at university level in the world.

Along with his academic pursuits, he eagerly devoted himself to the cause of Taiwanese independence movement. He inaugurated the "Taiwan Youth Society" in 1960, which was later to expand to the World United Formosans for Independence (WUFI).

The Society aimed at achieving Taiwan's independence from the Republic of China in Taiwan. That is to say, to build Taiwan "of the Taiwanese, by the Taiwanese, and for the Taiwanese"—not by the Chinese, whether be it Kuomintang (Nationalist) or Communist.

What he wanted to let the people know is a very simple truth:

"Taiwan is not China. The Taiwanese are not the Chinese. Taiwan should be ruled by Taiwanese themselves."

He wrote *Taiwan: A History of Agonies* to prove that Taiwan's clamor for independence is valid. So he kept it in mind based on documents to write it objectively. I think that it is the reason why this book lives on as a first class document.

The book was sold very well and reprinted several times in Japan in spite of its difficult contents.

In 1977 it was translated in Chinese. Many Taiwanese are said to have read it and copies were secretly circulated hand to hand amid martial law of Kuomintang Government in Taiwan. Many were deeply moved to learn the accurate history of Taiwan.

However, some years ago a certain Taiwanese in the United States voiced an urgent need to have Ong Iok-tek's *Taiwan: A History of Agonies* published in English to appeal to the world the complexities of today's Taiwan, and a good many people have responded to the call.

He then brought his idea to the attention of Dr. *Ng Chiau-tong*, the late-chairman of WUFI, and Dr. Ng earnestly encouraged my mother and me to "get to work".

It was indeed a stroke of luck then that we met Mr. Shimamura Yasuharu. He was no stranger to us after all as we found to our surprise and joy then that he was the translator of the whole contents of the Japanese-language magazine *Taiwan Youth*, the organ of the Taiwan Youth Society, into an English-language organ

the *Formosan Quarterly*. Mr. Shimamura had had his higher education in the United States, served foreign embassies in Tokyo, and currently a writer/translator. His due knowledge of Taiwan and things Taiwanese emerged to us at a right moment. He gladly offered to undertake translation to help the project "come true".

In the course of subsequent tête-à-tête I found to my joy that Mr. Shimamura has a perfect command of the contents of the book, the author's unique diction included, and that the book had at last found an ideal hand to work on its translation into English.

I felt a strange spell of destiny in all this. My heartfelt thanks, therefore, go to Mr. Shimamura and his dear wife Keiko who went all out to help us accomplish the difficult task of bringing this book back to life in, mark you, English.

My sincere thanks go to Mr. Chou Chun-nan who is the excellent editor. His work was accurate and sincere.

I appreciate Dr. Chiu Tun-jin and Dr. Shane Lee who went all out to help achieve this translation project and also to Mr. Wang K'ang-hou for their portion of invaluable assistance.

I want to give thanks from my heart to the president of publisher Lin Wen-Ch'in. He has patiently endured the lateness of my work all the time.

Last but not least, I wish to thank my dear mother who was always behind me cheering me up throughout the work and my daughter, Aya, whose support was indispensable in rendering all pronouns into English and handling bits of pieces of trivial work in the course of this project.

The author in heaven maybe grinning at the irony of his

book being still worth reading. It means his wish for Taiwan's Independence is yet to be attained. It means that the international community is yet to recognize Taiwan as a sovereign independent state out of consideration for China.

Furthermore, the ambitions of China to expand its territory become bigger and bigger.

Our day calls for this book. Readers of this book will understand without a shred doubt that Taiwan does not belong to China. History so proves and international law fully substantiates this.

In the spring of 2014, the so-called Sunflower Movement sprouted in Taiwan. Students assembled to strongly protest against the government leaning toward unification with China.

Many Taiwanese supported the students. I sense a fresh new chapter opening in the history of Taiwan. I felt very proud of my father when I knew some of the students leading the movement are said to have been inspired by this book.

I vividly recall that my father never paused a second throughout his life to think about the happiness of his homeland.

He had a clear vision of the ultimate future of Taiwan as a democratic welfare state administered directly by Taiwanese themselves.

May the Dreams Come True!

In summer, 2015, sunflowers blooming gold.

Some Remarks on Changes in Ong Iok-tek's Recognition of Indigenous People of Taiwan

Kondo Aya (近藤綾)[1]

Taiwan: A History of Agonies was written originally in Japanese for the Japanese readership half a century ago in 1964. Now legendary among publications on Taiwan, this is truly a monumental historical writing having enjoyed wide public support through several editions over the years.

Throughout the translation of this legendary book, untiring efforts were made to make certain that its originality be basically preserved in every detail as the author was exact and exhaustive with no intent to embroider facts. The level of his artistry as a historical author was perhaps among the highest undoubtedly on eras when documented materials were abundant. In his description of the indigenous people in Taiwan, however, he was understandably less exhaustive in quality and quantity from the present-day view of these people.

Therefore, I opted to make additional remarks on the subject

1 Granddaughter of Ong Iok-tek and researcher in indigenous people; author of *Travel Taiwanese*.

instead of altering original descriptions, lest the book's originality be tampered in any way. The subsequent remarks will touch on why such shortcomings could have come about.

Over half a century since the publication of this book till now Taiwan has undergone changes: martial law was lifted in 1987 to open way to democracy; social movements of all sorts budded and bloomed. The most significant was by far the way the rights of the indigenous people were widely acknowledged and promoted. Their culture and arts now came to be highlighted and their social status clearer identified.

In the meantime, studies on the history of Taiwan made giant leaps forward in freer political and academic environments. The mainstream of historical studies in Taiwan is now unanimous on the ancestry of the indigenous people dating far back in 3000-4000 BC. Publications on Taiwan today allocate certain amount of space for its history, as in the case of Heibonsha's *Illustrated History of Taiwan* (2007) by Chou Wan-yao (周婉窈) of which 30-211 pages on Taiwan cover prehistoric times through the history of the indigenous people.

Whereas in his *Taiwan: A History of Agonies*, Ong speaks less and shallow on the indigenous people of Taiwan. He was perhaps a victim of circumstances at the time of his writing, but he might not have been fully aware of the indigenous people.

After the publication of *Taiwan: A History of Agonies*, however, an incident helped heighten Ong's awareness of the indigenous people. In December, 1974, a certain Teruo Nakamura, a Taiwanese indigene born Suniuo and a civilian employee of the Japanese military, was discovered in Indonesia, Morotai Island, having survived thirty years with no knowledge of the war's end.

He was deported to Taiwan without any recognition of his

laboriousness or pension from the Japanese government. Ong was quick to react to this incident and rallied a drive the Council for Implementing Compensation for Ex-Japanese Soldiers of Taiwanese Ancestry. He followed up the movement throughout a decade thereafter till his death in 1985. A number of indigenes, notably the legendary "Takasago Corps", were drafted into the Japanese military. Ong made acquaintances among indigenous people through the compensation movement, felt sympathy for their livelihood, and furthered his understanding of the circumstances surrounding them.

In his last years Ong contributed a short thesis "The Takasago Tribe: Will they live on or vanish? Hopes await after achieving independence". (Takasago is the name commonly used in those days for indigenous people of Taiwan.) In this thesis Ong analyses quite vividly certain social problems facing the indigenes, point out, among others, how the Kuomintang's arbitrary policy of making the indigenes tourist resources and its repercussions and how their self-sufficient society fell apart in the face of a fast-growing monetary economy. It is a concise, right-to-the-point analysis of the current situation where Ong's unbounded sympathy for the indigenous people is seen flowing between the lines. The final paragraph reads:

"Advocates for Taiwan's independence have been aware of the need for rational and realistic studies of the Takasagoes. When they speak of Taiwan for the Taiwanese, the 'Taiwanese' will include the three hundred thousand Takasagoes. The movement for achieving independence for Taiwan aims ultimately at bringing about in Taiwan a society that pays high respects for human rights. It is absurd to accord human rights only to non-Takasagoes and not to the Takasagoes. The problem of

the Takasagoes will solve itself only when our independence movement succeeds. We wish therefore to appeal to Takasago comrades to join hands with us in the sacred cause of winning independence for Taiwan." (Ong Iok-tek: "The Takasago Tribe: Will they live on or vanish? Hopes await after achieving independence", II, *Taiwan Youth*, August, 1984, p. 18, published by the World United Formosans for Independence Japan Head Office) (Underline by the writer)

"A land that guarantees human rights for all the people"—that must have been Ong Iok-tek's ideal image of Taiwan. Alas, however, only a year after he had written this thesis, Ong Iok-tek fell victim to cardiac infarction and suddenly passed away at age 61. Were he alive today, he would no doubt have deepened his appreciation of the indigenous people, made many a friend among them, and most likely penned many a thesis on their respective histories, cultures and languages.

All of us, his survivors, are well aware of the limits beyond which no arbitrary comment should affect the originality of this book. I have therefore restrained myself from making due amendments to the author's statements on the history of indigenous people in Taiwan. Hence, this extra paragraph to draw our dear readers' attention to the above-mentioned background.

It is my sincere wish that this book, now appearing for the first time in English, a leading tongue of our time, will find many zealous readers across the world and help enhance broader understanding of Taiwan and its multi-racial history woven by a rich variety of cultures that constitute this "land of charms."

Explanatory Note

5) ... All tones are omitted; broad reading is shown that ... and ...

5) Where Chinese ... are available, ... names are followed in the index at the end of the volume.

1) The names of Taiwanese individuals and geographical names are given basically in Mandarin. Except when better acquainted in Taiwanese or in both Mandarin and Taiwanese. When given in Taiwanese, such names are initially spelled in Italics. Those already established in foreign countries, such names are spelled without hyphens.

2) Individual and geographical names in China are given basically in Mandarin, whereas those already established in other languages and well acquainted internationally are adopted as they are.

3) Chinese words spelled basically in the Wade System. U-Umlauts are normally spelled "v" in the formal Wade System but here left "u" for ease of reading.

4) Church Romanization is adopted to express Taiwanese on the conviction that it is better known than Taiwanese Romanization

System. All tones are omitted; broad sound [o·] is shown [ou] and nasal sound [-n] [N].

5) Where Chinese descriptions are available, such names are collected in the index at the end of the volume.

CONTENTS

Chapter 3
KOXINGA: HIS BRIGHT AND DARK SIDES
—Cheng period (1661-1683) ... 83

Chapter 4
A PILE OF BLOOD AND SWEAT
—Qing period (1683-1895) ... 103

Preliminary Remarks

A pressing sense of urgency drove me to write this book—to portray what past my dear ten million[1] countrymen have lived in Taiwan, what predicament they are surviving today and what future awaits them ahead.

Taiwan today is situated at one of the most heated friction points of the cold war, and I trust this book should help draw the attention of foreign readers, first and foremost, to the situation in Taiwan and help them further their understanding of its realities, how its problems have ever come about, and, hopefully, suggest ways leading to solutions.

Every time I drop by a bookstore I feel a mixed sense of envy and irritation; shelf after shelf of books, too heavy even for "the toughest of oxen to carry", are on display on thousands of subjects written by just as many writers. But, alas, so few among them touch on and about Taiwan. I might by sheer chance hit upon a few, but seldom

..

1 [All statistical data including population given in the text are of 1964 when the book was published first. Now the population is 23 million (2015).]

will I find ones that guide me to the kind of solution I look for.

Can I not then evade my responsibility of daring, over and beyond what little gift I might be blessed with, a humble writing of my own?

Believe it or not, few Taiwanese show interest in Taiwan's history, much less dare take time to study it.

The rulers of Taiwan have always been afraid of the Taiwanese awakening to their own history, and have resorted to every possible measure to apply pressure on them, tangible and otherwise, to have them look the other way. That applies not only to the field of history alone but at anything at all that may be geared to encourage the Taiwanese to look into themselves. Every door to thought is closed tight, every door to publication is shut, and into the vacuum drift in a whole set of ideological system prepared by the rulers. Any attempt to resist the system meant death or expulsion.[2]

I majored in linguistics, Taiwanese, but I couldn't help but feeling piercing eyes constantly behind my back. Language study requires some insight into geography and history. Studying in Japan as I do, I would hunt materials in Japan, do all deskwork here, and publish books also in Japan.

At no time in the past have books of this kind ever been published in Taiwan, much less today under the Kuomintang rule. Had I dared, I would have been liquidated right off. Safe as it might seem in Japan, I would still have to risk my life to have this published amid the numerous cat's-paws of the rulers rampant around me.

If not my life at stake, I would have to bear plenty of hostile abuses and slanders. Any fair-minded reader will see that nowhere this book

......................................

2 Taiwan was under martial law throughout the period 1949-1987, during which it was completely deprived of freedom of speech and action.

do I advocate dangerous thoughts of any kind.

Taiwan belongs to the Taiwanese; the Taiwanese alone are the true masters of Taiwan. Only a rational solution to the Taiwan problem, and that alone contributes to world peace—that is simply and exactly what I am advocating in this book. However, that is the sort of attitude the rulers detest most. The rulers bend and twist history the way it suits them. They would use power, money and every other means at their disposal to portray to the world a grossly twisted history of Taiwan. Thus, it is not unlikely that people might unknowingly come to overlook such bends and twists done on the history of Taiwan and turn around to criticize me for having bent and twisted history myself!

I believe there is only one truth and that the truth prevails in the end. I only fear whether or not my study is scientific enough and my view of the history of Taiwan envisaged thereon is good enough to survive sufficiently fair criticisms from third parties.

Historical data on Taiwan are not so scarce as one might expect but it is a pity that such data were all written by the rulers of the time or by the third parties.

The Taiwanese had lived illiterate years without education until the period under Japanese rule, and have left rather few written data. With so little left to work with, I embarked on a challenging work of portraying a visible image of an invisible Taiwanese and of listening to the voice of a voiceless Taiwanese. Fortunately, I have had the pleasure of meeting so many distinguished persons who so kindly offered me timely advice and guidance, without which I could not have completed this book. Thanks to their goodwill support, I humbly believe I have produced a material that has come close enough to trace the correct footsteps of the Taiwanese.

I earnestly hope that this book offers my countrymen a chance to

awaken to themselves and the entire world a clue to a better under-standing of the Taiwan problem.

Last but not least, I wish to offer my heartfelt gratitude to Pro-fessor Shunpei Ueyama of the Institute of Cultural Sciences, Kyoto University, and other distinguished persons for their valuable support. My sincere thanks also go to the personnel of the publisher Kobundo without whose untiring efforts this book might not have come to life.

Ong Iok-tek
December 5, 1963
At home in Ikebukuro, Tokyo

INTRODUCTION

A Stormy Situation Facing Taiwan

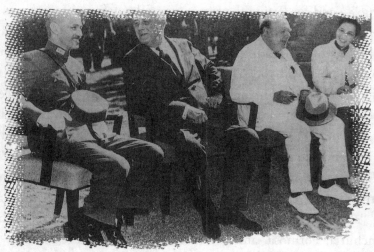

The Taiwanese claim that the Cairo Declaration was signed without the
Taiwanese people duly consulted and therefore not binding in any way

Taiwan, a sweet potato-shaped island lying off the coast of the Chinese continent across a 180-kilometer-wide channel, the Taiwan Strait, is a strategic bottleneck separating the two spheres of East Asia—North and South. Equivalent in size to Kyushu, Japan, 36,000 square kilometers, Taiwan is the home of some ten million Taiwanese and two million Chinese who fled from the Chinese mainland after the war, both living in a jumble.

As widely known, the Kuomintang regime, crowned with Chiang Kai-shek as its Generalissimo, is ruling Taiwan today, bluffing as it does with the oddest of slogans "Recover the Mainland" in hopes of heating the Cold War hot—indeed a terrifying situation.

Chiang Kai-shek is popular among some Japanese for his "touching" remark made in 1945 at the war's end—"Repay Violent with Virtue"—and for letting the remnants of the defeated Japanese army return home safe. Most of the Japanese, however, do seem to favor Taiwan's annexation at the hands of Chinese Communists. Be it "Counterattack on the Chinese mainland" or "Liberation of Taiwan", the concept of a single China prevails all along, and so it seems to be a common notion to many that the destiny of Taiwan is well in the grips of Chiang Kai-shek and Mao Tse-tung and, therefore, that the Taiwan issue is an internal affair of China, no more or no less.

This common notion is built on a legal concept based, for one, on the Cairo Declaration of November 27, 1943, which stipulates that "all the territories Japan has stolen from the Chinese, such as Manchuria, Formosa, and The Pescadores, shall be restored to the Republic of China" and, for two, on the Potsdam Declaration of July 26, 1945 which subsequently confirmed to that effect.

The Taiwanese claim that the Cairo Declaration was signed without the Taiwanese people duly consulted and therefore not binding

in any way. Interestingly, though, arguments over the declaration thenceforth served to lead scores of politicians and scholars in different countries to voice ambiguities over the nature of the declaration itself. And the hard-earned legal basis thus began to crumble.

For instance, the then British Foreign Minister Anthony Eden made a public statement on February 4, 1955, in which he said:

"First, the question of who holds sovereignty over Taiwan today is either ambiguous or undecided.

Second, the fact that the Allied Powers delegated the governance of Taiwan to Chiang Kai-shek has no relevance to the transfer of sovereignty in any way.

Third, the fact that Japan renounced all rights over Taiwan in the San Francisco Peace Treaty did not necessarily mean the territorial rights over Taiwan were transferred to either Communist China or the Republic of China.

Fourth, all those small islands off the mainland China obviously belong to Communist China but any attempt to claim them by force would constitute an 'international issue' threatening international peace and security." [1]

These issues aside, those deafening slogans of "Recover the Mainland" and "Liberate Taiwan" sound hollow with neither side taking any action. The cross-strait staring match is stalemated; a fait accompli "Two Chinas" is clearly in the forming.

Most people tend to take a philosophical view of the impasse over

..

[1] From "Basic research on the Taiwan issue" by Iyeda Shigezoh published in *International* Issues, Vol. 15, June 1961.

the Taiwan Strait and say the situation is inevitable, while others passionately blame the United States for interfering with the affair.

But is it not a bit formalistic an argument? To begin with, the Taiwan issue is not China's internal affair, not at all. It is a sort of issue that no simple linear equation can possibly solve, hence the current stalemate over Taiwan. It calls for a quadratic equation involving the two Chinese nations under Chiang Kai-shek and Mao Tse-tung on one side AND the populace of Taiwanese on the other.

With no intent to draw the readers' attention by shifting the point of argument elsewhere, the author believes that the key to the China issue is buried within the Taiwan issue. That is to say, the issues should be approached in the reverse order—Taiwan first and then China. Find a rational and realistic solution for the Taiwan issue, and the China issue should resolve all by itself.

In other words, let Chiang Kai-shek's nationalist regime vanish, allow the Taiwanese build a republic of their own, recognize Communist China as the only legitimate Chinese regime and then allow a republic state of the Taiwanese into the United Nations. This is the one and only way to have all the issues resolved in a single stroke. The author is certain this is the way the wind shall blow in the future.

Who are the Taiwanese anyway? Are they ever entitled to the right to demand independence?

Not a few may be suspicious. There never has been an image of Taiwanese "seeking independence". It is largely because the Taiwanese people have never spoken out loud, not vocal enough to express themselves loud and clear. Why so? It is undoubtedly because they have long been denied freedom of speech.

It is not that the Taiwanese have neglected to speak out, appealing their sentiments; in fact, not a few Taiwanese overseas had kept

on publishing locally, though less in quantity, numerous pamphlets, while those within the island had sought every opportunity to appeal to the foreign tourists.

The *Harper's Magazine* published in its September issue, 1963, a report from Taiwan by Albert Axelbank titled "Chiang Kai-shek's silent enemies", which read:

> "The words 'independence' and 'autonomy' are tabooed in Taiwan. But, the Taiwanese leaders, regardless which side they take, pro-Kuomintang or non-Kuomintang, confided in the author that over ninety percent of the Taiwanese population support an independent republic state of their own."

Reports on some dangerously huge energy building up in Taiwan are quite widespread through the pages of such leading journals as *The New York Times, The Observer, The China Quarterly* (UK), *The Globe and Mail* (Canada), etc. In Japan, such distinguished critics as Ooya Sooyichi and Usui Yoshimi, published their views on the situation in Taiwan, and major newspapers had their correspondents in Taipei report home vivid accounts of what they witnessed there.

True, there are some politicians in various countries who do have a deep understanding of Taiwan, but international public opinion is still far from having acquired sufficient driving force to back up Taiwan.

No doubt, the Taiwanese ought to find answers to their own problems, but, as the interests conflicting so intensely between the camps, the East and the West, and various powers intertwining the way they do, the load is just too heavy for the Taiwanese to shoulder. It is essential to count on another driving force of global scale, namely

a sound international public opinion geared for seeking justice and humanitarianism.

International public opinion once immensely contributed toward preventing the Cold War from turning hot to nearly threaten the fate of mankind. It even played the role of thwarting the despot in a certain country exercising an excessive level of dictatorship. The downfall of Ngo Dinh Diem in South Vietnam in 1963 is a case in point. International public opinion was quick to react to Ngo's ruthless oppression of Buddhists. The United States was blamed for having aided Ngo and, cornered by critical international reactions, gave up Ngo Dieh Diem.

Throughout the 1960's we witnessed in Asia charismatic dictators falling one after another: Syngman Rhee in April, 1960, Ngo Dinh Diem in November, 1963, Sukarno in September, 1965, and Norodom Sihanouk in March 1970.

Their charismatic slogans varied from "anti-communism", "Nasakom" to "neutrality", but they were all alike in what they practiced: a ruthless dictatorship over the people they governed, a cunning mechanism to allow themselves and their families to enjoy lavish lives and which eventually became a straight road to the total destruction of nations and peoples.

Once the oppressed rose in protest against the ruling, however, the pendulum violently swung to knock the dictators off the plate—all so surprisingly fast.

Yet, one of them has managed to survive: Chiang Kai-shek in Taiwan. Nothing can befool people so much more than Chiang Kai-shek's hollow slogans of "legitimate China" and "Counterattack of the mainland". So hollow as his slogans may be, Chiang Kai-shek is there to survive. Why?

There may be plausible reasons why, but then every dictator is doomed to fall. History will never pardon him, nor will matured international public opinion tolerate him—never. People's tolerance naturally has its limits.

Some changes are due in Taiwan in the near future, one may rightly anticipate, but how such changes will come about and how different will such changes be from the rest of the world, they ought to know in advance for their own benefit. Just exactly how different will the outcome be?

This is an ethnic struggle between the Taiwanese and the Chinese; a sort of movement to liberate a colony. That is the way the four-hundred-year history of Taiwan finally concludes. It is one significant international contribution to settle at a single stroke the so-called China problem. One might ask whatever leads to such a conclusion. This humble book in fact attempts to offer an answer to that inquiry.

Chapter 1

A LAND OF FATEFUL PAST
—In search of a new world

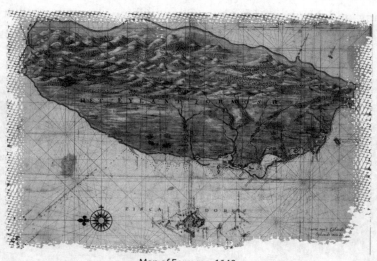

Map of Formosa, 1640

1. Taiwan: How it was so named

Strike off Taiwan, and one finds in the map of offshore China only the tiny islands of Quemoy (Kinmen) and Matsu. So small is the area to their credit, the Nationalist Government, or Kuomintang, detests being addressed as Taiwan in the Olympics and whines that it would not participate unless identified as representing the Republic of China—a bizarre complex of the flock of refugees chased out of the mainland into the tiny island of Taiwan.

However, they are not the first to feel that kind of complex. Three hundred years ago, Cheng Ch'eng-kung, aka Koxinga disliked the sound of Taiwan's name "Tai-oan", as pronounced in those days, which meant "burial afterwards", and changed it to *Tang-tou* or "East Capital"—a pitiful gesture to counterbalance such names as Peking and Nanking. His son, Cheng Ching, later changed it to *"Tang-leng"*. After overthrowing the Cheng family, the Qing Dynas-

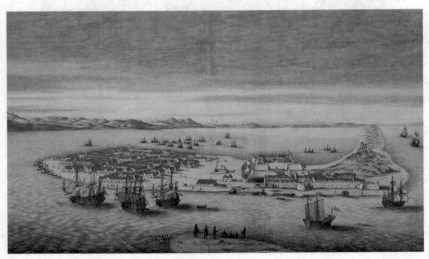

Bird's eye view of Tai-oan and Fort Zeelandia

ty pondered over possible alternatives for the name "Tang-leng" they detested to inherit from the Cheng family. With no decent name to switch to, the Qing renamed it "Taiwan" as it was commonly known then.

Today, the people of Taiwan call their fatherland Taiwan and themselves Taiwanese; they do so with deep affection and not a fraction of complex.

As relatively well known, Taiwan owes its name to the indigenous people, Takasago, but how the Chinese character Taiwan came to circulate eventually to identify the entire island is itself quite an amusing story.

The term "Taiwan" was first documented as "Tai-oan" during the Ming Dynasty in *The Record of the East Barbarian Lands,* by Chou Ying (1426-1522). Approximately in the same period, Shen T'ieh spelt it "Da-wan" in his thesis "Memorial proposing to build a permanent castle and deploy troops to Penghu". The title was transcribed "Tai-en" in Japanese documents *Trade between Chinese and Foreigners* and *Chinese and Japanese Universal Encyclopedia* and as "Tai-en" in *History of Nagasaki Harbor.*

A substitute kanji "臺灣" (Taiwan) was commonly used in the Wang-li period between 1573 and 1620. Chi Ch'i-kuang wrote in his *The Manuscripts of Jung Chou*: "In the Wan-li period a pirate Yen Ssu-ch'i nested in a place near Tainan and called it Taiwan for the first time." According to *The History of Ming*: "In the end of the Wan-li period, red-haired barbarians (Dutch) landed near An-p'ing, cultivated land, and built a city they called 'Taiwan'."

The way different characters were coined then suggests that the word "Taiwan" is not Chinese. On the west bank of the T'ai-chiang (*Tai-kang*) where an inlet cut deep between An-p'ing and Tainan,

the Siraya, indigenous people of Pinpu, were then settled in Tainan and its vicinity. Those Sirayas customarily called the aliens Tai-an or Tayan, hence "Taiwan".

About when the immigrants came in contact with the Sirayas is not known but presumably before the term "Tai-oan" was documented in *The Record of the East Barbarian Lands*.

The immigrants misheard the term and mispronounced it "Tai-wan", or "taiuan" to be accurate, with the second vowel pronounced stronger so as to sound "Taioan" to the Dutch. Unaware that it was how they themselves were called, the Dutch employed it to name the place "Taiwan".

Originally, "Taiwan" designated a certain island, *It-khun-sin*, in An-p'ing. It-khun-sin was more a large shoal along the coast than an island, which stretched southward as far as *Chhit-khun-sin*. It was so named as its shape resembled a strange fish described in *Chuang-tzu*. There must have been quite a scholar in the community.

The immigrants called the place they had settled in "Taiwan" and the west bank of the T'ai-chiang *Chhiah-kham*, inhabited in those days by the indigenes. The immigrants kept their watchful eyes on that area. The *Taiwan Prefecture Gazetteer* edited in 1694 has a vivid account of the situation:

> "The red-haired Dutch loved the place. They leased land from the indigenes and built a castle of their own, named Zeelandia, and erected a watchtower Chhiah-kham, or Provintia, one overlooking the other."

It-khun-sin soon overcrowded, the immigrants plucked up their courage and pushed on to the land of Chhiah-kham. As the immi-

grants stretched farther out, so did the area known as "Taiwan" as far as what is today called "Tainan".

Fu Yuan-ch'u's memorials submitted to the throne in the Ch'ung-chen period (1628-1644) had it: "Taiwan is occupied by the red-haired barbarians and the Spaniards from Luzon have indiscreetly reached *Keelung* (Chi-lung) and Tamshui (Tan-shui/*Tam-chui*). Taiwan is only one day away from Keelung and Tamshui." Taiwan covered yet only a limited area down south.

Shortly afterwards, when He K'ai reported on Taiwan in his memorial, Taiwan was already known to have come to cover the whole of the island:

"Taiwan lies beyond the Penghu Islands, two days away by sea from Chang-ch'uan, the coastal Fu-chien. The land is fertile and about the size of a large county."

However, it is known that all through the years under the Dutch and the Cheng family, only a limited area in the vicinity of Tainan had actually been cultivated.

The Taiwan county is a vestige of those days. The Qing Dynasty set up Taiwan Prefecture to administer the island and underneath it placed counties—one to the south, Feng-shan, another to the north, Chia-yi, and in addition one county called Taiwan.

Today, the island is called Taiwan in English and its people Taiwanese. Personally, however, the author would prefer Formosa to Taiwan and Formosan to Taiwanese, i.e. a beautiful island and a beautiful people.

Everyone knows that the Portuguese named the island of Formosa—what is known today as Taiwan. A beautiful island full of greens

afloat yonder attracted the Portuguese seamen, so much so that they are said to have acclaimed "Ilha Formosa", "ilha" meaning island and "formosa" beautiful.

The Portuguese seamen, in fact, had the habit of screaming "Ilha Formosa" at the sight of every island they spotted yonder and, in fact, there are twelve or so Ilha Formosas afloat in Asia, Africa and South America! Momentary enthusiasm subsides in a way, but the fact remains that Taiwan is the most prominent of them all, and so there should be no problem trademarking Formosa for Taiwan.

Exactly when did the Portuguese so name the island? A map of East Asia made in the 16th century now in store in the Ducale Palace, Venice, clearly describes Japan, Tanegashima and Formosa, each in its exact location. It is known that the Portuguese arrived at Bungo in 1541 and brought firearms to Tanegashima in 1543. It is assumed then that it was roughly at that time Formosa was so named.

2. Of Pirate Families

Taiwan County Gazetteer, published in early 1721, has it:

> "Yen Ssu-ch'i and his henchmen hail from the mainland China. Yen Ssu-ch'i first immigrated to Taiwan."

Yen Ssu-ch'i (1589-1625) hailed from Hai Ch'eng, Fu-chien, a valiant man well skilled in martial arts. In his youth Yen Ssu-ch'i killed by mistake a servant of some man of power and fled to Japan. He opened a needlework shop in Hirado. He made a fortune there and made himself well known as a mediator of various disputes on visiting Chinese trade ships. He would generously spend money to

settle disputes and won himself reputation as a man of chivalrous spirits.

In the summer of 1624, Yen Ssu-ch'i, at age 36, was backed by some 28 adventurous seamen, including Yang T'ien-sheng, Yen Chen-ch'uan and Ch'en Te, to head a pirate band. Cheng Chih-lung, aged 21, who married to the daughter of a local Japanese named Tagawa, also joined the band. They first made a killing of big fast money in Japan, sailed onboard thirteen ships down to Taiwan, set up a base in Tainan and built nine fortresses there.

In Taiwan, at that time, the remnants of Japanese pirates, commonly called Wako, were still rampant and the Dutchmen were also quite active. In the early stage, those two groups and the Yen Ssu-ch'i family of pirates were operating on a delicate balance—in edgy competitions now and curious partnerships then.

In the autumn, the following year, Yen Ssu-ch'i went deer hunting in Chia-yi and had a big catch. On return he threw a gorgeous banquet and had a good time. The good time, however, was only short lived—Yen Ssu-ch'i died of malaria immediately afterwards.

Cheng Chih-lung (1604-1661), leader of one of the nine fortresses, succeeded Yen and took over the leadership of the entire band. Cheng Chih-lung hailed from Fu-chien and was baptized when young in Macao.

In the summer of 1623, an uncle on his mother's side, Huang Ch'eng, had Cheng Chih-lung escort his trade boat to Japan. There Cheng Chih-lung fell in love with a seventeen-year-old daughter of Tagawa and married her. On July 14th, the following year, his wife gave birth to a baby boy Fukumatu, latter-day Cheng Ch'eng-kung aka Koxinga according to *Taiwan Anecdotes* by Chiang Jih-sheng. Immediately afterwards, Cheng Chih-lung set sail for Taiwan with Yen.

Some man of culture, Cheng Chih-lung decreed to ban killing, raping, committing arson and stealing rice. There were families of immigrants living on farms then.

Cheng Chih-lung's aim was quite clear. He intended to dominate the Taiwan Strait to make fortune from commerce and trade. He took full advantage of his relations with the Tagawa family to build direct links with the Japanese. He signed trade agreements with the Dutch-men and submitted to the Ming Dynasty as well.

The letter of appointment issued him by the Ming Dynasty is quite fanciful: "The loyal retainer Cheng Chih-lung is hereby appointed Commander of Sea Defense in recognition of his services in eradicating the pirate *TeN Yit-koaN*."

TeN Yit-koaN was a common name of Cheng Chih-lung himself. He was also popularly called Old Yit-koaN. KoaN is a Fuchien word used to address people with respect.

A man of insight, or a cunning opportunist at that, Cheng Chih-lung surrendered to the Qing Dynasty in 1646 at the budding sign of the Ming's decline. But Cheng Chih-lung was grossly mistaken. The Qing Dynasty wanted him to have Cheng Ch'eng-kung surrender. Cheng Chih-lung tried every means to convince his son to submit but all to no avail. Cheng Chih-lung was eventually exterminated as "a snake in the bosom".

The family tree of the pirates terminates with Cheng Chih-lung and his son, Cheng Ch'eng-kung, but if one traces it farther upwards numerous historical episodes should unveil themselves.

In mid 16th century, a certain bandit Wu Ping emerged. Based in Nan-ao, Canton, he operated for some while in its vicinity, and was later subjugated by a renowned general Ch'i Chi-kuang. Ch'i Chi-kuang had distinguished himself by often forcing back Japanese

pirates. But, two of Wu Ping's subordinates, *Lim To-khiam* of Ch'ao-chou, Canton Province, and Ts'eng I-pen would not surrender and kept on haunting the coastal areas of Canton and Fu-chien. Taiwan was made one of their bases.

In 1563, Commander Yu Ta-yu in chase of Lim To-khiam, reached the Penghu Islands. Lim fled to Taiwan; Yu tailed him on. It so happened that Yu was a stranger to the local waterways. On hearing that the seaways around *Lok-ni-mng*, An-p'ing, were formidable, Yu gave up his chase and retreated to Penghu to enforce his defense there. Lim was relieved but knew he could hardly hold out long enough in that yet undeveloped island. He had to build boats. He killed indigenes, boiled their blood thick enough to make a substitute for the varnish to fill in the slits of deck boards. He sailed between It-khun-sin and Lok-ni-mng on way to Cham Pa, Indochina.

Taiwan County Gazetteer has it that Lim To-khiam was once a ring of Japanese pirates. An anecdote goes he buried eighteen boxes of his plunder in Mt. *Ta-kau*—Taiwan version of Sindbad.[1]

No sooner had Lim To-khiam drifted ashore way down south than a band of pirates of Lin Feng from Ch'ao-chou, Canton, emerged. Lin operated along the coast of Canton for a while but was quickly tracked down and chased into the routine route of escape through Penghu into Taiwan: first Penghu, then Taiwan and eventually out to Luzon.

Ts'eng I-pen had long been in obscurity but suddenly resurged about that time. In 1580 he came from Nan-ao to Penghu, where he set up his base. Not a few immigrants returned and joined Ts'eng

1 "Lim To-khiam and Eighteen Boxes" in *Anthology of Taiwan Folklore* edited by Li Hsien-chang, 1936.

there.

3. Hardships: It all began in the Penghu Islands

The Penghu Islands are situated so inseparable from the main island of Taiwan as to be regarded, in the broad sense of the term, part of Taiwan proper today. However, that was not the case back then. The Penghu Islands had been known to the world well before Taiwan, and, in the latter half of the 14th century, had a population of several thousands. Dozens of trade ships frequented there throughout the year. The Yuan Dynasty went out of its way to appoint administrators to watch over the area.

History tells that the Qing Dynasty, after having eliminated the Cheng family, seriously thought of abandoning Taiwan but intended to hang on to the Penghu Islands. Today, the Taiwanese and the liberal camp at large generally believe that Quemoy and Matsu should be returned to Communist China but, since the Penghu Islands are part of Taiwan, a well-defined boundary line must be drawn between the Penghu Islands and the Chinese mainland. Whereas in the past, the Qing Dynasty would draw a borderline between the Penghu Islands and Taiwan and hold on to the Penghu Islands essential for the defense of the mainland. It mattered little to the Qing Dynasty if Taiwan lay waste.

A Qing general Shih Lang (1622-1697) was first to assert that, were the Penghu Islands to be defended, the dynasty must hold onto Taiwan under its control. That was, in fact, his way of pleading not to readily abandon the island he had toiled so hard to conquer. Shih meant to insist on retaining Taiwan for private as well as public interests. In his renowned "Letter on the matter of interests of retaining or

abandoning Taiwan" he wrote:

"If we should forsake Taiwan for the defense of Penghu, Penghu with an area far smaller than Taiwan would be left alone in the midst of the sea far away from Amoy (Sha-men). Threats from outside would be intolerable; Penghu would be vulnerable. Guarding Taiwan alone can help secure Penghu. Taiwan and Penghu are inseparable. The coastal areas of the mainland are best defended if only Taiwan and Penghu are guarded as one unit. Both islands should be mutually dependent to ensure security in the region."

A glance at the map will show how accurate Shih was in his strategy. Shih defeated Liu Kuo-hsuan in Penghu and forced the Cheng family in Taiwan to unconditional surrender. When Taiwan fell in the hands of *Chu Yit-kui*, the Qing troops fled to Amoy. Similarly, in the Sino-Japanese War, the Qing troops were quick to accept defeat when the Hishijima detachment occupied Penghu.

Penghu became part of Taiwan economically only after Qing rule. Previously, it had depended on Amoy for supplies. Amoy began to develop after its traffic increased to and from Penghu and Taiwan.

The residents in the coastal areas of Fu-chien and Canton immigrated to Penghu for the first time in the 13th century and to Taiwan about three hundred years later in the late 16th century. *Yuan Shi* or the *History of Yuan* is very precise in its accounts on Penghu but brief on Taiwan.

The earliest record on the immigrants in Penghu is found in *Records of Alien Peoples* by Chao Ju-shih published in the Sung Dynasty. It mentions that the Penghu Islands were part of Chin-chiang

County, Fu-chien Province and that the residents were incessantly plundered by Bisyana, natives of small Ryukyu islands west of Tung-kang.

The Ming Dynasty abandoned Penghu. Ku Tsu-yu describes in his *Essential of Historical Geography*:

"While on his mission to control the sea, T'ang Hsin-kuo, uncertain whether the residents would rebel or obey, proposed to move them all to the mainland. In 1388, all residents were moved out, the administrative office closed down and the island vacated. In the vacancy sneaked in outlaws and later Japanese pirates for water supply."

In the late 16th century onwards the islands turned a home of pirates.

Huang Shu-ching gives another account in "Talks on Chhiah-kham" in his *Record on the Mission to the Taiwan Strait*:

"In 1372, a large army was sent to subjugate the disobedient residents and move them to areas near Chang-ch'uan."

Scholars of East Asia history seem yet uncertain of the circumstances. The initial attempt to persuade the residents was probably made in 1372. With little progress in sight, a large army was sent over in 1388 to enforce deportation. Some residents fought back in vain. Resistance subdued, the residents were deported to their original domiciles in Chang-chou and Ch'uan-chou.

The new-born Ming Dynasty met formidable foes on the sea—the Japanese pirates called the Wako, bands of former samurais in

Kyushu and the Seto inland areas who had fared badly in the waning days of the Ashikaga Shognate and made living looting along the Chinese coastal areas. Many distressed residents in Fu-chien and Canton joined them to help reinforce the already formidable band of Japanese pirates.

The Ming Dynasty adopted a dual-edge countermeasure to meet the situation: actively subjugating them while passively forbidding people to go out in the sea. Marine traders were forbidden to engage in overseas trade and the offshore islands were abandoned. The deportation of Penghu immigrants was just in line with the Ming's policy of abandoning offshore islands. Such a policy was rational enough from the point of view of the Ming Dynasty but certainly a matter of life or death for the immigrants. It is easy to imagine how they lamented over the Ming's outrageous treatment.

Historically, deporting the Penghu immigrants during this period signaled the start of China's discrimination and suppression of the Taiwanese. The Chinese government felt that interactions with the islands of Penghu and Taiwan would bring no political and economic benefits, let alone possible security risks.

This might be difficult to understand if you image Taiwan as you know it today. Just imagine quite another Taiwan, a wilderness full of plagues on one hand and the home of Chinese ethnocentrism on the other. In a nutshell, the seed of prejudice was thus sown, and the seed would grow thereafter with roots spreading farther and deeper.

Overseas Chinese began immigrating southward already in the Sun period, but the subsequent Chinese governments regarded overseas Chinese "undutiful" in the light of Confucian Sinocentrism. China is the "greatest of all the countries in the world" and "the rest are lands of barbarians". The Chinese are born in China and ought to

be thankful to "live in a realm of peace and prosperity".

For instance, when 25,000 Chinese were massacred in Luzon by the Spaniards in 1603, the Fu-chien governor Hsu Hsueh-chu was instructed by the home government to send a letter of protest to the Spanish Governor-General in Luzon, in which Hsu Hsueh-chu stated: "Those rambling Chinese overseas are rabbles who abandoned their fatherland for the sake of profits and are not worthy of protection...."

There is a striking difference in the way governments would have reacted in such cases: a European government would have easily waged war over the life of a missionary, whereas to China a massacre of several hundred thousand had amounted to nothing but an incident. What was the letter of protest for? It was simply a matter of honor, the Chinese government's gesture to save its own face.[2]

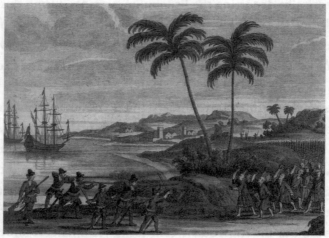

Fighting between the Dutch and the Chinese

..

[2] Chapter 11 "China's Policy on Overseas Chinese" in *Supplementary History of Overseas Chinese* by Narita Setsuo, published in August 1941.

Overseas Chinese far away from home in the Southeast Asia mattered little to China, live or die. But, the immigrants in Penghu and Taiwan lived too close to the mainland to be readily called "overseas Chinese" and their behaviors were much too rebellious for decent Chinese citizens. The immigrants in Penghu and Taiwan were discriminated as potential rebels and constantly put under surveillance and suppression.

In the history of East-West encounter, the Penghu Islands were involved earlier than Taiwan, and the Penghu immigrants had gone through that much more hardships than the Taiwanese.

The same year 25,000 overseas Chinese were massacred in Luzon, the Dutch fleets landed in the Penghu Islands. The Ming had already evacuated from the islands. So, the Dutch fleets set out to occupy them. Caught off guard, the Ming quickly sent troops and demanded the Dutch to leave the islands. The coastal immigrants were banned to trade with the Dutch. Quite outnumbered by the Ming troops, the Dutch reluctantly agreed to retreat, to the disappointment of the coastal residents. After all, the Dutch had brought rare goodies from foreign lands without them having to sail so far out to get them. "What better business chance could there be?" [3]

In 1622, a Dutch fleet of six vessels and 2,000 troops failed to capture the Portuguese base in Macao. Quick to grasp the situation in the area, the Dutch instructed the fleet and men to head, as initially planned, north to the Penghu Islands and land at *Ma-kiong-o* (alias Ma-kong).

It was then that a disaster befell the immigrants of the Penghu

3 Excerpts from "Fu-chien (3) Foreign Taxes", *Book on the Strengths and Weaknesses of the Various Regions of the Empire*.

Islands. Several hundred of fishing boats were captured by the Dutch and 1,500 fishermen were requisitioned to build a fortress, of whom 1,300 died of hunger or disease before the fortress was completed. The Dutch had rationed only half kin[4] (0.3 kilogram) of rice per head per day. After the fortress was completed, those who had survived the ordeal were sent to Batavia as slaves. En route to Batavia some died of overwork and others of disease, and barely half of them made it to Batavia. The fate of the Penghu residents then overlaps with that of the Taiwanese years afterwards.

4. Japan's Ambition

What prompts the Chinese to claim that Taiwan is an inherent territory of China? The Chinese will take it for granted that the Taiwanese are Chinese to begin with; furthermore, they will make a big point of the early expeditions of Ch'en Leng (610) of the Sui Dynasty, Yang Hsiang (1292) and Kao Hsing (1297) of the Yuan Dynasty. Now, were a single expedition a warrant for territorial rights, how often would the world map have to be revised? Follow the Chinese line of argument, and even the Japanese have a thirty percent claim to Taiwan—prior to the Dutch!

The so-called Japanese were not only the Wako pirates alone. While practicing piracy based in Taiwan, the pirates would go farther into the mountain to assault the indigenes, as depicted in the *Min Book* by He Ch'iao-yuan:

"Alien immigrants from the East first settled along the coastal

4 [Hereinafter spelled in kilogram.]

areas but later in the Chia-ching period of the Ming they were driven into the mountains by the Japanese pirates."

This evidences the fact that the Wako pirates had the intention of almost permanently settling in Taiwan.

In Japan Taiwan was known in those days as "Takasago" or "Takasagun", a corruption of the name of a mountain in Taiwan, Mt. Ta-kau. Information brought home by the Wako pirates must have tempted the Japanese to have a territorial ambition on Taiwan.

In 1593, Toyotomi Hideyoshi sent his envoy Harada Magoshichiroh to Luzon. Harada was also instructed to deliver Hideyoshi's personal letter urging Taiwan to pay tribute to Japan. Obviously, Hideyoshi regarded Taiwan an independent state Takasan-koku, but it was a total nonsense where there was no party to receive such a letter in an island of so many tribes.

In 1609, Tokugawa Iyeyasu had Arima Harunobu explored the east coast of Taiwan. The most remarkable was an expedition attempted in 1613, ten years prior to Yen Ssu-ch'i, by the local Magistrate of Nagasaki Murayama Tou'an with 13 ships and 4,000 troops. The expedition failed as a storm destroyed all the ships and troops. Had the expedition succeeded, the history of Taiwan would have followed an entirely different path. Knowing of all such "achievements", Hamada Yahyoe could not bear the sight of the Dutch behaving as rulers of Taiwan. (1628, to be discussed later)

Japan's advance in the southern sea at that time may be defined as the dawn of mercantilism, but the tide ebbed off as Japan began sporadically closing its doors to the outside world through the years 1636-1639.

5. The Tragedy of Indigenes

When the Taiwanese say that Taiwan belongs to the Taiwanese, some Chinese quibble that Taiwan belongs to the indigenous people and they alone have the right to their land. Behind this line of argument by the Chinese are seen glimpses of their scheming design to label the Taiwanese "aggressors" and shamelessly enjoy their share of spoils.

In her analysis Barbara Ward categorizes colonialism in four types. One is the case of the civilization of the colonist and the social structure of the colonized being too far apart to be bridged, eventually leading the colonized either to vanish altogether or to survive as miserable holdovers in some isolated reservation. The painful fate of the Tasmanian natives is a case in point. Another is the way the colonized are left to survive in isolated reservations in misery and want as in the case of the Native Americans. The indigenes in Taiwan regrettably fall into the latter.[5]

In general terms the indigenes in Taiwan are Malayo-Polynesian but not quite of any one particular ethnic group. Though categorized in seven ethnic groups, namely Atayal, Bunun, Tsou, Paiwan, Ami, Yami, and Saisiat, their modes of habitation as well as manners and customs are so diverse that they could not have migrated at the same time from the same area. The *Min Book* has the following to depict the circumstances:

"There is no knowing where the Eastern barbarians have come from. They inhabit way apart in many groups, forming villages of

5 From *Five ideas that change the world* translated by Ayukawa Nobuo, published by Arechi Shuppan Publishing in September 1960.

1,000 here and 500-600 there. They are by nature brave and fond of fighting."

The indigenes in Taiwan made their living mainly by fishing and hunting and occasionally engaged in farming, though of rather primitive style. A Dutch missionary Georgius Candidius (on job 1627-1637) wrote:

"The women, who are complete drudges, do most of the farming work; and, since neither horses, cows, nor ploughs are used, all the work has to be slowly done by means of pickaxes.

Moreover, whenever the rice appears aboveground, much labor is needed for the process of transplanting, as the young shoots stand very thick in some places and not in others. Again, when the rice becomes ripe, they do not use sickles to cut it down or scythes to mow it, but have a certain kind of instrument in the form of a knife, with which they cut off each stalk separately at about a handbreadth from the ear. After the rice has been cut they carry it to their dwellings without thrashing it or taking the husks off, and every day they pound just so much as may

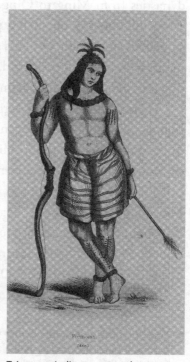

Taiwanese indigenous people

be required. At night, two or three bundles are hung over the fire to dry; and, next morning, the women rise two hours before daylight, pound the rice, and prepare the quantity required for the day. Thus they continue to do day after day and year after year, never preparing more than is daily needed... Men would simply war and hunt and, idle by nature, would let the farmland alone, much less improving the soil." [6]

Born in Fu-chien where mountains cover ninety percent of the land, the Chinese immigrants had lived under constant threats of hunger until they were eventually driven to Taiwan at the turn of dynasties from Ming to Qing. How could the Chinese immigrants stand idle looking on such a gorgeous environment? They first assumed an air of some virtuous gentlemen and signed land lease agreements with the indigenes, paid a land tax known as "*Hoan-toa-choo*" (big lease) and began cultivating land.

There is no record to verify the size of the indigenous population at that time. But, we can assume with certainty that they lived in coastal plains. As the immigrants grew in number and land cultivation progressed, some were assimilated and others unwilling to cohabit with the immigrants were pushed farther into the Central Mountain Ranges at considerable risks.

Might the Taiwanese feel relieved to know that the indigenous Taiwanese were not alone in tasting such agonies? The Native Americans dwindled in number from 730,000 or so in 1600 down to 400,000 in

...........................

6 From "Chinese Immigrants during the Dutch Rule" by Kuo Shui-t'an in *Documents on Taiwan* published on December 27, 1959. For the original see *Formosa under the Dutch* by W. Campbell.

1891; the population of the Eskimos in Point Barrow dropped 60% in thirty years from 1861 to 1891.[7]

The present population of the indigenous people in Taiwan should be a little short of 200,000.[8] In 1931, they numbered 140,000 and over the subsequent 30 years they increased only by a little over 40%; whereas, over the last ten years the population of the Taiwanese has risen from 2.5% of pre-war annual average to 3.5%. Thus, a fall in the rate of population increase of indigenes was conspicuous.

Those of us who are used to the scenes of American Indians shot and killed in western movies are liable to wrongly assume that primitive aborigines are doomed to fall in number at gunpoint. In reality, however, massacre is not necessarily the main cause of population decline. A decadent sex life may be one of the causes; unsanitary lifestyle another. Unpreparedness against hunger and contagious diseases also triggered population decline.

......................................

7 According to "About the Decay of Underdeveloped Native Populations" in *Studies on Imperialism* by Yanaihara Tadao.

8 [This is the data of 1964. Now the population of the indigenous people is 543,661 (2015).]

Chapter 2

A NEW WORLD YET INCOMPLETE
—Dutch period (1624-1661)

Taiwanese indigenous people were catching fish

1. Dutch Rule

The present-day Taiwan included, the island has been the stage of rivalry for altogether three times among the colonizing powers. This international profile of Taiwan tends, as it does, to portray its history different from that of China.

Those who are unfamiliar with the history of Taiwan often compare Taiwan's status vis-à-vis China to, for example, that of Kyushu to Japan and hastily conclude that the Taiwanese' demand for independence is just as nonsensical as the Kyushuans' wish for independence from Japan proper.

Allow me to ask them: Has Kyushu ever been split from the other parts of Japan and made a stage of rivalry among the colonizing powers as often as three times? Were the Mongolians' invasion and the British fleets' attack of Kagoshima regarded the crises of Kyushu alone? Certainly not, Japan stood up against perils for the entire nation.

Taiwan is different in that regard. Taiwan has been left to the will of the world powers and, worse still, under their control for as long as several tens of years. On top of that, China has grown ever haughtier toward Taiwan on the very account of Taiwan having survived the years the way she had. The Chinese have grown to belittle the Taiwanese to the extent of loathing them. It is indeed a self-centered sense of animosity in the minds of the Chinese with no thought whatsoever for the way the Taiwanese have lived throughout these years.

The Dutch fleets which had brought an unprecedented calamity to the people of Penghu[1] succumbed to the outnumbering fleets of the Fu-chien of Commander Nan Chu-i and once again had to re-

[1] Ref. Section 3, Chapter 1.

treat from the Penghu Islands. The 8-month-long battle ended with a truce agreement, which read:

1. The Dutch troops shall retreat from the Penghu Islands,
2. The Ming Dynasty shall not object to the Dutch occupation of Taiwan, and
3. The Dutch shall be guaranteed the right to trade with China.

The Ming Dynasty was satisfied to trade a no-man's-land Taiwan for the Penghu Islands, an area under China's control since the Yuan Dynasty. The Dutchmen, however, had their own designs.

The Dutch fleet was only 850 troops-strong and hardly in match with the then enforced Ming fleet of 10,000 troops. Reports from their expeditionary forces in Taiwan had it that island was larger and fertile as compared with the Penghu Islands and better fit for health. The Chinese and the Japanese were already trading in a large scale with the local Taiwanese, the reports said, and the Dutch figured it was high time they muscled in to monopolize trade. This explains why the Dutch so readily gave up the Penghu Islands then.

In September, 1624, the Dutch fleet landed in It-khun-sin and quickly started constructing a fortress which would come to be called Zeelandia, more for the purpose of trading than of military strategy. The indigenous people were cooperative enough and supplied them food, water and firewood. They went out of their way to help the Dutch chop out bamboos for building the fortress—a story similar to that of the Native American Indians who helped whitemen build Jamestown. However, the several thousand Han immigrants there already sensed danger afoot. And they sensed it right.

Taiwan had thitherto been a free new world. Immigrants had be-

gun cultivating land at their own risk, engaged in hunting and fish-
ing, bartered with the indigenes and traded with the Japanese with
due profits. It was one living environment they could not have hoped
to enjoy in the war-torn, poverty-stricken mainland. The Dutchmen
also were aware of discontent of the immigrants.

The Batavia Diaries, a narrative depicting the immigrants as ob-
served by the Dutch, had it:

"When we landed in Taiwan, the Han Chinese did not welcome
us. There was no way we could come in good terms with them.
They agitated the indigenes to protest regulating trades of deer
meat and skins and fish. Some 200,000 pieces of buckskin,
various dried deer meat and stock fish were produced annually.
There were one hundred or so visits every year of Chinese junk
boats, bringing manpower in to engage in local fishing and bring
home dried deer meat, etc."

Ever since then, all through the 38 years of rule in Taiwan, the
Dutch never for a moment relaxed their wariness of the Han immi-
grants.

What the Dutch were afraid of the most was the Japanese who,
though far less in number, steadfastly insisted on their priority rights
and refused to pay tariff imposed on all incoming ships. The Chinese
had succumbed at gunpoint but never the Japanese.

The Dutch and the Japanese squared off at a threatening stand-
still. The Dutch merchant office in Nagasaki (established in 1609)
tried, in vain, to persuade the Dutch Governor-General in Batavia to
compromise. In 1628, a Japanese Hamada Yahyoe assaulted Dutch
Governor Pieter Nuyts. Behind Hamada was the Nagasaki Magistrate

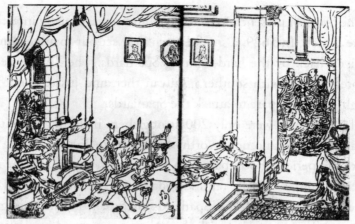
Capture of Dutch Governor Pieter Nuyts by the Japanese

Suetsugu Heizo who had confidence of the Tokugawa Shogunate. A critical diplomatic strife ensued, threatening a breakoff of relations between Dutch and Japan. Soliciting peace with Japan, the Dutch Governor-General of Batavia shifted the blame to Nuyts and sent him to Japan as a criminal.

2. Footsteps of the Spaniards up North

The Spaniards were also resentful of the Dutch occupation of Taiwan. Based in Luzon (established in 1571), the Spaniards were engaged in trade with China and Japan and any stumbling block along their trade route could ruin their business. So, two years later in 1626, a Spaniards fleet skirted around the east coast of Taiwan, discovered San Tiago on its way along the coast line to Keelung, where they built a fortress named San Salvador. Then in 1629 the Spaniards sailed on along the northwest coast to Tamshui and built another fortress, San Domingo.

The Spanish presence in northern Taiwan was equally intolerable for the Dutch. In 1629, a small Dutch fleet set out to attack only to be driven back by the hard-fighting Spaniards. The Dutch were in fact preoccupied with southern Taiwan then and just did not have enough power to spare to attack the Spaniards.

The Spaniards were only 200-strong then, including the citizens of Manila, and left no note-worthy footprints in Taiwan during their rather brief period of occupation. A few Spanish names and the ruins of their fortresses casually remind today their presence then. Playing by the book, as it were, the Spaniards encouraged Han immigrants to come to Taiwan, traded with the indigenes, engaged in missionary work and welcomed Chinese trading ships. Their efforts paid off and the number of immigrants increased by the day, and some came as far as Bei-tou (*Pak-tau*) and joined the local indigenes in sulfur mining. A record shows that by 1635, the Keelung Harbor had grown large enough to berth simultaneously as many as 22 Chinese ships.

Generally speaking, however, the Spaniards were far less enthusiastic than the Dutch. The Spaniards' interests were predominantly in Luzon and their occupation of northern Taiwan meant no more than building a tower to watch over the Dutch. In 1642, the Spaniards were eventually driven by the superior Dutch fleet out of Taiwan, thus closing the 16-year history of their occupation of Taiwan.

3. Transit Trade Boomed

In those days, the western powers were largely motivated by mercantilism. They contended with one another in a fierce Machiavellian rivalry with just one target in mind: acquiring colonies.

The colonies in those days had little to do with latter-day capital-

ism. The colonies under capitalism meant more a marketing ground than a supply base of raw materials for the home countries. Larger scale investments and aggressive development schemes helped, as it were, to keep on feeding sheep fatter as ever to shear them forever. One can find the most successful of examples in Taiwan under Japanese imperialism.

In the colonies under mercantilism, brutal and voracious plunder was the order of the day, chickens being killed to collect eggs. One can find typical examples in Cortes' conquest of Mexico in 1521 and Pizarro's expedition of Peru in 1531. Fortunately enough, the Dutch in Taiwan were not that inhumane. However, the historian Ludwig Riess is somewhat impertinent when he argues in his *Geschichte der Insel Formosa* (1897, translated by Yoshikuni Tokichi), that the Dutch had an underlying notion of uplifting cultural level of the indigenous people.

Obviously the Dutch had intended to make Taiwan a transit point for their trade with Japan and China. Trading was far more profitable and less labor-demanding than plundering and, above all, longer lasting. If obedient to the government and harmless to the company, the Dutch had no reason to kill or persecute the colonized. After all, the Dutch were quite satisfied with the huge profits they amassed in Taiwan.

The Dutch exported to China such products as sugar, deer meats, deer horns, rattans, etc. and imported from China raw silk, silk products, pottery, rhino horns, herbal medicines, gold, etc. Chinese junks transported them to and fro on guarantee by shipping agreements with Cheng Chih-lung. Part of the silk fabrics, pottery and gold were sent from Taiwan to Batavia and to the Netherlands. And from Batavia were imported to Taiwan such Southeast Asian products as spices,

peppers, amber, tin, lead, hemp, cotton and opium, most of which were readily shipped onwards to China. The Dutch made huge profits selling sugar and buckskin to Japan. Likewise, they exported a large amount of sugar to Persia.

In terms of gross trade gains, the Dutch factory in Taiwan was second only to its counterpart in Japan among all Dutch commercial houses in various regions in Asia. According to the statement of accounts in 1649, nine commercial houses including Ceylon and Siam reported losses and ten including Japan and Taiwan registered profits to the tune of 1,825,602 guilders (one guilder was approximately a hundred yen), of which Japan topped others with 709,603 guilders (38.8%) followed by Taiwan with 467,534 guilders (25.6%). The top two houses accounted for 64.4% of the total. Since the profits made by the commercial house in Japan were mostly from the Taiwanese and Chinese products transported from Taiwan, Taiwan's position in Dutch trade in Asia was substantially vital.

Just how large a profit did the Dutch amass throughout their 38-year rule of Taiwan? The following table conveniently shows exactly that:

Income and Expenditure in Taiwan (Unit: Guilders)

Year	Expenditure	Income	Profit
1640	255,000	268,000	13,000
1641	216,000	233,000	16,000
1643	234,000	318,000	83,000
1649	---	---	467,500
1653	328,000	667,000	338,000

Source: *Ethnology Studies*, Volume 18, No. 1, 2 (March 1954) and "Outline of Taiwan History (Modern)" by Nakamura Takashi

Generally speaking, the Dutch spent over two-thirds of their time ruling Taiwan for running an exploitative economy to exhaust the resources; however, in that period they ended up with not so large a profit. It's worth noting that the Dutch raised more profits in the remaining one third of their time when they actively induced development in the island. Needless to say, though, such huge profits were a result of systematic exploitation of manpower of ever increasing number of immigrants.

It is also worthy of note here that throughout the entire period Taiwan's economic development served to considerably weaken its economic ties with the mainland China. Without the immigrants themselves aware of the changes taking place, Taiwan kept on shaping up its own sphere of economy and a political unit of its own, gradually molding them into one unique group of its own.

4. The Indigenes under Control

The Dutch were quite sober in judging what advantages and disadvantages they held over both the immigrants and the indigenes.

The Dutch figured that, simple and obedient and constantly under the threats from the immigrants, the indigenes would side with them if properly persuaded and assimilated. After all, the Dutch were far less in number with only several hundreds of government officials, merchants and their families and only some 90 soldiers stationed sporadically at a dozen or so places.

First to come in contact with the Dutch were the indigenous villagers at Sinkkan (Sincan). The villagers initially offered help but were later incited by the Han immigrants to kill some Dutch soldiers. The Dutch fired back so heavily in retaliation that the villagers had to

make peace. In 1625, they offered a piece of land on the west bank of the Tai-kang for the Dutch to build Fort Provintia and themselves retreated to the Hsin-shih area. In 1627, a certain Candidius, the first Dutch missionary to Taiwan, entered the village, studied the local dialect Siraya and began preaching the indigenous villagers. In the same year, Hamada Yahyoe incited a group of 16 indigenes led by Rijcka to travel to Japan and have an audience with the third Tokugawa shogun Iyemitsu. The idea was to directly appeal to Iyemitsu the tyranny of the Dutch. Aware that meeting Iyemitsu would be no easy deal, Yahyoe advised Rijcka to conveniently present themselves as the formal delegates of the "Kingdom of Takasago" and to offer Iyemitsu the entire kingdom in return to his pledge to drive the Dutch away.

Rijcka and his men returned to Taiwan with Yahyoe the following year. Quick to learn what had happened in Japan, the Dutch arrested and jailed Rijcka and his group and in no time sent troops to encircle and instigate the Sinkkan village. The villagers fled to the mountains in terror. They were later forced to submit in exchange for a living quarter for the Dutch, thirty heads of pigs and a bundle of rice per household. In 1630, Candidius returned to Sinkkan, resumed preaching and gradually won the confidence of the villagers.

The pacification activities in Sinkkan well underway, the Dutch now turned to opening trade with four nearby villages i.e. Saulang[2] , Bacluan[3] , Matau[4] , and Tavokan[5] . Using a fabric Cangan as a bait, the Dutch were even welcomed by the villagers in the initial stage but

..............................

2 Chiang-chun Village, Bei-men County.

3 An-ding Village, Hsin-hua County.

4 Madou Village, Ts'eng-wen County.

5 Ta-nei Village, Ts'eng-wen County.

the villagers were soon abetted by the immigrants to become suspicious of the Dutch. At last, on learning what had happened to Rijcka and his men, they grew hostile toward the Dutch.

In 1629, fifty-two Dutch soldiers chased smugglers into Matau and got brutally killed by the villagers. In 1634, Matau and Saulang confronted head-on. Sinkkan took Saulang's side only to have sixty three of their men killed by Matau.

Sinkkan villagers were the Dutchmen's favorite. The following year the Dutch sent 500 soldiers to assault Matau, killed 26 of the fleeing villagers, young and old, and burned the whole village to the ground. Hard pressed, Matau surrendered.

The following year the Dutch set out to subdue Saulang. Horrified, Saulang turned over its own chief and the six culprits who had killed the Dutch and surrendered. In a plot to set Saulang against Sinkkan, the Dutch let Sinkkan villagers behead seven Saulangs.

The Dutch rode the crest of their success thus far to put pressure on Tevoran (Taivoan)[6] and triumphantly returned to Zeelandia.

The chain of events served to persuade the indigenes, from north to south, to submit to the Dutch. In February, 1636, the delegates from altogether 28 villages, north (15) and south (13) of Tainan, assembled at Sinkkan to jointly vow allegiance to the Dutch Governor Hans Putmans.

The event in 1641 later transformed itself into an annual local assembly called Landdag, a mechanism whereby the Dutch tighten their grip on the indigenes to make their control over them perfect and efficient.

In the meantime, the efforts of such outstanding Dutch mis-

6 Shan-hua Village, Hsin-hua County.

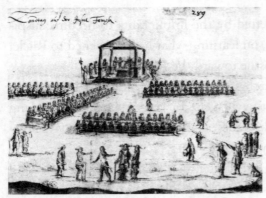

A Landdag meeting between the Dutch and Taiwanese indigenous people

Het H. Euangelium	Hagnau ka D'lligh
na [de beſchrijvinge]	Matiktik ka na ſaſoulat ti
MATTHEI.	**MATTHEUS.**
Het eerſte Capittel.	Naunamou ki lhægh ki ſoulat.

1 HET Boeck des Geſlachtes JEſu CHRISTI, des ſoons Daꞷids / des ſoons Abꞷahams.
2 Abꞷaham geꞷan Iſaac. ende Iſaac geꞷan Jacob. ende Jacob gheꞷan Judam / ende ſijne bꞷoeders.
3 Ende Judas gheꞷan Phares ende Zara by Thamaꞷ. ende Phares gheꞷan Eſrom. ende Eſrom geꞷan Aram.
4 Ende Aram geꞷan Aminadab. ende Aminadab geꞷan Naaſſon. ende Naaſſon geꞷan Salmon.
5 Ende Salmon gheꞷan Booꞷ by Rachab. ende Booꞷ geꞷan Obed by Ruth. ende Obed gheꞷan Jeſſe.
6 Ende Jeſſe gheꞷan Daꞷid den Koningh. ende Daꞷid de Koningh geꞷan Salomon by de ghene die Uriaſ

1 Oulat ki kavouytan ti JEZUS CHRIStus, ka na alak ti David, ka na alak ti Abraham.
2 Ti Abraham ta ni-pou-alak ti Iſaac-an. ti Iſaac ta ni-pou-alak ti Jakob-an. ti Jacob ta ni-pou-alak ti Juda-an, ki tæ'i-a-papar'appa tyn-da.
3 Ti Judas ta ni-pou-alak na Fares-an na Zara-an-appa p'ouh-koua ti Thamar-an. Ti Fares ta ni-pou-alak ti Eſrom-an. Ti Eſrom ta ni-pou-alak ti Aram-an.
4 Ti Aram ta ni-pou-alak ti Aminadab-an. Ti Aminadab ta ni-pou-alak ti Naaſſon-an. Ti Naaſſon ta ni-pou-alak ti Salmon-an.
5 Ti Salmon ta ni-pou-alak na Booſ-an p'ouh-koua ti Rachab-an. Ti Booſ ta ni-pou-alak na Obed-an p'ouh-koua ti Ruth-an. Ti Obed ta ni-pou-alak ti Jeſſe-an.
6 Ti Jeſſe ta ni-pou-alak ti David-an ka na Mei-faſou ka Si bavau. Ti David ka na Mei-faſou ta ni-pou-alak ti Salomon-an p'ouh-
A koua

CHAP. I. (1) THE book of the generation of Jesus Christ, the son of David, the son of Abraham. (2) Abraham begat Isaac; and Isaac begat Jacob; and Jacob begat Judas and his brethren; (3) and Judas begat Phares and Zara of Thamar; ar \ Phares begat Esrom; and Esrom begat Aram; (4) and Aram begat Aminadab; and A^nadab begat Naasson; and Naasson begat Salmon; (5) and Salmon begat Booz of Rachab; and Booz begat Obed of Ruth; and Obed begat Jesse; (6) and Jesse begat David the king; and David the king begat
A

The Gospel of Matthew in Sinkkan dialect (right) with corresponding version in Dutch (left)

sionaries as Candidius, Robertus Junius (1629-1643), and Daniel Gravius (1647-1651) paid off. Churches were built, schools opened, and the indigenes' children were offered education.

The Sinkkan was adopted as the common language and a romanized system of writing was introduced. The New Testament, Doctrinaire Confession, Ten Commandments, etc. were used as teaching materials. Dutch was also taught at school and some classes were run solely in Dutch.

The Dutch dedicated a quarter of a century of their time in Taiwan for preaching the indigenes. Junius alone is said to have baptized 5,900 and, if put together with 30 or so other missionaries,

the total number should have amounted to some figure. As a result, the level of intelligence of the indigenes was lifted up remarkably, so much so that some of them dared offer to even risk lives for the sake of the Dutch. Later, at the outbreak of Kuo Huai-i's (*Koeh Hoai-it*) Rebellion (of which we shall discuss afterwards), those enlightened indigenes came near to killing the whole of the local immigrants.

The Dutch-educated indigenes stuck to spelling native words in romanized scripts even after the Dutch left Taiwan and passed that tradition onto later generations. The Qing took over Taiwan and in its early stage of rule treated those Dutch-educated indigenous intellectuals as a class of their own called *Ka-chheh*:

> "Those who have studied the language of the 'red-haired barbarians' are called Ka-chheh. They will dip the shaved tip of a quill in ink and write various documents horizontally from left to right. When not in use, the quill pen was slipped into the hat or held in the case on the waist." [7]

This smile-provoking description of the quill pen brings us fountain-pen users of today closer to our predecessors who used to manipulate their pens in their own way.

Not a few immigrants took advantage of the indigenes' meager knowledge of Chinese characters and tried to cheat, for instance, when signing land lease contracts. But romanized Dutch texts were always attached as copies to help prevent cheating. Quite a few romanized contracts are found dated over the Eras K'ang-hsi (1662-1722), Yun-

......................................

[7] Extracted from "Fan-su-liu-k'ao" or "Six Concepts of the Customs of Indigenous People".

Sinkkan Manuscript

cheng (1723-1735) through Ch'ien-lung (1736-1795), and some into the Chia-ch'ing (1796-1820) Era. The romanized script was thus for the indigenes a godsend on this side of the grave.

5. The Early Honeymoon Period

No matter how skillfully won over by the Dutch as their reserves, the indigenes could not possibly have acted on their behalf in positive

value-creating exercises. The livelihood of the indigenes then was still meager in a rock bottom primitive society. No currency yet circulating, theirs was a downright poor self-sufficient economy. By nature they were idle and short of volition to work. The Dutch had no sooner put their transit trade on track than they turned to utilizing the vast vacant land.

With the help of Cheng Chih-lung, the Dutch transported over to Taiwan the war-torn, hunger-stricken peasants in Fu-chien and Canton coastal regions—a grand exodus that spurred the history of the development of Taiwan. *The Batavia Diaries* has it for April 3, 1631:

> "The company has shipped over 170 Han people to Taiwan. Lack of space compelled a thousand or more still queuing up for their chance to get aboard. The commander cares to send more ships to bring over more Hans if they are of utility value."

Meanwhile, more Hans must have arranged their own way over without hoping against hope to board Dutch ships. The Dutch in fact accorded them preferential treatments by various means:

> "Our trade there had a bright future ahead, as our men (the Dutch) had learned to flatter the Chinese onboard a number of incoming sail-boats bound for Taiwan, often offering them clothes right on the deck." [8]

The "bright future ahead" meant a potential increase in their

..

8 Extracted from "Studies on Taiwanese National Character" by Lien Wen-ch'ing published in January 1942 issue of *Folklore Taiwan*.

trade with Japan with the increase of Chinese manpower, specifically of buckskin and sugar which are major export commodities to Japan. A Chinese document states to the same effect:

"During the period 1628 through 1644, the Fu-chien area was hard hit by a serious drought. Cheng Chih-lung requested governor Hsiung wen-ts'an to ship tens of thousands of starving people to Taiwan. They were supplied three pieces of gold per head and a cow per three [authenticity uncertain] to cultivate barren land. Cheng Chih-lung had already left Taiwan by then and the Dutch had an exclusive control over trade and collected no land tax. The 2000 Dutch troops were stationed within the fortresses while tens of thousands of refugees lived and cultivated outside the fortresses, each in their own way without a tint of suspicion. Land cultivation thus began in the island, fertile farms were opened and long ridges stretched on. The land was so splendid, yielding three crops a year, that the people in Chang-Chuan emigrated to Taiwan as if to go to a marketplace for shopping." [9]

How to deal with the constantly increasing population of the Han immigrants was an urgent concern of the Dutch. One of the immediate measures they undertook was the well-known Public Land System, whereby the company owned all and the immigrants who as tenants paying a 5-10% rent. The system was in fact a replica of the feudalistic land ownership system practiced in the Netherlands. It was essentially the current mandatory collective land cultivation system applied as it was in Taiwan whereby the settlers were provided with

......................................

9 Extracted from *History of little country* published by Hsu Nai in 1861.

implements, plough cows, and funds. Irrigation canals were ready for use and security arrangements intact to guard the settlers against the threats from indigenous people.

The Dutch authorized outstanding immigrants to organize a kind of autonomous body in the same manner they had controlled the indigenes through local assemblies.

Later in the Qing Dynasty, Yao Yin describes in "An Account of Pu-li village" the circumstances in detail:

"The area stretched over several tens of *Li* [unit of distance] and the cultivated land over several thousand Jia (*Kah*)**10**. Nearly ten thousand landowners employed tenants. They were all disorganized and would never keep promises without *thau-langs* [local leader] ruling them. Besides, there was no way wages were guaranteed. The Dutch used to organize several tens of tenants into one *kiat* and encouraged them to cooperate to settle matters. Those with more funds were elected to lead kiats; they were called *sio-kiat-siu* [junior leaders]. Several tens of kiats were further bound into groups and headed by one among them who was wealthy, influential, fair and worthy of public trust; he was called *toa-kiat-siu* [senior leader]. In time of need, the government would inquire senior leaders, who in turn inquire junior leaders to settle problems. After the system was installed, law and order prevailed." **11**

..............................

10 Unit of area laid and left behind by the Dutch, roughly equivalent to a hectare (1 jia=0.97 ha), which the Qing Dynasty tried several times to switch back in vain to the continental system. [For ease of understanding, the unit "Jia (Kah)" is henceforth expressed "hectare (ha)".]

11 Extracted from Yao Yin's "An Account of Pu-li village" in *An Account of East Cha*.

This socio-economic hierarchy of senior/junior leaders on top of tenants led to bring about a feudal society peculiar to Taiwan and constrained Taiwan's development thereafter.

6. Taiwanese Society under Dutch Rule

Typical of Taiwan's rural sceneries may be the image of buffaloes roaming along lazily chewing sugar canes. Today, over 400 thousand plough cows are kept at 810 thousand farmhouses. For reasons peculiar to Taiwan its agriculture has long depended on plough cows for farming power and benefited little from mechanization. It should come a surprise to most people to learn that there had never been a plough cow in Taiwan way back.

It was in 1647 through 1651 that the first cow landed in Taiwan when the Dutch missionary Gravius brought in 121 of them from India. The Dutch set up two offices, south and north, to administer breeding of plough cows. The ones hard to domesticate were left wild. Left wild indeed, cows kept on growing in number and multiplied to some thousands by the early Qing period. Plough cows replaced hand hoes and Taiwan's agriculture entered an entirely new phase of development.

Incidentally, buffaloes were brought in from China in the Qing Dynasty and, born fit as they are for heavy work, buffaloes were employed mainly to transport weighty loads. Horses perhaps were not fit for Taiwan's natural environment. America's history of pioneering in the West has many things common with that of Taiwan, but one cannot find in Taiwan mounted cowboys dashing across a grassy plain. Instead, one would have seen a train of cow-driven wagons rattling leisurely by—a scene so typical of Taiwan.

The Dutch not only made improvements on local species of greens and fruits but also imported new varieties such as Dutch beans, alien pepper, alien cabbage (now called Korean cabbage), alien tomato (called honey orange in Tainan), mango, custard apple fruit, etc. Pigeon and pig were also brought in by the Dutch.

Hunting was preferred as industry to farming under Dutch rule. Tourists from Taiwan visiting Japan today will, if they travel to Nara, find flocks of deer strolling about. Curious a sight it might seem, Taiwan, particularly Taichung and Chia-yi, was a well known deer-breeding site back in those days under Dutch rule, just as popular as in Thailand, Cambodia, and the Philippines.

Deer meat was either jerked or salted for export to China as emergency food. Deer penis is known still today a byword for aphrodisiac.

Buckskin was highly valued throughout the Warring States period in Japan as an essential material for armors and pouches of all sorts. Such warlords as Arima Harunobu and Murayama Tou'an were charmed rather by abundant, inexpensive Taiwan-made buckskin than by the land itself. Buckskin trade with Japan was in fact a very profitable business for the Dutch, yielding profits of 100 to 150%.

Very skillful in deer hunting as they were, the indigenes could not possibly produce

Taiwanese indigenous people were very skillful in deer hunting

enough to meet the ever-increasing demand. There again the Dutch needed the immigrants to help them out.

There were two methods for collecting buckskin: one, so-called *Pak-sia* system, engaging purchasing agents to collect buckskin from the indigenes for delivery to the company. The purchasing agents in compensation delivered cloths, tobacco, salt, etc. to the indigenes. The system was a unique method first adopted by the immigrants in the early stage to avoid offending indigenes. But, the indigenes were lazy, temperamental and hardly countable for steady supply of buckskin. Dutch missionaries stationed in different localities were authorized to issue hunting licenses for the immigrants. The missionaries were also authorized to exercise executive power as well as power over collecting tax and judicial matters.

There were two ways to capture deer, either by ground traps made of ropes and bamboo sticks or by digging trap holes for deer to fall in. The trap cost one *real* per month (1 *real* equals 2.5 guilders: a mercenary was paid 3 *reals* in those days). A 15-*real* tax was imposed on each trap hole per month. When too many deer were caught, skinning could not catch up in time and the bottom piles would begin to rot. Overhunting inevitably led to near extinction of deer in Taiwan.

The Dutch levied tax on fishermen, 10% per trip. It was those fishermen that had pioneered the development of Penghu and Taiwan. The Portuguese had named the Penghu Islands Pescadores meaning an "Island of Fishermen". A hundred or so sailboats would come every year from Penghu and mainland China, according to Dutch records.

Fishing boats would first make a stop at Zeelandia to obtain the fishing permit and then sail out to fish, north to south, and again return to Zeelandia to pay tax according to the catch.

Mullet was abundant then and its eggs were dried into the so-called Mullet Roe and its meat salted for export mainly to China. Mullet Roe is one of Taiwan's specialties today. Visit a market in Tainan today, and you will witness shops advertising themselves in the Japanese style: "Shops of Long 300-Year Standing Since such and such Year in such and such Era". They certainly have good reasons for boasting their years of service in supplying dried mullet roe.

The Dutch erected beside the fortresses in Zeelandia[12] and Provintia (1625) a number of other sturdy constructions for administrative offices, warehouses, hospitals, churches, schools, etc. using stones, bricks, limestone, lumbers and metals. Materials not locally available were brought in from China and Batavia. Those structures, built conspicuously stronger than the common hutches and cottages, had the effect of exerting an inexplicable psychological sense of oppression on the immigrants and indigenes.

Throngs of carpenters, plasterers, stonemasons, decorators and other craftsmen rushed to Taiwan to meet the booming demands; so did also merchants to handle daily supplies. Booming coastal shipping attracted many to run sampan services or to work as hired hands.

The Dutch were shrewd enough to start afterwards levying a quarter to half *real* poll tax on immigrants of all trades. The poll tax was categorically levied—equally on those onboard seasonal fishing boats.

7. Kuo Huai-i's Rebellion

The first decade of Dutch rule, a honeymoon period as it were, when the Dutch had welcomed immigrants and treated them with

12 Main fortress completed in 1624-32 and exterior in 1634.

care, once past, the ruling Dutch gradually began feeling the latent threat of the immigrants; the ruled immigrants began resenting the tightening control by the Dutch and heavier taxes imposed on them.

Poverty hit hardest the immigrant hunters. Missionary Junius wrote in his letter dated October 23, 1640, of a number of immigrant hunters, too poor to pay for the license, came to him for loans on buckskin they had not even acquired. Immigrant hunters pleaded with him, wrote Junius, that if he had refused to loan, they would have ended up paying their mates a lot higher interests of 4-5% per month for the money they needed.

Among the immigrants were those who dared illegal hunting/ fishing and smuggling to put up resistance in their own passive way. The Dutch were quick to pick them up and executed every one of them. The last Dutch governor Frederick Coyett wrote in his *Neglected Formosa*[13] , while accounting for the circumstances leading to the abandoning of Taiwan, that prior to Kuo Huai-i's Rebellion the immigrants had complained to the company of the harshness of Dutch rule and of the hardship brought to them and appealed for equal rights for the Han immigrants.

The rebellion led by Kuo Huai-i in 1652 induced all subsequent rebellious movements, large and small, engineered by the Taiwanese. It is a monumental event that stands out in the history of Taiwan.

Kuo Huai-i was at the start a henchman of Cheng Chih-lung and, after Cheng submitted to the Ming Dynasty, stayed on in Taiwan with He Pin (to be described later), each possessing a few thousand men under their control. The two settled down in the vicinity of the

......................

13 Published in the Netherlands in 1675 and translated into Japanese by Tanigawa Umeto.

Li-chan-hang-ke River south of Provintia, Ho cultivating along the north bank and Kuo the south. Kuo Huai-i was elected leader and exercised influence over the vicinity and later appointed senior leader when the Dutch installed the Public Land System.

Kuo had always detested the ruthlessness of Dutch rule and at last on September 7, 1652, he summoned all of his men to his home and ardently incited them over wine:

> "My friends, we have long been exploited to the bones by the red-haired barbarians and we are bound to vanish at their hands before long. Why do we sit and wait for death? We should rise and fight. If we should win, Taiwan would be ours to keep. If we should lose, we should die in glory. What say you?"

The party roared in approval. A plan was laid out to throw a banquet under the harvest moon, invite leading Dutchmen from the fortress at Provintia and kill them all at the height of the banquet. They would then pretend as if to escort the visitors back to the fortress and charge in.

All should have worked out, had it not been for Kuo's own brother's betrayal. This brother and a certain Pouw, an influential immigrant living in the vicinity of Zeelandia, got panicky, sneaked out of the gathering and reported to Zeelandia. The 10th Dutch Governor Nicollai Verburg heard the report in disbelief and dispatched a band of scouts to Kuo's village. No sooner had the Dutch scouts arrived than Kuo and his men got wind and fled. Betrayed, Kuo was quick in action; he immediately mobilized 16,000 men and assaulted Provintia.

Caught off guard, the Dutch guards fled. Kuo effortlessly took the

fortress, killed over a thousand Dutchmen in the Provintia area, set the town on fire and destroyed everything in sight.

The following day, Verburg sent 120 Dutch troops to Kuo's village. Both sides faced each other on the west bank of the Tai-kang for one full week. Soon 2000 indigenes arrived with sophisticated firearms supplied by the Dutch, eager to do authorized head hunting. Poorly equipped with a few primitive matchlocks, spades, hoes, bamboo spears and clubs, the immigrants were no match for them, and 1800 were killed instantly. Kuo died in the battle and his sub-captain Louegua was captured and later burned to death. His corpse was dragged along the roads, his head gibbeted and exposed to public view. The bodies of two other captains were torn apart by five horses.

With no one to lead their way, the immigrants fled straight to their home base along the bank of the Li-chan-hang-ke River and set to defend the south side. Some indigenes happened to know a shallower point of the river and guided the Dutch troops across. Surrounded on all sides at *Au-ang* (Da-hu), the immigrants fought for seven days and nights; some broke through besieging forces but all were cornered in Kang-shan and annihilated.

A total of 4,000 men and 5,000 women and children were killed in the course of the rebellion, not including those killed in the battle of the Tai-kang. *Taiwan Prefecture Gazetteer* has it: "All the Hans in Taiwan were killed." But not a single Dutch soldier died in action.[14]

The ferocious nature of the Dutch made the would-be immigrants then queuing up for their turn on the opposite shore hesitate to

14 *Oud en Nieuw Oost-Indien*, Francois Valentyn; Chou Hsien-wen's essay in the *Taiwan's Economic History*, 4 volumes, published by the Bank of Taiwan; *Manuscript of Taiwan's History*, Volume 9, "Revolution against the Dutch" published by Taiwan History Compilation Committee, and *Taiwan's General History* by Lien Ya-tang.

come to Taiwan. A sharp drop in manpower supply turned the hith-
erto mushrooming Taiwan economy fast downward. And the Dutch
had at last come to "hear the piercing cries of cranes in the wind and
approaching battle cries in the rustling of trees". A threatening rumor
choked the Dutch—the rumor of Cheng Ch'eng-kung aka Koxinga
on his way to assault Taiwan.

Chapter 3

KOXINGA: HIS BRIGHT AND DARK SIDES
—Cheng period (1661-1683)

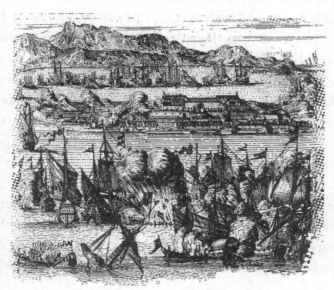

War between the Dutch and Koxinga (1661)

1. The Cheng: A prototype of the Kuomintang regime

Cheng Ch'eng-kung aka Koxinga is an undisputed national hero, an object of public admiration of both the Chinese Communists and the Nationalists. He is for the Communists a heroic figure who liberated Taiwan from the barbarians, as for the Nationalists a spiritual pillar of their dream of counterattacking the mainland China.

Who is Cheng Ch'eng-kung in the eyes of the Taiwanese? His honorific title "King of Pioneers" literally means the Father of Taiwan's development. So profound was the yearning for Cheng Ch'eng-kung among the immigrants, the Qing Dynasty restored his honor in 1700, by publicly declaring that "Chu Ch'eng-kung[1] is a retainer of the Ming Dynasty and no traitor."

As well known, Cheng Ch'eng-kung passed away two years after his arrival in Taiwan. He had been in power only too briefly as compared with the total 23 years of rule of Taiwan by the Cheng. His son Cheng Ching's rule that lasted over 19 years perhaps carries more significance.

The Taiwanese somehow remember more of Cheng Ch'eng-kung than of his son Cheng Ching and grandson Cheng K'e-shuang due perhaps to general sympathy for tragic heroes. When reading the history of the Taiwanese, one ought to bear in mind that the personal charms of Cheng Ch'eng-kung and the essence of the regime he had created are two different matters.

The Cheng regime and the present Kuomintang share many striking similarities. Cheng Ch'eng-kung professed then to be subject to the Ming Dynasty in the same manner that the Kuomintang clamors today its being a legitimate Chinese government. Out of the clamor

[1] Chu, the surname of the Ming Dynasty, was accord him, hence Koxinga.

emerged its national policy of "Counterattack the Mainland", for which the entire people of Taiwan are being compelled to sacrifice.

The irrationality of the Taiwanese people being forced to wage war against the mainland they know so little of has its counterpart in the way the Cheng regime treated the immigrants back then. The immigrants then had escaped hunger and horrors of war and barely made their way to Taiwan. They had just found before them an expanse of fertile land and a bright future ahead. A call for counterattacking the mainland must have sounded so hollow, none of their concern.

The Cheng regime then, just like the Kuomintang today, had not a chance in a million to succeed counterattacking the mainland. The only way left them was to build a new state in Taiwan with the help of the native Taiwanese. Ludwig Riess wrote:

"Should Heaven have allowed the pirate regime to give those surviving retainers of the unqueued ancient Chinese the power to maintain genuine foreign trade, then the historians would have been overjoyed at the development and thus the history of East Asia might have come to record one extraordinary phenomenon. However, the traditional ways of thinking and the demands of the surviving subjects of the Ming Dynasty, who had recently immigrated to Taiwan, never intermingled to make that happen. No doubt, one part of them, with their back on the Empire of China, the mausoleum of their ancestors, objected to establishing a barbarian empire to oppose the Spaniards, the Dutch, and the Britons, while the other let the surviving head of the old kingdom accede to the throne in hopes of restoring the empire of his ancestors." [2]

2 Extracted from *Geschichte der Insel Formosa* translated by Yoshikuni Tokichi, p. 125.

Suggestive a statement it is of a deep delusion in the minds of the refugees and of the fate of a regime built on their obsession.

2. Flight to Taiwan

Initially, Cheng Ch'eng-kung never had Taiwan in his mind; his invasion of Taiwan was only a last-ditch resort. In the year 1652 when Kuo Huai-i rebelled against the Dutch involving the immigrants in a fateful battle, Cheng Ch'eng-kung had just downed Hai-cheng and was amid the six-month-long siege of Chang-chou in China. Six years afterwards in 1658 Cheng Ch'eng-kung and his troops of 230 thousand marched north to attack Chin-ling (Nanking) and suffered a fatal defeat.

Cheng Ch'eng-kung (Koxinga)

The fatal defeat at Chin-ling in fact turned Cheng Ch'eng-kung's attention to Taiwan. He first hesitated in the face of the heavy Dutch defense and the island's adverse natural environment. It was then that an interpreter for the Dutch, He Pin, sneaked out to Amoy with an accurate marine chart and brought it for Cheng Ch'eng-kung's attention. He Pin stressed that the island of Taiwan, if properly developed, would be potentially viable to contend with the mainland.

In April, 1661, Cheng Ch'eng-kung assigned his son Cheng Ching to defend Amoy and Quemoy and himself left the mainland on his way to invading Taiwan with a hundred battle ships carrying

25,000 troops. That literally turned out to be his last battle. Cheng Ch'eng-kung's fleet passed by Penghu and reached off the coast of Lok-ni-mng. Bypassing the South Gate between It-khun-sin and *Pak-soaN-be* then under the control of the fortress of Zeelandia, the fleet advanced through the North Gate (between Pak-soaN-be and Ka-lau-oan). That was a tactful strategy based on He Pin's marine chart. The Dutch panicked. Overjoyed, the immigrants mobilized every ship and cart they had at their disposal to help land the Cheng soldiers. The Tai-kang fallen, the fortress was totally isolated. Cheng Ch'eng-kung summoned the Dutch to surrender:

> "My Dad opened up this island, Taiwan. Now that I need it, kindly get out!"

That was a rather odd message. Did Cheng Ch'eng-kung believe in earnest that his father Cheng Chih-lung had developed Taiwan single-handedly? How did he assess the significance of those great many immigrants there? Even the Dutch could have insisted on their share of contribution. Having personally shown least interest in Taiwan, how could he have had the nerve of claiming every credit for having developed it thus far?

The fortress of Provintia surrendered right way; but Governor Coyett of the fortress of Zeelandia rebuked Cheng Ch'eng-kung's outrageous invasion of the island and vowed to fight to the last man. Coyett gathered all remaining hands at Zeelandia, pressed Batavia for help and even tried to mobilize indigenes from various localities in an attempt to attack the Cheng troops from behind. Batavia arranged some troops to meet Coyett's incessant demands but only too late. Messengers heading for local villages were caught along the way by the

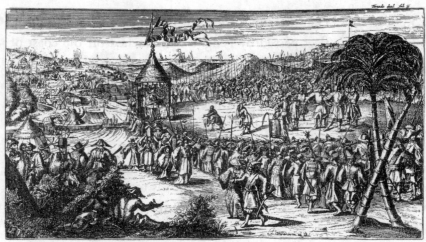

Negotiations between Cheng Ch'eng-kung and the Dutch

immigrants. Only *A-tek-kau-jiong* of the Dorida (Da-du) of Middag Kingdom (near the Da-du River) repulsed Cheng troops twice but was ambushed and killed on his way to rescue the Dutch. [3]

After the Dutch surrendered, Cheng Ch'eng-kung led his troops to patrol through the villages of Sinkkan, Bacluan, Saulang, and Matau to show off his power. It was only on that occasion that Cheng Ch'eng-kung ever left Provintia. That explains how sensitive he was to the reactions of indigenes. Those native Pingpus were soon assimilated or forced to move far into the mountains. It might well have been better off for the indigenes to remain under Dutch rule.

Lacking further means to defend themselves, the Dutch bowed to Cheng Ch'eng-kung; a treaty of peace was signed between the victorious Cheng Ch'eng-kung and the Dutch in February, 1662. The treaty was in fact a generous one in that it meant more an agreement

3 *Taiwan Anecdotes* by Chiang Jih-sheng.

signed between the transferer and the transferee than between the
winner and the loser. The Dutch were allowed to take away, beside
company assets, all personal belongings and food, supplies and am-
munition necessary for them to reach Batavia. They were also granted
the right to march away to music with pomp and glory.

Provintia once downed, Cheng Ch'eng-kung immediately pro-
mulgated a new government and Provintia was made the seat of
Ch'eng-t'ien-fu with T'ien-hsing County to the north and Wan-nien
County to the south. After the Dutch surrendered, Cheng Ch'eng-
kung performed memorial rites for the mountains and rivers and the
gods of heaven and earth, and renamed the entire island Tang-tou. He
declared that It-khun-sin be named An-p'ing. Cheng Ch'eng-kung
himself resided at Zeelandia, now renamed An-p'ing Castle, and ad-
ministered government. The immigrants felt more at home with the
Chinese system of government under Cheng Ch'eng-kung.

3. The Cheng: Its nature

However, Cheng Ch'eng-kung had already issued an order to the
following effect in the name of his own title Head of State:

"I, the Head of State, wish to solicit the support of you all for
the task of developing Taiwan. You all will therefore wish to
secure houses and land to pass on to your descendants. All civil
and military officials serving at the capital and An-p'ing shall be
granted the right to construct respective office buildings and to
procure and permanently own land in proportion to the size of
family. The civil and military officials in the two counties shall
be entitled to the said right. The land of the indigenes and the

immigrants currently under cultivation shall not be violated. The civil and military officials shall first report the size of land required before cultivation thereafter. The immigrants shall first report data of their lands under cultivation. In the event of malpractices, the relevant land shall be confiscated and all parties involved shall be severely punished."

The famous "Farmland System" was conceived on a basis of this principle. However sternly warned not to molest the immigrants and their land, how could the soldiers or rather starving flocks of wolves be expected to perform justice? The system was in reality an open permit, if not encouragement, for embezzlement and pillage. This Farmland System and the Public Land System under the Dutch are not two of a kind. The latter only pertained to nominal ownership of the company, whereas the Farmland System under Cheng rule let the civil and military officials actually own public as well as private lands. It was a de facto privatization of land.[4]

The whole process was warranted by a powerful dictatorial military system.

The immigrants witnessed up close the man they had welcomed now reigning as their second ruler after the Dutch. Most pressing was the problem of explosive population increase, particularly of late comers who settled over the immigrants as ruling classes.

The population of Taiwan in the last period of Dutch rule was estimated to be a hundred thousand or so. Cheng Ch'eng-kung brought along 25,000 troops, followed by their families numbering

4 "Studies on Taiwanese national Character" by Lien Wen-ch'ing published in May 1942 *Folklore Taiwan*.

Ch'en and the baby born of the adultery be immediately beheaded and their heads be brought back in barrels. Tung and Cheng Ching barely survived the ordeal with someone covering them up. It was indeed Cheng Ch'eng-kung's dauntless law-abiding spirit that sustained the high morale of his army.

A family feud ensued following Cheng Ch'eng-kung's abrupt death over the succession of power. Cheng Ching took after his father, but Cheng Ch'eng-kung's youngest brother Cheng Hsi was persuaded by some schemer to challenge the scandal-smitten Cheng Ching. Crush the plot he did, but Cheng Ching never felt at ease in Taiwan. He quickly returned to Amoy, where he wore himself out in constant conflicts with the Qing Dynasty.

It was none other than Ch'en Yung-hua, most outstanding political figure throughout the three generations of the Cheng regime, that devoted to assiduously defend and administer Taiwan. Born in T'ung-an, Ch'en Yung-hua was a knowledgeable economist, a prominent politician unrivaled in the period under Cheng rule. Ch'en Yung-hua designed a thirty-year program toward achieving independence, calling out to the public to "grow in the first ten years, enlighten in another ten years, mature in the last ten years to vie with the mainland in thirty years".

Ch'en Yung-hua toured north and south to encourage all counties in their efforts to cultivate wasteland. He promoted sugar industry as a means of earning foreign exchange, taught baking bricks, and promoted salt production to help increase tax revenues. Ch'en Yung-hua built Confucian temples and schools to propagate education.

The total area of land developed in the Cheng Era was far larger than under Dutch rule:

1. The Chu-lo (Chia-yi) area.

2. The Feng-shan area excluding Lower Tam-sui.

3. *Chui-sa-lian* (Lin-p'i-pu, Tou-liu) areas. A commanding officer Lin chi died in battle here.

4. *PoaN-soaN* (Chang-hua) areas developed starting from Pei-kang.

5. *Tek-cham* (Hsin-chu) area developed starting from the Ta-chia River.

6. A part of the northern area developed along the Tamshui River. Chian-t'an-ssu Temple was built then; the Sulphur Mountain was used as made a penal colony.

7. *Long-kio* (*Heng-chhun*) area developed starting from Ch'e-ch'eng.[6]

The title "*Kai-san-ong*" (or King of Pioneers) should decorate Ch'en Yung-hua and his men equally for their devotion to the development of Taiwan. For the efforts they so exerted they deserve to be part of the ancestors of the modern Taiwanese.

Anywhere at anytime, education in colonial lands is geared solely to serve the rulers. Therefore, one cannot offhandedly pick on Japan alone for having forced a "slavery education" on the Taiwanese. The "San-min-zhu-i" (Three Principles of the People) of the Kuomintang, the Confucian education system of Ch'en Yung-hua and the Japanese system of education in Taiwan are after all three of a kind.

Ch'en Yung-hua perhaps had in mind to educate the sons of Ming settlers first to be administrative officials. What benefit were the common immigrants to get?

In the early days of the Qing Dynasty, many immigrants revolted under the slogan of "Recover Ming; Eliminate Qing", but that could

6 Extracted from *Taiwan Gazetteer* by Inō Kanori published in November 1902.

not have been a fruit of such education. Without wits to strive for sovereign independence after ousting the alien Manchurian Qing, what else could the immigrants have wished for—but "Recovering Ming", however hollow?

A few words might be due at this point on some literati resident adrift in Taiwan at the time. As their personal backgrounds later suggest, those people had little or no contact with the common immigrants. Since, as generally said, Taiwan under the Qing was a land of little or no culture,[7] those literati had contributed nil to the cultural as well as to the academic life of Taiwan. Just for the record, here are some of such individuals:

Shen Kuang-wen, a descendant of Shen I-kuan, served as an official in charge of vehicles and horses. During the Dutch era, he drifted ashore in Taiwan. He was well received by Cheng Ch'eng-kung after his arrival in Taiwan. Under Qing rule he refused to pig-tail and died in Taiwan.

Lu Jo-t'eng, as earlier mentioned, served as minister of defense and died in Penghu.

Wang Chung-hsiao served as a high official in the Interior Ministry. He followed Lu to Taiwan; he did not pursue his political career, and indulged in drinking and making poems. He died four years after arrival in Taiwan.

Li Mao-ch'un left many writings. After arrival in Taiwan, he settled at Yun-kan, built himself a hermitage, named it "Home of Dream and Butterfly", where he passed his days chanting Buddha scripture. Fa-Fa Temple in Tainan is one of his relics.

........................

7 According to a short thesis "Taiwan's Culture in the Qing Dynasty" by Ozaki Hotsuma in *History of Taiwan Culture-continued* published in March 1931.

Ku Chao-chien was a scholar well known in Peking, died shortly after settling in Taiwan.

Shen Ch'uan-ch'i, a scholar and a deputy inspector, was offered but declined any public position in Taiwan and practiced medicine for the benefit of the public.

4. The Cheng: Its inner conflict

No sooner had Cheng Ch'eng-kung fled to Taiwan than the Qing Dynasty quickly promulgated a containment policy to financially force him to submit. In 1663, the Qing Dynasty entered into an alliance with the Dutch; a Dutch fleet of 16 vessels and 2,600 troops attacked Amoy, Quemoy and other bases of coastal bases, forcing the Cheng regime into a dire predicament. To avert the crisis, Ch'en Yung-hua solicited Cheng Ching's approval to draw up and vigorously promote a trade-based national development policy.

He lost no time in opening multilateral trade relations with the Philippines, Thailand, Japan and England. So vigorous was his drive that the British East India Company, for example, hastened to open a commercial house in Taiwan already in years 1675 through 1680. Ch'en Yung-hua advised the Dutch to relinquish colonial ambitions and enter in amicable trade relations with Taiwan. It was largely due to such "Trade First" national development policy that the Cheng regime managed to hold the fort down for as long as 23 years.

Such a policy certainly accelerated Taiwan's economic breakoff from the mainland quicker than under Dutch rule. Objective restrictions thus emerged anew between Penghu/Taiwan and the mainland.

That must have been a welcome trend for the immigrants, certainly not anything to grieve over. Under Cheng rule their livelihood,

though temporarily, improved visibly as seen in Huang Shu-ching's *Record on the Mission to the Taiwan Strait*:

"Foreign trade brought profits to Taiwan; people enjoyed luxuries, fine clothes, and precious goods."

In the eyes of the ruling classes, however, the trade-based national development ought to have been a prerequisite for a "counterattack on the mainland". Though indispensable for the maintenance of the present regime in power, it was, as pointed out by Ludwig Riess, humiliating for the Cheng regime which was steadfastly proclaiming to represent the legitimate Ming Dynasty to have to deal with its enemies on equal terms. The notion of international trade never existed in the mentality of Chinese dynasties up until the end of the Qing Dynasty. The notion of receiving tributes as against granting return gifts was all that there was.

Ch'en Yung-hua, the initiator and architect of the Cheng regime, perhaps might not have been content only with Taiwan's independence, but after his death in 1680, the reins of power quickly passed into the hands of his successors P'ing Hsi-fan and Liu Kuo-hsuan who steadfastly advocated counterattacking the mainland. Cheng Ching had by then grown weary of politics and lost hope for the future; he had washed his hands off politics. Leaving everything in the hands of his mother Tung and his eldest son Cheng K'e-chang, he built himself a luxurious villa out in *Chiu-a-be* (*TeN-a-liau*) and pursued pleasures of the flesh. The following year he died of illness.

His son and heir Cheng K'e-chang was expected to succeed him. Ch'en Yung-hua's son-in-law, K'e-chang was bright and courageous at age sixteen and had already won Tung's favor and trust. How-

ever, certain anti-Ch'en Yung-hua elements, notably P'ing Hsi-fan and Liu Kuo-hsuan, intrigued against K'e-chang in a plot to oust him and place his brother Ke-shuang in his place. Then a rumor flew about abusing K'e-chang, an adopted son of a butcher. Tung's trust in him quickly faded; she sat and watched K'e-chang brutally killed by his own relatives. Ke-shuang was P'ing's son-in-law, a feeble boy of twelve when all that happened. Thus, P'ing Hsi-fan stepped in to grab the whole political machinery.

5. Resistance or Truce?

The Chinese Communists today let the Kuomintang rule Quemoy and Matsu, but the Qing Dynasty then was desperate to capture Cheng's coastal bases. That is to say, the Communists regard the Taiwan issue an internal problem, whereas the Qing Dynasty treated it as a foreign affair. In other words, the Communists have chosen to leave Quemoy and Matsu as a symbol of bondage, as it were, to avoid drawing a borderline over the Taiwan Strait, otherwise they would lose the pretext for "liberating Taiwan". The Qing Dynasty desperately tried to capture the coastal bases in hopes of drawing just that borderline over the straits.

It was quite understandable of the Qing Dynasty to have behaved that way. It was for the Qings a great big dream just come true to have arisen in the barren fields up northeast and successfully conquered the entire Chinese continent. What was the point of wishing for more, much less invading Taiwan that had never been even a territory of China? At the dawn of their new-born dynasty the Qings' was hardly a stable government, constantly disturbed by rebellious moves of which the Three Clans Rebellion (1673-1681) was one.

The Qing Dynasty approached the Cheng regime time and again to talk peace. Initially, the Qing Dynasty asked the Cheng to accept wearing alien costumes and queue as conditions for the peace talk. Queue, by the way, is a male hairstyle peculiar to the Manchurians— the hair shaved off on both sides with the central portion braided into a long pigtail. The Japanese called it pigtail and in the Sino-Japanese War reportedly used it to tie the POWs. The Japanese came to occupy Taiwan and ordered the Taiwanese to have their pigtails cut but they refused to comply, protesting the pigtails were precious next to life. Under Cheng rule, their counterparts back then reacted contrariwise when forced to wear pigtails: "That's the last thing we will ever wear!" This is one good example of how a tradition can be deep-rooted and yet so idiotic.

On learning that the coastal residents were hard hit by the Qing Dynasty's boundary decree, Cheng Ch'eng-kung lamented: "By wishing to retain these few lines of hair of mine I have forced sufferings on my people back home." As Cheng K'e-shuang submitted to Shih Lang, one of the royal families of the Ming Dynasty, Chu Shu-kui, saw off five of his concubines committing suicide in order to follow him to the grave and then hanged himself. He left a death poem reading:

"I sought shelter overseas
Solely for the sake of these few lines of hair,
Now all is over,
May my ancestors accommodate me."

Dear readers, do not slight the value of the "few lines of hair", as that was the moral support of the three-generation-long struggle of

the Cheng family against the Qing Dynasty over a span of 23 years.

The Qing Dynasty was demoralized by the Cheng's strength of mind and eventually hammered out a compromise. In 1679, the Qing Dynasty proposed their final peace terms to Cheng Ching:

"Having exchanged fire on the sea, this court has offered several times Your Excellency to submit to no avail. You declined to agree each time because our local officials made it a condition that you wear queue upon coming to China. Taiwan is not a territory of China but a land cultivated by your father and you. You do not seem content only with Taiwan and rise up against this court, presumably because of your lingering attachment to your homeland. However, unlike the traitor Wu San-kui, Your Excellency have not pretended to an imperial throne. Likewise, how should this court heed to small foreign islands?

Now, all rebellious moves are subdued. Wise and courageous as you are, you would not dare attempt to compel withered tree to bloom again, nor force people into great misery. If Your Excellency should choose to retreat to Taiwan, this court will cease fire. Never again attempt to invade China. Your Excellency need not wear queue. Whether or not to submit and pay tribute is entirely your own choice. This court wishes Taiwan to be another Korea, another Japan.

Thus, Your Excellency need not harm people, nor contest people. People in the coastal areas thus rest in peace free from pains. All has been said. Do ponder it well." [8]

........................

8 P'ing-nan General Beise Laita's letter to Cheng Ching.

But, Cheng persisted on holding the trade post at Hai Cheng; the negotiations failed.

6. The Harshest Demand Ever

The Qing Dynasty at last resolved on crushing the Cheng regime for good. Yao Ch'i-sheng, governor of Fu-chien and Che-chiang, was appointed to take charge of intelligence, and the naval commander Shi Lang was assigned to make preparations for war. The Cheng army made the last-minute efforts to fortify defense against the forthcoming Qing offensive. Liu Kuo-hsuan, the defense minister and chief of general staff, personally took charge of the strategic position in Penghu.

Alas, the pay was too meager; the morale was way down low. The Cheng garrison repeatedly appealed to Taiwan for supplies. Cheng K'e-shuang consulted P'ing Hsi-fan, who advised: "Where we have land we have assets; we shall issue another requisition order."

Startled, Liu Kuo-hsuan said: "Our people are already overburdened when harvests are ruined, the rice price sky-high, and all people are exhausted. Requisitioned harder, and our people will panic. The government should let out its stockpiles."

Cheng K'e-shuang again consulted P'ing Hsi-fan, who impudently replied: "The soldiers are there to protect the people. Right now our government finance is hard up and all officials are poor. If we didn't ask people, whom else are we to ask for funds?"

In the autumn of 1683, Shi Lang set out for Taiwan with over 200 vessels and 30,000 troops. His immediate target was Cheng's mainforce units of 15,000 under the command of Liu Kuo-hsuan. A week-long fierce battle was won by Shi Lang. The entire Cheng forces

were annihilated; Liu Kuo-hsuan fled to Taiwan alone. P'ing Hsi-fan still insisted on fighting on, but, more Cheng soldiers betraying him, it was hopeless. The battle was over; Cheng K'e-shuang proposed an unconditional surrender.

Shi Lang occupied Taiwan without bloodshed. He comforted Cheng soldiers who renewed allegiance to the Qing Dynasty and arranged ships for those who wished to return to the mainland. To win the hearts of the people, Shi decreed to exempt tax for three years.

The Record of Conquest of the Sea has the following paragraph describing the psychology of the immigrants in those days:

> "In August Shi Lang led his fleet and landed in Taiwan. People betrayed no sign of fear and kept on living as usual. Crowds flocked and crossed the streets to welcome Shi Lang. They looked up on Shi Lang as they would worship their own parents. Why could he not come sooner!"

Since this record was compiled to highlight Shi's distinguished services, descriptions may sound somewhat exaggerated, but it does vaguely portray how hard a life the immigrants had endured under the Cheng regime.

Be that as it may, no one would be naïve enough to believe that those immigrants who had had their own fate oriented by others really expected those others also to guarantee them freedom and happiness thereinafter.

Chapter 4

A PILE OF BLOOD AND SWEAT
—Qing period (1683-1895)

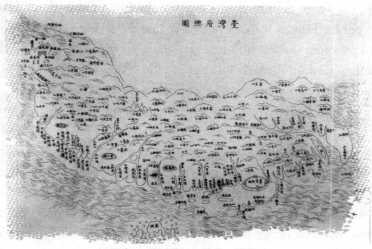

An 18th century Chinese Map of Formosa

1. "Isolate Dangerous Elements"

It was clear from the conditions set for peace negotiations with Cheng Ching that the Qing Dynasty's policy toward Taiwan was to eliminate all possible threats from the island. Therefore, once the Qing Dynasty crushed the Cheng regime, its policy was geared to keep only the militarily strategic Penghu, repatriating all immigrants on Taiwan back to the mainland, and abandon the island.

Alarmed by the policy of the home government, Shih Lang raised various reasons to argue against it. He said Taiwan was indispensable for the defense of the Penghu islands, that it was too imprudent to deport all the 250,000 immigrants back to the mainland and that, should the Dutch or other countries attempt to take Taiwan again, the threats would stay unreduced. Coming from none other than Shih Lang, the timely words of advice made the Qing Dynasty reluctantly incorporate Taiwan into its territory. The following year, 1684, Taiwan Prefecture was set up under Fu-chien Province comprising three counties: Taiwan, including Penghu, Chu-lo, and Feng-shan. All the administrative apparatuses were copied from the Cheng regime.

The Qing Dynasty's bad image of immigrants lingered on all along; all immigrants were deemed dangerous. How to place them under the heaviest of restrictions thus became the bottom line of the dynasty's immediate Taiwan policy. The dynasty swiftly promulgated "The Regulations for Surveying and Compiling Itinerant People" and imposed extremely strict restraints on the movement of people. Single persons without occupation were called "drifters" and forced to return to the mainland. The following Three Bans were imposed on new incomers:

1. Applicants were first issued certificates of original domicile, subjected to inspection by the Taiwan Regional Defense Headquar-

ters, and granted entry only after a thorough scrutiny by the T'ai-Hsia Military command. Anyone attempting to secretly enter the island was subjected to severe punishment.

2. Those going to Taiwan are not allowed to bring their spouses and children along with them; neither can those already resident in Taiwan invite their relatives over to join them.

3. No one was allowed to go to Taiwan from the Canton coastal areas where sea pirates are rampant and traditions persistent.

It is worthy to note here that the last of the three bans was meant to discriminate against Hakka people, allegedly to fulfill Shih Lang's personal vendetta. Shih was born in Chin-chiang, Fu-chien. He often fought hard losing battles against a group of Hakka-turned pirates from Ch'ao-chou who had later sided with the Cheng troops.

But it was true that, among the immigrants, more Hakkas were outlaws than Fu-chienese. Lan Ting-yuan, who was on the staff of the talented and capable general and administrator Lan T'ing-chen who had suppressed the rebellion of Chu I-kui, had these to say about the Hakka at that time:

"Hakka people were those who lived in Jao-p'ing, Ch'eng-hsiang, Da-pu, and Ping-yuan Counties of Canton and immigrated to Taiwan to work as day laborers or tenant farmers. Hakkas would live in groups of several hundreds or a thousand and formed what was called Hakka villages. People in these villages were united tight. They would slug men dead and destroy their corpses for trivial reasons. They were fond of litigation and robbery. They would even steal people's cattle and rebrand them in broad daylight. Once people lost their cattle inside any Hakka village, they had but to give it up. Any attempt to argue would only backfire on

them, be it a crafty offer to exchange cattle or a lawsuit against them on charge of stealing cattle. The officials were powerless to stop such trickeries." [1]

The "Ke" in Ke-chia (Hakka) means "guest of the host" or "people from other places". This expression was also used on the mainland. Be it Hakka, Fu-chienese, or Cantonese, they are all unmistakably Han Chinese. But those Hakkas who settled in southern China a moment too late and thus became "visitors" or "guests" were discriminated. Small in number, the Hakkas were well united and had unique customs, traditions, and language of their own. They were apparently belligerent, and that made people more vigilant and disdainful of them. This is a chicken-and-egg argument with no solution.

The ban was lifted and many Hakka people moved to Taiwan. Better land already settled in by the Fu-chienese, they had to grudgingly settle in hilly areas. It was inevitable therefore that in the process of developing land, both repeatedly encountered. The rulers took advantage of this situation to "divide and rule" them both to their disadvantage.

The Qing Dynasty had always dreaded the immigrants in Taiwan increasing in population to pose a threat to the mainland. Saigo Tsugumichi's invasion of Taiwan in 1874 compelled the Qing to make a positive turn in their administration of Taiwan. Over the 190 years up until then, the Qing Dynasty had maintained an isolation policy whereby the immigrants were to be kept either barely alive or nearly dead.

......................................

1 Extracted from "In discussing with Wu about governing Taiwan" in *Records of Suppressing Taiwan*.

To prepare for the worst, the Qing government stationed in Tai-wan 10,000 troops to watch over up to 250,000 immigrants. In those days, Taiwan consisted of one Prefecture and three counties but actually of two counties, north and south, around Tainan, and the area east of the Central Mountains known as the uncivilized *"Au-soaN"* (back mountains) was left out as a land beyond the reach of administration. A 10,000-strong garrison was far too large for the small area under Qing's rule. From the Taiwanese point of view, the history of the Qing Dynasty was that of a process of how the immigrants fought their way against the Qing's isolation policy to expand their sphere of power.

2. Heading for Taiwan in Droves

Immigration restrictions in those days appeared imposing but always had built-in loopholes as traditionally common in Chinese bureaucracy. Bribe them neck-deep, and the Chinese officials would gladly look the other way.

Along the coast of Fu-chien run sawtooth coastlines with inlets here and bends there offering good points for a number of ports. The west coast of Taiwan is shallow and suitable for landing. There was a constant inflow of illegal immigrants along the coast. The junks in those days could accommodate some twenty odd people on larger ones and ten odd on smaller ones. Illegal immigrants were, if male, disguised as boat crew to deceive the inspectors. Every boat carried seven or eight of such disguised illegal immigrants. Women, children and the aged were locked in inside secret cabins below the deck. The so-called "guest masters" expertly handled all such transactions.

Not a few boats sank or wrecked of overweight or of poor navi-

gational skills. Should illegal immigrants come in quarrel with boat crews, they could be ruthlessly thrown into the sea or "water poured" in their argot. Some were left ashore on some strange island they were told to be Taiwan—a trick called "life freeing". Others were forced to disembark well before the boat reached the shore, left struggling in the mud and sand—another trick called "planting the taro". Watching them being washed out in waves gasping for air is still another trick called "feeding the fish".

Even if one narrowly escaped death to get to Taiwan, he would be caught soon enough and punished and deported to his original domicile. From December 1758 through October 1759, twenty five cases of illegal immigration were ferreted out involving 990 men, women, young and old, of whom 34 were drowned.[2]

The Qing government regarded jobless single men the most dangerous of all immigrants and deported them to their domiciles of origin immediately on arrest, but they were the ones most desperate to immigrate to Taiwan. Arrested and deported time and again, they would come right back. Plenty more new would-be immigrants were queuing up for their chances. In his *Taiwan County Gazetteer Continuation* Hsieh Chin-luan made interesting observations:

"...Taiwan's fertile and spacious land has attracted many poverty-stricken Fu-chienese and Cantonese. Though the land has been almost reclaimed over two hundred years, many kept on rushing in what they were convinced to be a treasure land.

They would flock in Penghu and Amoy and wait for vessels Taiwan-bound. The island is only several hundred kilometers away but it

2 From *Taiwan County Gazetteer*.

was a trip of violent winds and waves that they had to risk their lives on. Blessed with good fortune and fair weather, some lucky ones made it as planned, landing anywhere and managing their way somehow.

The trip was too treacherous for cowards and family men to challenge. Those with decent trades to live by would not dare either.

But, those without families would come, so would those with criminal records or those with no means of living elsewhere—all convinced they could somehow manage to survive, once landed in the island.

Thus, Taiwan was flooded with idlers, hooligans, and fugitives. No wonder the government labeled Taiwan a haven of the evil."

A collection of popular tales, published in the Dao-kuan's era, has a lyric titled "Don't You Ever Go to Taiwan". It vividly portrays how people were motivated to go to Taiwan, and one feels a tint of melancholy reading between these lines the hardships they endured en route to Taiwan:

"Nothing to do at home,
Argue with wife —'Why not to go to Taiwan?'
Straight to the shore you rush,
Beat down the boat fare to smuggle your way to Taiwan.
Pity the boat is too small for comfort.
What a Hell, it's God's will, live or die.
Dried potatoes and dried radishes is all you've got to eat,
Nine out of ten of greens are sure to vomit.
Ask boat-master for water to clean up with;

He blows up and throws back some vulgar curses.
Thank God, with a piece of luck
Made it to Taiwan.
Landed under cover of darkness;
Lost in darkness; can't tell east from west.
Alas! Held up by bandits and
Robbed of all you have got..."

Immigrants rushed to illegally cross the channel to Taiwan risking their lives as they just could not make a living on the mainland. They figured they could somehow find some means of subsistence in Taiwan, and they somehow did.

In 1695, Yu Yung-he traveled to Beitou, Taiwan, to mine sulphur. In his book *Travel Record of the Sea*, he described with interest a booming Taiwan at that time:

"In Taiwan Prefecture, the seat of the capital spans 30 kilometers east to west and 24 kilometers south to north.... Autumn harvest is double that of the mainland, and that included sugar. Other miscellaneous cereals are also cultivated with stable harvest at all times. So, poor people, young and old, in the destitute inland flock to Taiwan and love to live in the capital.... The foreign-made silver coins hold sway in the market and the local Taiwanese prefer them of all coins in circulation.... Cheng Ch'eng-kung was extremely strict in law enforcement and his subjects learned to abide by the law, to the point that often goods were stuck by the roadside for days and no one would dare steal them."

In twenty-five years thereafter, Taiwan developed at a remarkable

pace. Lan Ting-yuan had this to say in his essays in sheer surprise:

"Prior to the Chu I-kui Rebellion, Taiwan covered only an area several hundred 'li' around; Feng-shan and Chu-lo were regarded lands of miasma quite outside of law and order. Now, Taiwan stretches to Long-kio in the south and to Tamshui and Keelung up north, expanding over an area of 1500 'li' around; and people noisily ran about like ducks after profits.

Previously no one would dare to come near the foot of the Big Mountain (Central Mountains) where the indigenes are known to live with a custom of killing men. Today, people move into these areas in numbers to open up land despite fear of being killed. Han people penetrate even as far as *Ka-le-lai-soaN* (southern mountain ranges), *Au-soaN* (east coast) *Kap-a-lam* (I-lang), *Chong-gau* (northern Taitung), and *Pi-lam-bai* (southern Taitung) to trade with the indigenes. As time passes the area extends farther and wider as migration expands to the point despite reinforced prohibition order."

In 1723, Lan Ting-yuan submitted a representation to have part of Chu-lo County chopped off to install Chang-hua County (capital in Chang-hua) covering from Hu-wei-hsi River to Ta-chia River and Tamshui Independent Sub-prefecture (capital in Hsin-chu) covering the area from Ta-chia River to the Keelung area. His idea was to boost administrative capabilities and to relax the already invalidated "Three Bans Policy".

In 1732, the Qing Dynasty was compelled to lift the ban on the immigration of Fu-chien people to Taiwan with families. But the ban was reinstituted in 1740, because "in the past, land was plentiful while

people too few, but now, the land is filled with too many people."

The numbers in the following chart indicate the staggering tempo of development:

Unit: Jia (app. 0.97 Hectare)

County	1684	Newly Cultivated	New or Actual Area
Taiwan County	8,561 Farmland: 3,885 Veg. Garden: 4,678	4,311 (1685-1740)	New and Old combined: 12,221 (1755)
Feng-shan County	5,048 Farmland: 2,678 Veg. Garden: 2,370	6,740 (1685-1734)	New: 103 (1749-1759)
Chu-lo County	4,843 Farmland: 970 Veg. Garden: 3,873	12,271 (1685-1731)	New: 404 (1750-1759)
Chang-hua County (Est. 1723)	370 Old: 140 Newly Cultivated: 230	13,177 (1723-1734)	New: 4,026 (1750-1759)
Tamshui Independent Sub-prefecture (Est. 1723)	Unknown	900 (1731)	New and Old combined: 4,814 (1762)

Source: Page 8, *Frequently Used Taiwanese Vocabulary* by Ong Iok-tek, published Dec. 1957

This chart was compiled from unedited statistics in the *Taiwan Prefecture Gazetteer*. It roughly substantiates the following facts: in the early period of Qing Dynasty's rule, Taiwan County was well

ahead in development, then Feng-shan County in the south and Chu-lo County in the north, in that order. However, later Chu-lo County leaped to the top and, more surprisingly, the newly established Chang-hua County tripled in just 12 years what it had taken Taiwan County half a century to achieve. Further, by 1755, the agricultural land area in Taiwan County had shrunk due to floods and other disasters that lay waste some farmland at the time.

Compared with three former counties, Chang-hua County and Tamshui Independent Sub-prefecture were developed at a surprising speed. The three former counties, inhabited by those immigrants since the Dutch days, had no space for new comers, who then had only to head for the north.

The situation inevitably let the Qing Dynasty lift the ban on immigration to Taiwan in 1760 and consequently abolish its discriminatory measures against the Hakka.

3. The Life of the Pioneers

Taiwan did offer a better chance for secure livelihood than the mainland, but to say that the roads were paved with ankle-deep of coins in Taiwan would be a fantastic exaggeration. Behind Taiwan's rapid expansion and development lay soaked in its soil the sweat, blood and tears of many an immigrant.

Countryside in Taiwanese is "grassland", as the plains in southwest Taiwan, where winter is dry, turn a wide expanse of natural grassland with wild grass growing as tall as man's height. Grassland is an ideal habitat for deer. Cultivation in Taiwan in those days meant turning grassland into farmland. Out in the front were lonely pioneers far beyond the reach of government protection, as described in the line

of a poem by a general in the north, Juan Ts'ai-wen: "the deer fields were mostly opened by landless vagrants."

Describing the pioneers' villages up front, Lan Ting-yuan reported as follows:

"A Hakka village in To-lo-kok in Chia-yi County has 79 households with 257 settlers a tenth of whom are from Fu-chien. Only one of them is married with wife, six of them over 60 years old, and none under 16. They have 32 'kah' of farmland to cultivate. Single immigrants cannot own land of their own to begin with; they are employed by local chiefs as tenants and live in huts in groups of 30 to 40. They seldom cause problems in busy farming seasons but in off seasons they will idle their time away and waste hard-earned money drinking, betting and street fights. In the area between north of Chu-lo and south of Feng-shan live only one thousand females against one hundred thousand single males." [3]

Loneliness, boredom, anxiety, and frustration—there was no telling what any of such symptoms could lead to, if left uncontrolled. That was why Lan repeatedly wrote to advise higher authorities to let the immigrants' families come over to Taiwan.

There are data to substantiate Lan's concern then. In 1732, a certain Wu Fu-sheng revolted in Feng-shan. He took Kang-shan and, pretending to invade *Hu-siaN* (Tainan), moved downstream along the Lower Tamshui River to attack Ban-tan. The following year he was defeated by the Qing army and Wu and his 20 or so followers

3 Extracted from "Notes on Shih-pa-ch'ung-hsi River" in *Records of East Expedition*.

were arrested, deported to Fu-chou and eventually executed. The affidavits made of twenty odd of them are preserved this day and vaguely tell their living environment then.

Name	Age	Occupation	Domicile of Origin	Residence (county)	Assets	Kin
WU Fu-sheng	38	None	Ping-he	Taiwan	3 huts, 2 hectares land	2 sons
LIN Hao	62	None	Chao-an	Feng-shan	5 houses	None
WU Shen	47	None	Lung-hsi	Taiwan	4 huts	1 brother
YANG T'ai	31	None	Tong-an	Taiwan	None	1 brother
HSU Chou	23	None	Tong-an	Feng-shan	6 huts	None
HWANG Sai	65	None	Chin-chiang	Taiwan	3 huts, 1.3 hectares land	None
HSIEH Chang	32	None	Chang-t'ai	Taiwan	None	Mother, wife, 1 son
YANG Pei	42	Geomancer	Penghu	Taiwan	None	None
HONG Hsu	55	Medicine	Chin-chiang	Feng-shan	2 houses	Wife and 1 son
SHAN Da-kai	34	None	Chang-pu	Taiwan	None	Mother
LI Cheng	36	Fishery	Taiwan	Taiwan	None	None
HSIEH Liang	42	Tobacco sale	Hai-feng	Taiwan	None	None
CHEN Ch'ing	22	None	Taiwan	Taiwan	None	1 brother

CHIU E	37	None	Hai-cheng	Taiwan	2 houses	Mother
K'e Ning	55	None	Tong-an	Taiwan	1 hut	Wife
CHIANG Lien	49	None	Tong-an	Taiwan	5 huts	Mother, wife, 1 daughter, 3 sons
TSAI Kuo	36	None	Chang-p'ing	Taiwan	4 huts, 3 houses, land half hectare	Father, wife, 1 brother, 1 son
CHUANG Yu	35	None	Taiwan	Taiwan	3 houses, land half hectare, sugar land 4 hectares	2 brothers
HSU Kui	24	None	Tong-an	Taiwan	None	Mother
YANG Yu	36	None	Ping-he	Taiwan	None	None
CHEN Er	23	None	Taiwan	Taiwan	7 huts, land half hectare, garden 3 hectares	Parents, uncle, brothers, wife and son
CHENG Yao	38	Fishery	Lung-chi	Taiwan	2 huts	Mother
LI Dong	42	None	Feng-shan	Feng-shan	Land 1 hectare	Parents, 1 brother, 1 son
LI Ch'ueh	40	None	Taiwan	Taiwan	None	None
LIN Lien	39	None	Chang-t'ai	Taiwan	1 house	Mother

Source: "Wu Fu-sheng Incident" by Owner of Spring Dream Garden, published in *Taipei Cultural Relics* in November 1955

Of the twenty five twenty were jobless; some lived in thatched huts and others roofless. They perhaps lived as drifters; except for

those from Taiwan, Feng-shan, or Penghu, they must have smuggled into Taiwan. Ten of them were without kin in Taiwan and many with kin there but without wives.

4. Corrupt and Incompetent Officials of the Qing Court

Officials assigned to deal with the immigrants should have been well aware of the responsibilities their positions called for and treated the people with sympathy and understanding. But those who were actually appointed were all ill qualified and abominable.

Troops came from Fu-chien on a 3-year shift and none, in principle, to be recruited locally. They would frequent brothels and opium houses and, when revolted against, they would run quickly away. Crack troops had to be dispatched each time from the mainland to silence local revolts.

The officials were to serve for 3 years each time but, as a patois went, "three year term done in two years", every one of them was only too anxious to be transferred back home. They were all in the habit of temporizing, busying themselves saving money. Another patois went "doors to the public offices are wide open but not accessible without money"—a keen satire on bribery rampant in public offices then.

The governor of Fu-chien province who was assigned to supervise the civil and military officials in Taiwan was only anxious to demonstrate superficial peace and good order in Taiwan. Fearful of the danger in the voyage across the strait and the malicious environment in Taiwan, the governor was reluctant to be stationed in Taiwan; he left the entire work of administration to the local offices.

Fu-chien Province was a poor frontier province every qualified

official would shun; Taiwan was a remote, backward area of Fu-chien only unlucky officials were sent to serve. In mid-19th century, a military commander in charge of Fu-chien and Taiwan, Hsu Tsung-kan, once lamented:

"The worst of officials among all provinces were in Fu-chien, and the worst among Fu-chien officials in Taiwan. Yet they were still people; they were still government officials. Not that there were no people worth governing, nor officials worth recruiting, poverty is what had caused it all—that which had shunned all countermeasures. The crimes of robbery and kidnaping were not yet substantiated and to be judged on later. Wailing over cold and hungry with no lasting work to live by, they had drifted in and had no home and family to return to. Rather than content to sit and wait to die, they would run every risk in sight. That is how poverty obstructed administration. If let alone, they would be obstinate; if killed, more violent."[4]

5. "Minor Rebellion Every Three Years, Major Rebellion Every 5 Years"

As Inoh Kanori rightly pointed out, the Qing Dynasty's 200 year rule was a history of successive rebellions by the immigrants and its haphazard efforts at pacification.[5] He listed up major documented rebellions as follows:

...........................

4 Extracted from *Compilation of Ssu-wei Letters.*

5 *Taiwan Culture Gazetteer*, Vol. 1, p. 751, published in 1928 by Toko Shoin.

Year	Chief Perpetrator	Remarks
1696 (K'ang-hsi 35)	Wu Ch'iu	Attempted to restore Ming Dynasty
1699 (K'ang-hsi 38)	Tonsuyan (T'un-hsiao) villagers	In Miaoli
1701 (K'ang-hsi 40)	Liu Ch'ueh	In the name of God
1721 (K'ang-hsi 60)	Chu I-kui	Took entire Taiwan in 7 days
1726 (Yun-cheng 4)	Kut-tsong	In Nantou
1728 (Yun-cheng 6)	Padain villagers	In the south
1729 (Yun-cheng 7)	Timor villagers	At the border of Tainan and Kaohsiung
1731 (Yun-cheng 9)	Lin Wu-li (*Lim Bu-lak*)	In Taokas (Ta-chia-hsi)
1732 (Yun-cheng 10)	Wu Fu-sheng	Already mentioned
1735 (Yun-cheng 13)	Baibala villagers	Near Ta-tu River
1770 (Ch'ien-lung 35)	Huang Chiao	Leader of cattle thieves
1786 (Ch'ien-lung 51)	Lin Shuang-wen	Heaven and Earth Society, for 3 years
1795 (Ch'ien-lung 60)	Ch'en Chou-ch'uan	Heaven and Earth Society, started as rice riot
1805 (Chia-ch'ing 10)	Ts'ai Ch'ien	Pirate from southeast Asia, harassing Taiwan coast, attempting to establish bases
1806 (Chia-ch'ing 11)	Hung Hui-lao	ditto
1807 (Chia-ch'ing 12)	Chu Fen	ditto
1811 (Chia-ch'ing 16)	Kao Nao	Rebelled out of superstition

1822 (Tao-kuang 2)	Lin Yung-chun	Because of dispute on camphor profit
1824 (Tao-kuang 4)	Hsu Shang	Betel nut trader
1826 (Tao-kuang 6)	Huang Tou-nai	Rebelled with indigenous peoples
1832 (Tao-kuang 12)	Chang Ping	Out of food riot
1844 (Tao-kuang 24)	Kuo Kuang-hou	For tax reform
1853 (Hsien-feng 3)	Li Shi, Lin Kung	Influenced by Taiping Rebellion
1854 (Hsien-feng 4)	Lai Ch'un	Li Shi's survivor
1854	Huang Wei	Heaven and Earth Society from mainland
1862 (Tong-chi 1)	Tai Wan-sheng	Heaven and Earth Society; influenced by Taiping Rebellion
1874 (Tong-chi 13)	Ch'en Hsin-fu-tzu	Rebelled when Japan invaded Taiwan
1888 (Kuang-hsu 14)	Shih Chiu-tuan	Out of taxation abuse

These rebellions were all fierce as symbolized by the well-known phrase, coined by Hsu Tsung-kan, "minor rebellions every three years and major rebellions every 5 years" but of course no simple repetitions of one after another. On the whole, Lin Shuang-wen's rebellion was the watershed of the two general periods to follow: during the first period rebellions were staged for mainly political reasons, while during the second period economic factors motivated them. Early in the first period, revolts were not led by definite organizers and aimed characteristically at restoring the Ming Dynasty.

A typical example was the rebellion led by Chu I-kui's. A theory

has it that Chu was formerly a general in the Cheng Chen-kung' camp. He raised ducks for living in a remote and poor village called *Lo-han-mng* in southeast Tainan. At that time the Feng-shan County was without magistrate of its own and Wang Chen of Tainan Fu was concurrently assigned to the post. Wang indulged in licentious life style and was extremely tyrannical. Chu rose to overthrow the corrupt government and to restore the Ming Dynasty. His cause received enthusiastic support from all corners of the island and his troops swept across the entire island in a week's time.

The way the wave of rebellions swept across the island so rapidly explains the intensity of the immigrants' anti-Qing sentiment. Chu was given the title of "King of Justice" (or "King of Resurgence") and named his era "Yung-he" symbolizing the immigrants' wishes for justice, the rule of law, and peace.

In the following 65 years up until Lin Shuang-wen's rebellion, quite many new immigrants were mingled with those of the two preceding generations. Urge for restoring the Ming Dynasty lessened; Lin chose to call himself "alliance leader" and his dictatorial posture faded. He named his rein "Shun T'ien" (meaning obeying Heaven) and focused his attention solely on catering for the present destiny.

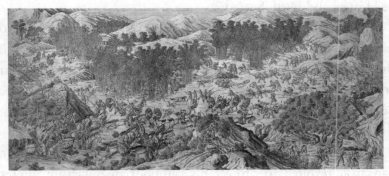

The rebellion of Lin Shuang-wen

A leading immigrant in the Taichung area, Lin was compelled by the government to revolt. A certain secret organization called Heaven and Earth Society was brought in from the mainland and Lin manipulated it to expand the sphere of his influence. Incidentally, some pro-KMT scholars claim it was Cheng Ch'eng-kung that had founded this society, but that is historically unfounded and more likely a mere flattery for him.

Monks of Shao-lin Temple at Chiu-lien Mountain in Fu-chien, who had distinguished themselves in the punitive expedition in Tibet, invited suspicion by the Qing government and were forced to go underground. It was then that the society was organized with superstitious rituals and feudal rules such as "thirty-six oaths" and "twenty-one rules".

The society was a typical Chinese political organization born of China's feudal social system. It was to nest long in China's underworld; Sun Yat-sen and his revolutionary machinery owed much of their operation to the organization. The notorious Green Gang and Red Gang descended from the society. In fact, such secret agents as the Blue Clothes Club and CC Group, which supported the Kuomintang government from behind, were by nature mere copies of the Heaven and Earth Society.

Those economically motivated revolts staged in later periods never spread nationwide as had those led by Chu I-kui and Lin Shuang-wen, obviously because the island had not reached the stage yet of commonly sharing a single pack of economic interests. Instead, many of the leaders of revolts were staged by local economic bosses or intellectuals.

Lin Yung-chun, a camphor wood logging contractor in the I-lan area, revolted to protect his camphor manufacture interests;

Kuo Kuang-hou, a celebrity in Taiwan County, spoke on peasants' behalf to earn himself the Qing government's displeasure. The Qing government had changed its taxation system to paying in silver instead of grains. Peasants were hard hit by the change; Kuo headed their petition and was branded a rebel on that account. Shih Chiu-tuan, a rich merchant in Lu-kang (*Lok-kang*), was led to revolt, so to speak, by the public who had cheered his criticism of Liu Ming-ch'uan's taxation scheme.

The indigenes revolted solely for economic reasons. True, many of the uprisings in the early period were results of greedy interpreters exploiting them but later on they disputed mostly over cultivation.

Why had the rebellions of Chu I-kui and Lin Shuang-wen, though fairly well in control of the situation early on, had to all so utterly fail? This is one vital issue we Taiwanese cannot let pass without scrutiny. Limited space limiting our farther elaboration, suffice it to say that the immigrants never had a clear common political vision of their own.

6. "Factionalism and Feuding"

During the period under the Qing Dynasty, the immigrants' egoistic private feuds over land found eloquent expression in what was called by the Qing officials "factionalism and feuding" meaning ugly inter-factional private armed conflicts. This custom, practiced in barren Fu-chien where people fought over land and water, was brought into Taiwan and became more complex.

From the Dutch era to mid K'ang-hsi era (17th century), there was no need to fight as land was plentiful in proportion to the population of immigrants. Immigrants would seek help from people

from the same locality or of the same kindred; as manpower was in short supply, old immigrants would generally welcome and help new comers.

From mid K'ang-hsi era onwards, as more illegal immigrants smuggled in large numbers, competition for land became fiercer. The fiercest was between two most confrontational groups: the Fu-chienese and the Hakka known as Fu-Ke Feuds. Totally different customs and languages between them added fuel to the flames. Next came the two divided within the Fu-chienese, the Chang-chou gang and the Ch'uan-chou gang known as Chang-Ch'uan Feuds. There were even feuds between smaller groups of different family names. To fight with the Hakka, the Chang-chou gang would unite with Ch'uan-chou gang; when Chang-chou gang fought against Ch'uan-chou gang, the Hakka would profit from their feud. Feuds could be two-sided or three, even four, depending on which side the indigenes underpinned.

The most typical was the case of the I-lan area, where in 1796, in the process of its reclamation, Wu Sha of the Chang-chou gang obtained an official permit to recruit landless vagrants for the project. Himself a Chang-chou, Wu handpicked over one thousand people from among Chang-chous, some 200 from Ch'uan-chou, and several tens from Hakka.

The Chang-chous were given priority in land distribution, the Ch'uan-chous limited, and the Hakka totally left out. The resentful Ch'uan-chous and Hakkas protested to the government—in vain.

In 1800, the Ch'uan-chous and the Hakkas collided, resulting in heavier losses on the former side. The Ch'uan-chous decided to abandon their land and flee to other areas, when the Chang-chous held them back, gave them land, an additional 0.42 hectare each, to

comfort them.

In 1806, the Chang-chous crushed head on with the Ch'uan-chous in the Taipei Area; the latter were defeated and fled to the I-lan, where local Ch'uan-chous helped them in retaliation.

It was then that the Hakkas and the indigenous Alisai villagers, who had long had grudge against the Chang-chous for their cruelty, took side with the Ch'uan-chous. However, they too suffered defeat at the hands the Chang-chous and lost their hard-earned land.

There is a saying popular in Tainan that goes: "When Tsai meets Tsai, even ancestors' memorial tablets cannot be left unbroken; when Ch'en meets Ch'en, they are sure to stab each other." This satirizes that people of a kin can destroy one another in bloodshed once their interests collide—a notch graver case of factionalism and feuding.

The most ridiculous confrontation in the eyes of us today was perhaps that between two schools of music, *Se-phiN* and *Hok-lok* quarreled over the difference in ancestry and the choice of instruments. In one village where Se-phiN happened to be popular, not a soul of the Hok-lok school could be found performing and vice versa.

The Qing officials were virtually powerless in suppressing factional struggles, always fearful of feuds escalating into rebellions. In fact many such struggles did develop into rebellions often on account of some corrupt officials bribed into siding with either side.

Once a rebellion broke out, the Qing government would publicly recruit "vigilantes" to suppress it. When the rebels were Fu-chienese, the vigilantes to suppress them would be Hakkas; if the rebels were Chang-chou gang, the vigilantes to control them would be Ch'uan-chou gangs or Hakkas. If the rebels were a mixture of all three, the vigilantes to tackle them would be indigenes. Such vigilantes were in essence antagonists engaged on profits to sell loyalty to the government.

Feuding totally vanished during years under Japanese rule. Factional armed struggles, or ruthless and brazen personal vendettas common in feudal society, had no space to thrive in a modernized society with powerful police force to crush them in no time. The Japanese did not need to resort to the archaic divide-and-rule tactics. A well-developed transportation system, economic prosperity, and the propagation of education—all added to make the Taiwanese realize that before the Japanese they shared a bond of mutual destiny and to lead them naturally to foster a common notion of casting aside minor differences for the sake of main aims.

7. Fu-chien's Colony

Despite the Qing government's isolation policy, Taiwan was knitted into Fu-chien as its indispensable colony.

In 1684 there were 7,534 ha of rice field, 10,919 ha of sugar cane field registered, totaling 18,453 ha.[6] Though the figures might have been registered lower just to evade land tax that was twice as high as in the mainland, we can speculate that, in the later period of the Cheng era, there were large areas of unattended wasteland due to shortage of farm hands recruited by the military.

Of the already scarce farmland rice fields were far less than sugarcane fields. This was because rice was harder to grow than sugarcane in Taiwan and, location-wise, the area south of Cho-shui (*Lo-chui*) River was better fit for growing sugarcane than rice.

Further, the Dutch put more emphasis on sugar production; the Chengs too promoted sugar production to earn foreign exchange. So,

..............................

6 Taiwan, Feng-shan, and Chu-lo counties combined; see the chart on page 112.

it was evident that sugar was well above rice in total production. In the later part of the Cheng era, however, rice production was boosted to meet military needs and population increase, but after the demise of the Cheng regime, rice production dropped and more profitable sugar production again shot up.

However, the Qing Dynasty turned to encourage rice production for security reasons and chose to ban exporting rice out of the island. Thus, Taiwan's agriculture had perpetually swung to and from between rice and sugar right from the start of its development.

There was plenty of rice in Taiwan, enough to meet the needs of relatively small numbers of immigrants and troops, whereas in Fu-chien Province to which Taiwan belonged had suffered from chronic famine throughout the supposedly peaceful, prosperous eras of K'ang-hsi, Yun-cheng, and Ch'ien-lung. In an attempt to turn Taiwan into the rice storehouse for Fu-chien, the Qing government changed Taiwan policy and relaxed ban on immigration to Taiwan to boost manpower in Taiwan.

Now, Taiwan was made a colony of Fu-chien. From Fu-chien came just about everything without restrictions: coarse fabrics, farming equipment and coarse pottery for poor immigrants and silks, satins, furniture, daily commodities, high quality wine from Chen-chiang and Shao-hsing for the rich. Those imports were sold at prices twice as high as in Fu-chien.

Any local attempts to start up manufacturing industries met fatal dumping assaults of cheap imports brought in by merchants; those merchants invested the profits to buy up rice, sugar, and camphor and shipped them to the mainland for huge profits.

Those merchants organized guilds or trade associations, known as "*kau*", which monopolized trade at the ports of Taiwan Prefecture,

Lu-kang (established in 1784), and *Ban-ka* (*Ban-hua*, established in 1792, meaning canoe in aboriginal language). The three kaus Taiwan Prefecture were historically the oldest.

Lu-kang in the late Qing Dynasty

The three kaus were *Pak-kau* handling trade with north China, *Lam-kau* with south China, and *Kang-kau* within the island of Taiwan. When immigrants rebelled, these kaus helped the government, recruiting vigilantes and raising funds to cover military expenses.

The immigrants handled rice exports through respective kaus at a fair price on a regular commercial basis. Astounding volumes of rice were collected in lieu of land tax.

In the year 1729, for example, land tax was equivalent to 169,266 dans[7] of rice, of which 89,730 dans were put aside for 15 battalions of troops stationed in Taiwan, and the rest delivered by regulation to the mainland in two installments—one for military consumption called "Tai-yun" and the other for civilian use called "P'ing T'iao-mi". The trading association provided ships for delivering the rice. At the time, the Taiwan route was designated to ship rice on the way back from Taiwan. When there are not enough civilian ships on service, the government provided ships exclusively for shipping rice.

"Tai-yun" gazettes show that in 1731 the troops in Kinmen

7 1 dan ≒ 31 kiloliters.

and Amoy required 23,952 dans of rice; the dependents of troops in Taiwan who lived in the mainland consumed 22,260 dans, and the troops directly under the Fu-chien Provincial government used 15,570 dans, totaling 61,782 dans. P'ing T'iao rice delivered to four prefectures, namely Fu-chou, Hsing-hua, Chuang-chou, and Chang-chou, totaled 120,287 dans—the grand total aggregating 182,069 dans of rice. This system began in 1725 and continued until the end of the Qing Dynasty.

Now, just how did these figures account for in Taiwan's total rice production? Another set of statistics show that in 1741 Taiwan's total rice production was a little over one million dans; Tai-yun amounted to 61,000 dans, P'ing T'iao rice 120,000 dans, unscheduled purchases 100,000 dans—all totaling 281,000 dans. Commercial dealings and smuggling accounted for 200,000. In other words, 500 thousand dans of rice produced in Taiwan, or one half of the total production, was shipped out to the mainland; the other remaining half for consumption of the several hundred thousand immigrants—including some 90 thousand dans for the troops stationed in Taiwan.

Land was fertile in Taiwan then, so fertile that one good year's harvest could support four to five years. However, typhoons, droughts, and insect plagues frequented the island; the livelihood of the immigrants was not quite as comfortable as they had expected before leaving the mainland. Actually many immigrants were very poor and lived harsh lives, so harsh as to ignite intermittent rebellions.

From 1882 to 1891 northern Taiwan had to depend on the mainland for supply of thousands of dans of rice due to a rapid increase of population in the north and consecutive years of poor harvests. In the same period, however, southern Taiwan continued to export rice to the mainland—an awkward phenomenon basically caused by

overall political inefficiency and poor transportation system that had hindered Taiwan's sound growth into a single economic unit. The immediate reason, however, was that more advanced foreign steamships (mostly of the British) were readily available to bring in rice from outside. Shipping rice from down south with local junks was much too inefficient.

Rice production did increase throughout the Qing era not because per-unit area productivity rose in any way but merely because more arable land was cultivated. In fact, little had been done in refining farming skills, improving irrigation systems, developing fertilizers, etc. to boost rice production enough to export. Export of rice out of the island was possible simply because production exceeded consumption.

Taiwan's land system, the foundation of rice production, then largely comprised two types: one, a feudal system of land ownership and, the other, a modern land ownership disguised under the feudal system.

The former was government farmstead[8] , special farmstead[9] , public land tillage system[10] , and Lung-en land[11] ; the latter privately owned lands cultivated by immigrants and the Ping-pu.

Area-wise, the former was by far predominant. From the Yuncheng and Ch'ien-lung eras onward, however, the pattern of land ownership under the feudal system began gradually, but steadily, making way for one of modern ownership as land owners under the feudal

.............................

[8] Plantations owned by the government.

[9] Plantations owned by Cheng Cheng-kung's subordinates.

[10] Plantations cultivated by the Ping-pu or indigenous people who submitted to the Qing Dynasty at an early stage.

[11] Plantations cultivated by troops in indigenous reserves.

system, known as either cultivators or enterprisers, handed over the managing rights to the tenants in lieu of "primary rent" of usually 10% and themselves turned absentee landlords.

As against the primary rent was what was known as "secondary rent" usually of 50 to 60%. That was a farm rent paid to the tenants by sub-tenants cultivating the subleased land.

By and by, the tenants turned landowners themselves. As a rule the original tenancy contract between the cultivator and the tenant forbade the tenant from disposing of or subleasing the land. But the tenants had come to acquire so much power that the cultivators could no longer interfere with such arrangements.

Thus, over each piece of land was built a three-layer structure: the landowner on top of the tenant with the sub-tenant underneath. This structure ruled Taiwan's land system for a long time. It was uncertain whom to tax, with whom to negotiate to buy and sell land. It was in fact a stumbling block along Taiwan's road to capitalism. Later under Japanese rule, Kodama Gentaro, Governor-General of Taiwan, effected a major reform whereby the conventional landowners, the top of the layer, were removed and the tenants were put in their place.

8. Land and People beyond Qing's Rule

While Taiwan remained a feudal, colonial society under the Qing Dynasty, the Western powers had accomplished capitalism and were busy expanding their sphere of influence over to the East in the mid-18th century. Into the 19th century they targeted China and began escalating pressure aiming at semi-colonizing China. Engulfed in the turmoil, Taiwan suffered her share of agonies amid a complex inter-national political environment, which eventually swept Taiwan into

the hands of Japan.

It was England that shook awake the "sleeping tiger" and reduced it to an "ailing pig". The Opium War of 1839-1842 and the Arrow Incident of 1856-1860 threatened Taiwan's coastal lines and compelled Taiwan to open up its ports including An-p'ing (including Tainan), Kaohsiung, Tamshui, and Keelung.

Simultaneously, missionaries were let in to preach freely; the Presbyterian Church of England sent William Campbell aka *Kam Ûi-lîm* to Taiwan in 1870, who set up his base in Tainan began extending influence in southern part of Taiwan. The following year, 1871, the Presbyterian Church of Canada sent George Leslie Mackay to Taiwan to establish its influence in northern Taiwan with a base in Tamshui.

Japan invaded Taiwan in 1874 and a war broke out between China and France (1884-1885); in both cases the horrors of war directly hit Taiwan. In 1854, US Eastern Fleet commander Matthew Calbraith Perry surveyed coal deposits in the Keelung area; the Prussian fleet also coveted Taiwan. These incidents helped awaken the Qing government to the importance of Taiwan—military, political, and economic.

Here is an episode that the readers might find amusing. In February 1869, a Tauketok, the grand chief of the 18 tribes in southern Taiwan, inked a pact with American consul C. W. LeGendre for mutual assistance on events of sea disasters. It was a genuine, authentic international treaty formally ratified by the then government of the United States. A rare piece of international treaty at that.

Four trade ports were opened, and that signaled a new phase of Taiwan's trade as foreign trading houses began handing Taiwan's unique products such as tea, camphor, and sugar in the international trading arena. That, however, also brought a unique sort of worries for Taiwan: more foreign vessels were wrecked off the southern coast

of Taiwan and foreign seamen in disaster often beheaded by the indigenes. Foreign governments protested but the Qing government refused to comply on the pretext that the indigenes were inhabitants of land beyond its jurisdiction. Foreign fleets tried to assault the indigenes in their own way but with little

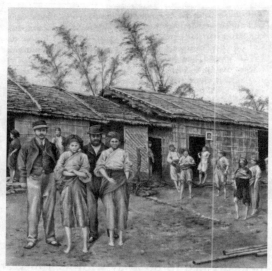

LeGendre (first from left) visited Tauketok's territory, 1872

avail. The case of the US vessel *Rover* was particularly tragic. It was wise of LeGendre to have had a direct negotiation with Grand Chief Tauketok and signed a pact, the afore-mentioned rare piece of treaty, to substantially improve the situation. Tauketok stood firm by loyalty and won honor. At that time, it was rather sensible. Tauketok stuck to his promise and won praise. It means Taiwan had two governments at that time and what happened then was symbolic in that Taiwan betrayed an aspect of its real nature under Qing rule.

It was not the indigenes under Tauketok's command that beheaded the fifty-four Ryukyu fishermen. Tauketok died in the even of Japan's invasion of Taiwan and his nephew P'an Wen-chieh who took after him led his 18 tribesmen to support the Japanese. Aware that the Qing government was indignant at Japan's invasion of Taiwan, P'an had his own way of calculating Taiwan's interests.

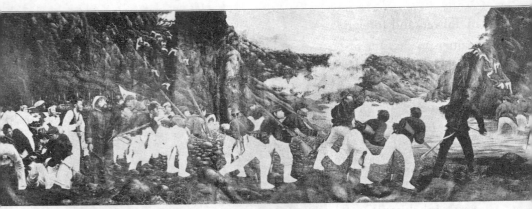

Japanese invasion of Taiwan, 1874

The situation having changed to that extent, the Qing government decided to do away with its 190-year-long passive policy and drew up a plan to positively manage the whole of Taiwan. Shen Pao-chen, Minister of Shipping, was appointed in charge of Taiwan affairs to innovate administration and to develop the eastern Taiwan. Then,

Liu Ming-ch'uan

in 1887, the Qing government made Taiwan an independent province and appointed Liu Ming-ch'uan its first governor.

Liu hailed from An-hui, a master in the arts of pen and sword, highly knowledgeable. He was the most outstanding official sent to Taiwan in the Qing era. He had no sooner arrived in Taiwan than a series of innovative policies were implemented.

He reinforced the military, built railways, monopolized the camphor

and sulfur industries, promoted the mining and tea industries, imported a modern system of education, and adopted practical measures for the management of the indigenes. While promoting such capitalistic measures, Liu Ming-ch'uan launched an epoch-making plan to re-measure the land for taxation purposes to help increase provincial government revenue.

Feudalism was too far deep-rooted in the Qing government's body politic, however, for Liu Ming-ch'uan's revolutionary policies to actually work. The local officials obstructing his reforms and old regulations blocking his way all along, his efforts for modernization in Taiwan failed just as in the mainland (1891).

The second governor Shao Yu-lien figured it best to put the mind of the people at ease; he quickly changed or abolished almost all of Liu's policies. The Sino-Japanese War broke out, and, sensing a danger afoot, he quickly yielded his post to T'ang Ching-sung and evacuated Taiwan. T'ang was about to face the plight of ceding Taiwan to Japan and find himself engulfed in the rough waves of history.

9. The Taiwan Strait—History's Watershed

Before closing this chapter, the author calls the readers' attention to such factors as are all too easily neglected: the natural environment of Taiwan—first, the Taiwan Strait and, second, Taiwan's natural features. The Taiwan Strait has always been a fateful obstacle lying between Taiwan and the mainland. Open a map on the table, and see how close lies Taiwan from the mainland; you might recall a literary expression "only a strip of water away". The Taiwan Strait has, however, played a vital historical function all long, albeit a narrow strip of water 180 kilometers wide. A mere mention of how the 40-kilometer-

wide Dover Strait has functioned in Europe's history should suffice to see the point.

The Taiwan Strait is not only wider than the Dover Strait but there is a wider point between Penghu and Amoy called the "Black Ditch" (*Ou-chui-kau*) where the currents create a violent vortex—a cold current from the north colliding a warm current from the south at this narrow point of the strait to create a strip of sunken current which makes navigation difficult. Even until recently, even naval vessels were wrecked, much less in the old days when navigators could only pray to Matsu God for protection.

And of course there are typhoons to worry about. There are various versions on the etymology of the term "typhoon". The author personally prefers the one mentioned in the *Taiwan County Gazetteer* which identifies typhoon a "wind sieve" meaning "violent winds shooting rains high up in the air." Taiwanese call it *"hong-thai"*: *hong* means wind and *thai* means sway. It matches well with the version mentioned in the *Taiwan County Gazetteer*. In short, the Taiwan Strait is no narrow strip of water one can cross unless well prepared.

Should one escape from the jaws of death crossing the strait, there will await horrible environmental diseases after landing, of which the most typical was malaria, commonly called chill and fever disease. When the French fleet occupied Penghu and also when the Japanese troops invaded Taiwan, most casualties were due to malaria. That explains how awful were the environmental diseases. That was why the immigrants devoutly worshiped more *Po-seng-tai-te*, the God of medicine[12] , than Matsu, the Sea God.

..............................

12 Also called *Tai-to-kong, Ngou Chin-jin.*

And there were those immigrants who had lived through a colonial life in such natural conditions for over 200 years. In his *A Collection of My Belly*, Wu Tzu-kuang[13] tells about Taiwan's customs: "In short, Fu-chein and Canton each had its own local customs, but, having once lived in Taiwan, they became exotic in their customs"—a sharp observation, indeed. Here are a few more examples.

Language-wise, the immigrants were predominantly from Fu-chien, and for the convenience of daily living the Hakka immigrants had to be fluent in Fu-chiense. Fu-chiense thus became a common language. Of the Fu-chiense immigrants Chang-chou gangs and Ch'uan-chou gangs lived intermixed in various places, thus causing aphonetic blending, which led to the emergence of a new common language called Taiwanese, neither Ch'uan-chou nor Chang-chou. As one compares it with extensively diverse dialects of Fu-chien, one comes to notice the importance of the differences. Scholars argue that if neither Ch'uan-chou nor Chang-chou the Taiwanese is an offspring of the Amoy language. But the Taiwanese and the Amoy language are apparently two different tongues in soft voice, accent and vocabulary.

"Mingling child" (Beng-leng-chu) is one of Taiwan's unique and popular customs. As well known, the family system in China has long favored succession in the male line. But females were scarce among the immigrants and marriage was hard to arrange. So, adopting boys from unrelated families became a fashion. "Mingling child" normally meant adopting and fostering boys of age 8 to 16 for money, but in some rare cases the adopted "boys" were almost of the same age as the adopting fathers and addressed to as "fathers". The system was despised by the Chinese as "confusing the lineage by letting in persons

..............................

13 Ch'iu Feng-chia's teacher.

of different surnames".

The scarcity of women necessarily elevated the status of women. Male chauvinism is only superficial also in China. Taiwan women do enjoy a better position; married women possess properties of their own and interfere with the distribution of inheritance by their husbands. Takekoshi Yosaburo points out:

> "As the relationship between men and women in Britain changed to female chauvinism in colonies, the Chinese ethics changed in Taiwan where men outnumbered women." [14]

Like overseas Chinese in Southeast Asia, the Taiwanese called the mainland "*Tong-soaN*" and the travelers from the mainland "*Tong-soaN-kheh*". Those names betrayed their sense of nostalgia as well as their cautiousness toward foreigners. A common saying goes: "... always bargain for half price in dealing with Tong-soaN-kheh" meaning the merchants from the mainland asked for ridiculously high prices which had to be halved and "the tiger in Tong-soaN" (a witticism with the word "tiger" *Hou* pronounced the same in Taiwanese *Hou* meaning "cheating". There is no such dangerous thing in Taiwan!).

In conclusion, Taiwan's political and economic departure from the mainland began in the days under Dutch rule, gained impetus in the Cheng era but lost momentum under the Qing rule as it was placed under the colonial rule by Fu-chien. And it was exactly due to this change in reverse that Taiwan's antipathy toward mainland China grew stronger.

..............................

14 Extracted from *Japanese rule in Formosa* published in September 1905.

Chapter 5

NO ONE BUT TAIWANESE
—Republic of Formosa (1895)

Flag of the Republic of Formosa

1. Forsaken Before You Knew

As a result of the Sino-Japanese War (1894-1895), the Qing government ceded Taiwan and Penghu to Japan.

However, to give up the Liao-tung Peninsula the Qing government adamantly refused, as the peninsula was situated at a strategic point close to the capital. Russia, Germany, and France meddled in the process. Japan had hard teeth to grind but conceded. But, the Qing government readily agreed to cede Taiwan which they had made little account of as a hard-to-govern colonial province afloat in the southern sea.

The news of the cession of Taiwan to Japan reached Taiwan already in the spring of 1895. The immigrants were shocked, bewildered and angered. The cognoscenti flatly blamed the envoy Li Hung-chang and his well-wishers, Sun Yu-wen and Hsu Yung-i, for the outcome of negotiations. They sent express fliers over to the mainland media, appealing thus:

> "It is indeed pitiful that from now on we Taiwanese can no longer be subjects of the Qing Dynasty. Has any emperor of our Qing Dynasty ever forsaken us? Traitors are Li Hung-chang, the savant/high official, Sun Yu-wen, Justice Minister, and Hsu Yung-i,

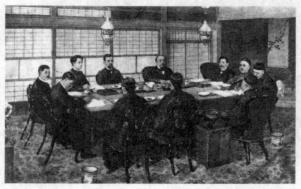

Qing Dynasty ceded Taiwan and Penghu to Japan in the Treaty of Shimonoseki

Deputy Minister of Personnel. You, Li Hung-chang, Sun Yu-wen, and Hsu Yung-i, what hatred bear you against us? We Taiwanese are about to lose the lives of our parents and wives, houses, lands, graves, spirits, properties, families into the hands not of the Japanese but of the wicked officials such as Li Hung-chang, Sun Yu-wen, and Hsu Yung-i. We Taiwanese are too poor to go anywhere, have no way to vent our resentment, nor to pay respect to our ancestors or to snivel to the empress dowager or the emperor. We will eventually die; we might as well try to get rid of the wicked officials and be the ghost heroes of the Qing Dynasty. We all die. Should we destroy these traitors and die, we might do good for the sake of the Great Qing Dynasty. We Taiwanese are doomed never to breathe the same air with Li Hung-chang, Sun Yu-wen, and Hsu Yung-i." [1]

The immigrants just could not see why a war fought some 2,000 km away had to result in the cession of Taiwan—to the Japanese, of all nations.

It was said that Japan was a barbaric land far out in the east founded by the descendants of Hsu Fu, a courtier of Emperor Ch'in and that its people forbade queues, never bind feet, nor smoke opium. In 1884, when the French invaded Taiwan, the immigrants called it "*Sai-a-hoan*" (foreign rebellion). When the Japanese invaded Taiwan, they called it "*Hoan-a-hoan*" (barbarian rebellion). The way these expressions sound suggests that the immigrants despised the Japanese and how they faced the realities of their land being ceded to Japan with utmost bitterness.

......................................

1 This denunciation was posted in front of the Chang-hua Yamen.

2. The Nature of the Republic of Formosa

On April 17, 1895, Itoh Hirobumi of Japan and Li Hung-chang inked a peace treaty at Shimonoseki, Japan, and in the two months' time until June 17th when the first Governor-General and naval commander Kabayama Sukenori accompanied by his officials and military functionaries invited foreign guests to an inaugural reception at the Taipei government house, Taiwan witnessed an episode of a "republic" abruptly budding in its soil.

The Taiwan governor T'ang Ching-sung (from Kuang-hsi) was elected president and the Hakka celebrity Ch'iu Feng-chia the vice president and commander-in-chief of the New Republic, a cabinet was installed and local provincial heads appointed. Assemblies were established at various locales (Taipei being the principal one) as their legislative organs composed of local celebrities from among the immigrants. Lin Wei-yuan, head of the powerful Lin Ben-yuan clan, was temporarily appointed to speakership but he adamantly refused the offer.

A flag with a yellow tiger on a blue background (The Qing Dynasty's with a blue dragon) was installed as the national flag. The reign title was named "Yung-ch'ing" and the new-born republic declared its founding to the international community—the birth of the first, unrecognized republic in Asia.

Seal of the Republic of Formosa

What was the nature of the Republic of Formosa? What was its function and what was its significance in the history of Taiwan? Let us read what President T'ang

Ching-sung had to state in a declaration issued in his name on the foundation day, May 25:

"Japan disgraced China and made demands at its will. The Treaty of Shimonoseki stipulates for huge monetary indemnities on top of the cession of Taiwan and Peng-hu. The people of Taiwan had stood loyal to the Qing government and do not wish to bow our heads and serve its foes, nor swallow this humiliation. I have made repeated requests not to cede Taiwan to Japan but the Qing government has chosen to honor international loyalty at the expense of our wish.

All Taiwanese are angered. Nowhere else to resort to, we have decided to stand on our own feet and founded a republic. People assembled at my office on May 21 and asked me to assume the post of presidency, but I declined the request. Today, people brought me a seal engraved 'Seal of President of the Republic of Formosa' and a flag with a yellow tiger printed on the blue background and repeatedly asked me to assume the post of presidency. Convinced of their immovable will, I consented to assuming the post. From this day onward Taiwan shall pronounce itself a republic and a newly installed assembly shall assume the reins of government.

Looking back, Taiwan has been governed by the Qing Dynasty for over 200 years and, though a new state of its own is being born today, we shall continue to liege service under the dynasty with due respect for old favors offered us by generations of emperors and with a deep sense of affinity.

If anyone should recklessly raise issues, we will regard him a traitor and dispose of him as such. We will renovate internal politics, seek aids from overseas, develop resources, rectify ill customs,

gradually construct railways and infrastructures and contribute for the wellbeing of the people of Taiwan."

It lacks style and refinement for a declaration of independence. To "liege service under the dynasty"—it is far too remote to be true to the spirit of independence. It was nonetheless quite expected because the birth of a republic the way it came about was only one episode in a drama co-staged by the money-thirsty Qing officials and leading landowners and intellectuals like Ch'iu Feng-chia who tried to hold on to their vested interests. T'ang Ching-sung was in fact only a sorrowful puppet hand-manipulated in the drama.

Ch'iu Feng-chia

The entire scheme for setting up a republic body of government was designed by Ch'en Chi-t'ung from Fu-chou, a deputy general who assumed the post of foreign minister. Before he was posted in Taiwan, Ch'en Chi-t'ung had served as counselor in the embassy in France. It dawned upon him to apply his new-gained knowledge in Europe and it was Ch'iu Feng-chia who jumped at the idea and put it to work right off. Ch'iu Feng-chia was a reputed "genius" in Taiwan then.

As it was thought better to avoid offending the Manchurian Qing emperor in Beijing, T'ang knew no other way but to call himself president rather than emperor. So long as the new state needed the

support of powerful immigrants, he figured fit to install a legislative assembly to cajole leading immigrants. But, for the time being, T'ang knew that he had to depend on the Qing officials and that support of the regular troops was indispensable for resistance.

Should resistance be made to last for a period of time, the international community could be expected to step in to interfere as it had done in the case of the Liao-tung Peninsula. Jealous of Japan's southward advance, Germany and France could, they figured, take whatever subtle measures available. It was, therefore, not so wishful a thinking for them to entertain under such circumstances.

T'ang was in a pathetic dilemma incapable of movement in either direction. Already on February 14, when the Japanese detachment under Commander Hishijima occupied Penghu, T'ang, aware that Taiwan could not defend itself, sent his family back to the mainland. The entire chain of events in Taiwan throughout that chaos, from the news of the cessation of Taiwan circulating all around to the coming and actual arrival of the Japanese, T'ang kept diligently reporting back to the throne and waited for instructions. Peking replied in early May:

"Since last March you have repeatedly telegrammed to the effect that Taiwan is short of troops and sitting in an imminent danger. ...You are to observe well the actual situation and refrain from resorting to radical measures out of a moment of righteous indignation. The peace treaty stipulates that Japan shall recognize, within two years, freedom of choice of nationality, permit those wishing to repatriate to dispose of or carry personal properties, and regard those wishing to stay subjects of Japan. You are requested to see to it that such points be made well known and no anxiety be left behind."

The stipulation in the Treaty of Shimonoseki on the free choice of nationality with a two-year grace period was much more civilized and humanitarian than the Cairo Declaration which unilaterally forces Taiwanese to become Chinese. However, such choice of nationality amounted to nothing for the majority of Taiwanese who regarded Taiwan as their homeland with no sense of attachment to the mainland.

T'ang Ching-sung's persuasion did not pay off; the people's anxiety and agitation lingered on. On May 2, he received an express telegram from Peking ordering him and his subordinate officials to evacuate Taiwan and return to Peking. Ch'iu Feng-chia and his men demanded he remain in Taiwan to maintain the military administration; T'ang was placed under constant surveillance.

The now totally undisciplined troops began hunting for a war chest of over million liangs kept under T'ang's control, as depicted in *Tai-yang poetry* by Wang Sung (published in 1905):

"...the soldiers eagerly cheat thousands of liangs.
The beggars yearned to be soldiers even just for one day..."

These lines sorrowfully describe the bare image of the soldiers and the way they behaved.

T'ang's decision to assume presidency of the republic was a perfunctory gesture to deal with the situation. Two days later, he was authorized to instruct his subordinates to freely decide their course of action. Among those who hurriedly arranged boats to evacuate the island were Executive Officer Ku Chao-hsi, Taiwan Military commander Ch'en Wen-lu, First Class Administrator Sun Ch'uan-yen, Military Attache Yang Ch'i-chen, Taiwan Commander Wan Kuo-pen, etc.; Lin Wei-yuan and other leading immigrants followed them.

Some of them were plundered by rioting soldiers.

The situation at that time is vividly depicted in the record left by Hu Ch'uan (the last Tai-tung County magistrate), father of Hu Shih. Most outstanding was a military attaché Liu Yung-fu who willingly vowed to "live or die with the people of Taiwan".

3. Qing's Soldiers and Taiwanese

Lest Taiwan's resistance should invite interference by the western powers, Japan hurried to seize and subdue Taiwan. On May 17, Governor-General Kabayama organized his division of 500 men in Kyoto, embarked the government ship Yokohama Maru at the Port of Ujina. On May 20, moments after their arrival at the Liao-tung Peninsula, Prince Yoshihisa of Kitashirakawa and his Imperial Guard Division were assigned to subjugate Taiwan.

The troops, fully dressed and equipped for the winter of Manchuria, were hurriedly headed as they were for the scorching heat of Taiwan. The two divisions converged on May 27 at the Gulf of Naka-gusuku in Okinawa. The following day, Kabayama and Qing government's envoy Li Ching-fang, son of Li Hung-chang, conducted the hand-over proceedings onboard the Yokohama Maru anchored off the Port of Keelung. It was originally scheduled to take place at the government house, but the situation was such that landing seemed hopeless without bloodshed and Li himself reluctant to risk his life. The Imperial Division swiftly landed at Ao-ti just behind Keelung on May 29.

The Japanese forces mobilized then with assignment to subjugate Taiwan, including reinforcements made afterwards, were about 50,000 men of two and a half division, 26,000 of laborers, and 9,400

of horses. As Japan had altogether seven divisions at that time, more than one third of the Japanese army was mobilized in Taiwan and the whole of its naval forces.

Whereas the republic had its forces positioned mainly in Taipei and its vicinities—a regular army of about 35,000 strength, mostly from Canton and Hunan. The voluntary troops of the immigrants probably numbered 100,000 or thereabouts—a combat unit, so to speak, of the feudal landlords, their tenants and sub-tenants.

The Japanese Imperial Division landed at Ao-ti met little resistance en route over the notorious San-tiao-ling to Keelung, which, with the assistance of the navy, they occu-

Prince Yoshihisa of Kitashirakawa and his Imperial Guard Division landed at Ao-ti

pied on June 3. The news of the fall of Keelung shocked Taipei.

But still there was the stronghold at the Shih-ch'iu-ling Hills in Keelung that had to be defended. T'ang sent reinforcements in rapid succession, but the troops of hastily recruited soldiers were unfamiliar with local geography and often missed their way. Moreover, they were meagerly paid and nearly starved. Officers often faked their ranks and frustrated the order of command. It was high time T'ang should take command himself but he did not want to leave Taipei. Begged to retreat to central Taiwan and farther down south to reorganize the combatting units, he would only equivocate.

The hell scenes in the desperate city Taipei at that time were vividly depicted by an American journalist James W. Davidson in his book titled *The Island of Formosa* (1903). On June 4, the soldiers on the run fled into the city, set fire and plundered everywhere. The soldiers from Canton and Hunan fought head on in the alleys.

At sunset that day, T'ang fled out of Taipei in disguise, guarded by scores of his men, and hid in a German businessman's house in Tamshui. On June 6, he fled to Amoy on board a German ship. The rest of the keypersons in the republic followed suit, gave up Taiwan and fled away.

It was openly reported then that a decent, sophisticated small Krupp field gun was sold for petty 2 or 3 US dollars and a modern Winchester rifle could not find a customer for barely 1 US dollar, indicative of how serious looting and robbing must have been under an anarchical state.

The only way out left for the terrified and disturbed Taipei residents was to have the Japanese troops enter the city the soonest— quite an irony that was. There entered the stage a Taiwanese named Ku Hsien-jung (1866-1937). Born in Lu-kang (Lok-kang), Ku had come to Taipei a few years earlier to engage himself in trade with the mainland. He was age 30 when he was commissioned by a tea trader Ch'en Chao-chun and a physician Huang Yu-chieh and other fugures in Ta-tao-ch'eng (*Toa-tiu-tiaN*) to travel alone to Keelung to contact the Japanese troops; Ku embarked on the commission and made it to Keelung. There he explained to the Japanese command headquarters the helpless situation in Taipei and volunteered to guide the Japanese troops to enter the city of Taipei. Ku was at first suspected as a spy and threatened in every way possible but he kept composed throughout the interrogation and eventually won the trust of the Japanese.

In recognition of his deeds then, Ku was appointed the following year head of the Taipei Bureau of Morality Protection. Throughout his lifetime Ku Hsien-jung remained cooperative with the Japanese; he was in 1934 made a member of the Japanese House of Lords by imperial nomination. In the eyes of many Taiwanese, however, he was a pioneer tool of Japanese imperialism or the top betrayer of Taiwan. But then, Ku himself was no doubt guided by his own conviction. (See Chapter 6 Section 10)

On June 7, Japanese troops occupied Taipei without bloodshed. It appeared to Governor-General Kabayama and his subordinates that no immediate stress would ensue. But Taiwanese heroic resistance was yet to come; an all-out resistance was to last therefrom over seven long years until May, 1902.

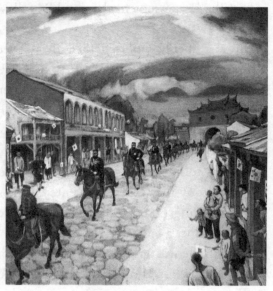

Japanese troops entered Taipei without bloodshed

On July 27, the crack troops were assigned to engage in a second wipe-out campaign in the area between Taipei and Hsin-chu beginning on the 29th. On 31st, the troops entered Hsin-chu; on August 14, Miao-li was taken; on 18th the troops reached Chang-hua. Taipei and Hsin-chu spanned 80km, Hsin-chu and Miao-li 26 km; and Miao-li and Chang-hua 85

km. The campaign progressed at an unexpectedly slow pace. The farther southward went the Japanese, the more intense became the resistance of the voluntary army.

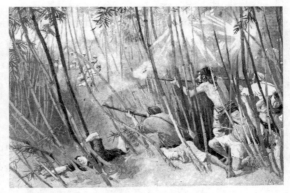

Fighting between Taiwanese and Japanese

Small units led by Hsu Hsiang, Wu T'ang-hsing, Chien Ching-hua, and Lin K'un-kang independently waged guerrilla warfare with inferior simple firearms against the Japanese troops fully equipped with sophisticated weapons and often pushed them into corners. However, after all, it was a battle that would never pay; twenty Taiwanese soldiers had to die to eliminate one Japanese soldier. It was a desperate war. Eight thousand corpses were reportedly left abandoned in the battlefields.

Throughout the operations from May 26 through December 15, 1895, Japanese casualties were 164 dead, 515 wounded, 26,994 hospitalized for illness during war, and 4,642 died of illness in war. Most of the deaths due to illness were victims of malaria.

While warring with the Japanese, Taiwanese had to fight against remnants of defeated Qing troops. Some of the Qing soldiers who had somehow bypassed Japanese disarmament expatriation decrees fled armed and looted on their way to south. At various localities Taiwanese stood in their way and fought back.

For example, on June 7, a group of fleeing Qing soldiers reached Hsin-chu; they gathered outside the South Gate and demanded food

supplies. The town defenders led by Lin Chao-tung (later fled to the mainland) attempted to disarm them in vain and engaged in open fighting. Ch'iu Feng-chia's troops rushed in to help annihilate them. By the gate was erected a monument "Tomb of Canton Volunteer" with a condoling poem reading:

"Living without a bowl of rice, who would sympathize? Dead over a thousand years, who would recognize?" [2]

In Tainan the valiant general Liu Yung-fu and his "Black Flag Corps" were quite alive. On August 30, army lieutenant general Takashima Tomono-suke was appointed Vice Governor-General of Taiwan. He quickly assembled the second division reinforcement (commanded by army lieutenant general Nogi Mare-suke), its accessory 4th mixed brigade (commanded by army ma-

Liu Yung-fu inspecting the fortifications at Takow

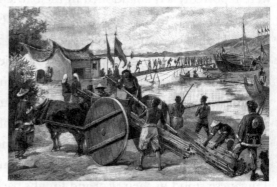

Black Flag Corps

..........................

2 Extracted from *Tai-yang poetry*.

jor general Prince Fushimi-no-miya Sadanaru), and the crack troops to form a battle array to seize Tainan from south, north, and northwest.

Liu Yung-fu (1837-1916) was a straightforward warrior and a confidant of T'ang Ching-sung since the Sino-French War, but they did not get along well. Advised by some powerful person to solicit Liu's support for the defense of Taipei, T'ang chose to send Liu to Tainan.

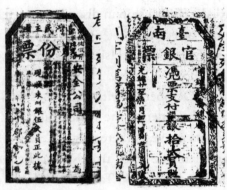
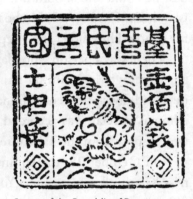

Paper notes of the Republic of Formosa Stamp of the Republic of Formosa

Liu's forces consisted mainly of the 4,000 Black Flag Corps, plus some 30,000 regular army and volunteers. His logistics were very poor. Liu had very hard time procuring supplies. He went so far as to levy head tax on those who tried to flee to the mainland and on all mainland-bound ships. He issued, starting June, paper notes for one, five, and ten dollar currencies and, starting July 31, stamps for 30 cents, 50 cents, and 100 cents. These stamps would turn out to boom in the stamp market and today are among well-known collectors' items. Foreigners who know nothing about the "Republic of Formosa" would certainly know these stamps.

Hard earned supplies were hardly enough to turn back the tide;

Liu's troops were much too depressed to fight any longer and deserted in numbers. In early October, Liu proposed a cease-fire to the Japanese through Great Britain and to negotiate on equal footing as a Qing commander. The Japanese replied his life would be spared if he surrendered as a bandit. Fearing that the disorder in Taipei would repeat itself, powerful merchants in Tainan told Liu he had done the best he could and should not over do it, suggesting him to leave the island. On October 19, Liu boarded a British ship in disguise and left for Amoy. Thus faded the "Republic of Formosa".

There was a person who played the role of Ku Hsien-jung in Tainan: a Presbyterian minister named Thomas Barclay. He led the Japanese 2nd division to enter Tainan on October 22 without bloodshed. Thomas Barclay was accorded a Fifth Order of the Rising Sun and won respect from the Tainan residents for years thereafter.

On October 28, the commander of the crack troops His Highness Kitashirakawa-no-miya Yoshihisa deceased in Tainan. While the official version had it that he died of malaria, there is a legend among local people that he was killed by Taiwanese. There is no knowing when, where, why and by whom, but the legend does betray a deep-rooted anti-Japanese sentiment prevalent in those days and the intensity of the popular resistance then.

A stark contrast between the way Taipei fell so easily and how Tainan resisted the way it did might be partly explained by the difference in temperament between the northerners and southerners. Taipei was a Tokyo in the way it had grown anew inhabited by migrant workers from different localities, whereas the central and southern Taiwan had a long tradition of its own with people bound by a strong love for their homeland. That might explain why Taipei would come to produce a number of financiers while mid-southern Taiwan scores

of politicians.

In a nutshell, Taiwanese resistance was an expression of a China-oriented anti-Japanese sentiment based on a primitive instinct of self-defense. The following poem speaks for the Taiwanese in those days:

"T'ang left; no leader left behind
Flag hoisted; like hollow roar of a tiger
Mobs, rabbles and what not;
Yet, resistance is not at all adverse." [3]

Such a sentiment, however, was some distance apart from the resistance devised and executed by the "Republic of Formosa". True, the two lines of resistance occasionally juxtaposed in the early stage and did in that sense leave an impression that both were led by the republic.

However, in the face of overwhelming Japanese forces and, being aware that foreign powers would not come to interfere, schemers and well-to-do landowners scrambled to leave Taiwan and barely made the mainland their final asylum. Meanwhile, Taiwanese continued resisting till the last bullet then and still went on resisting. There was no other way left for the Taiwanese but to be born Taiwanese and die guardians of Taiwan.

....................................

[3] Extracted from "Small Talk on Taipei Poems" by Liu Huang-ts'un in *Taipei Cultural Relics* Vol. 5, No.1 & 2, published in January 1957.

Chapter 6

IN THE VORTEX OF MODERNIZATION
—The Japan colonial period
(1895-1945)

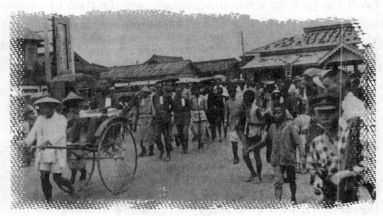

The Se-lai-an Incident (1915)

1. What Did the Japanese Inherit

At the time the Japanese entered Taipei City without bloodshed, Taipei had a population of 46,000, comprising three districts i.e. inner city, Ban-hua, and Ta-tao-ch'eng. How was Taiwan's largest city then?

"Dirty water flows into the surroundings and backyards; small swamps are everywhere, people and pigs cohabit, and although public toilets are available people urinate and excrete everywhere. Fountain water from the wells dug by the Japanese (in Liu Ming-ch'uan time) is pipelined in the city to supply drinking water, but tubs are all filthy. Their brains and eyeballs do not seem to recognize filth. Prostitutes are everywhere; many infected with syphilis of the third stage eroding their bone marrow..." [1]

Living in such an environment, how was the level of education of the Taiwanese? A Briton, P.H.S. Montgomery wrote in his thesis on the education in Tainan, the oldest cultural city of Taiwan with a population of 42,000, the following:

"...education is extremely retarded and the people's level of knowledge very poor. This is a natural phenomenon as most of the immigrants were laborers or laborer-turned businessmen. They are too busy living day to day to spare time for pursuing knowledge.
Businessmen are only too eager to purse and maintain fortunes to

[1] Extracted from p. 69 of *Invasion Into the South* by Ide Kiwata based on on-the-spot survey by Japanese health team, published in November 1943.

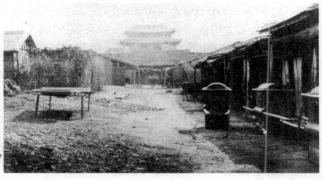

A street near Tainan, the oldest cultural city of Taiwan

foster mentality for knowledge. Men of letters from the mainland, who by nature live by culture for the sake of culture, have no social status to enjoy in Taiwan.

Farmers and laborers are not given even the elementary education; merchants do read and write but their knowledge is limited only to bookkeeping and business correspondence and seldom go beyond.

Literature and arts have never rooted, much less flourished, here where such are nothing but targets of hostilities.

...ninety-nine percent of men are illiterate; where men are that ignorant, how can women be expected to be any wiser?" [2]

A survey taken in 1900 shows as many as 169,064 of the population of 2.5 million used opium.

Arable land of 431,892 ha yielded a land tax of 860,706 Yen, of which 200,000 ha was rice paddy producing 1.5 million "shis" of rice. Other major products included 800,000 "dans" (a dan equals 60 kg) of sugar, 13 million "chins" (7.8 million kg) of tea, and 100,000 pounds of camphor.

There were 62 miles of extra-narrow railways from Keelung to

..........................

2 Extracted from "Report on Tainan, Taiwan Customs, 1882-1891".

Hsin-chu; inter-village roads were there but none to link counties. Post services were available, but it took 7.5 days for mail from Taipei to reach Heng-ch'un. That was Taiwan as the Qing left it and as Japan inherited it as its colony.

2. Successful Colonial Rule

The Japanese made strenuous efforts over fifty-one years to tailor Taiwan into a nearly perfect capitalistic colony. The Governor-General of Taiwan was appointed by the Prime Minister of Japan and was fully authorized to enact and implement decrees, equivalent of laws (based on No. 63 Law, aka the 63 Law, promulgated in March, Meiji 29, 1896), and to appoint/dismiss judges at his free will. That is to say, the Governor-General of Taiwan was the de facto "Emperor of Taiwan".

A fast rising fortunes of the country no doubt helped Japan succeed in her colonial rule of Taiwan, but equally significant was the vigor and eagerness on the part of all, from the Governors-General down to every citizen, to do the best upon honor of the homeland.

Altogether 19 Governors-General were appointed over the 51 years of Japanese rule, chronologically listed as follows:

Early Period (military appointees):
1. Kabayama Sukenori (May 1895~June 1896)
2. Katsura Taroh (June 1896~Oct. 1896)
3. Nogi Maresuke (Oct. 1896~Feb. 1898)
4. Kodama Gentaro (Feb. 1898~Apr. 1906)
5. Sakuma Samata (Apr. 1906~May 1915)
6. Andoh Sadayosi (May 1915~June 1918)
7. Akashi Motojiroh (June 1918~Oct. 1919)

Middle Period (civilian appointees):
 8. Den Kenjiroh (Oct. 1919~Sept. 1923)
 9. Uchida Kakichi (Sept. 1923~Sept. 1924)
 10. Izawa Takio (Sept. 1924~July 1926)
 11. Kamiyama Mitsunoshin (Mannoshin) (July 1926~June 1928)
 12. Kawamura Takeji (June 1928~July 1929)
 13. Ishizuka Eizoh (July 1929~Jan. 1931)
 14. Ohta Masahiro (Jan. 1931~March 1932)
 15. Minami Hiroshi (March 1932~May 1932)
 16. Nakagawa Kenzoh (May 1932~Sept. 1936)

Late Period (military appointees):
 17. Kobayashi Seizoh (Sept. 1936~Nov. 1940)
 18. Hasegawa Kiyoshi (Nov. 1940~Dec. 1944)
 19. Andoh Rikichi (Dec. 1944~Oct. 1945)

In the early period the military Governors-General were assigned primarily to suppress armed resistance by the Taiwanese and indigenes not yet submitted to Japanese rule and of course to lay foundation for the development of Taiwan. The civilian Governors-General in the middle period mainly coped with the political movements of the Taiwanese that ensued earlier armed resistance while answering to party politics back home.

Kabayama Sukenori, the first Governor-General of Taiwan

In the late period, as the Sino-Japanese War dragged into the Pacific War, the military Governors-General were commissioned to erect a military base in Taiwan for operations in southern theaters.

Japan emulated French rule in Algeria for its rule in Taiwan with the ultimate goal of thoroughly assimilating local residents' traditions, customs, and languages into Japanese. One of the methods was to encourage Japanese to immigrate to Taiwan. The policy of emigrating homelanders did not work out so well in Taiwan as in Colon, Algeria, but Japan's assimilation policy eventually paid off rather well in Taiwan.

As a result, Taiwan's population reached 6.6 million (of which 400,000 were Japanese in 1944); arable land totaled 880,000 ha (1942), of which 540,000 ha were farmland and 340,000 ha garden land; rice production aggregated 7.8 million shis and sugar 1.4 million tons; tea production amounted to 13.2 million kg (1939) and camphor 5 million kg (1920).

Public railways extended over 1,500 km; private railways (owned by sugar companies) 3,000 km; roads, wide and narrow put together, extended over 15,000 km. Cities were designed anew, and waterways above and under-ground were built. There were 12 public general hospitals, 2,534 public and private physicians (1940). Six colleges and universities were newly opened, 174 high schools, and 1,194 primary schools. Literacy rate soared to 71% (1944).

The Taiwanese were thrown, not by their own choice, into a rushing tide of modern society, and tasted the benefits of modernization. Needless to say, Japan amassed in the process inestimable benefits from Taiwan, not to mention 20 million Yen per annum of sugar tax, enormous amounts of dividend from various industries, etc.

3. Some Comparisons: Vertical and horizontal

Looking painfully back on the days under Japanese rule, the Koreans always condemn Japan's imperialism the world's most ferocious sort; liberal Japanese agree in resentment that the Koreans do have a point when they feel as they do. The Koreans certainly have a good reason to detest the Japanese and are no doubt free to feel as they wish. The author believes it worth while at this point to make a rational comparison of Korea and Taiwan.

Let us take a look at some figures. First, the numbers of regular Japanese army troops stationed in Korea and Taiwan were two divisions and one brigade, respectively, or a ratio of four to one. The ratio fits nicely in terms of population ratio in the year 1941 when the populations of Korea and Taiwan were 24.7 million and 6.24 million, respectively. But in terms of area, the ratio was 6 to 1 or 220,000 km^2 to 36,000 km^2, respectively. What it means is that Taiwan was under far heavier military control than Korea.

The Japanese Governor-General in Korea was also authorized to make legislative regulations equivalent to decrees by the Governor-General in Taiwan, but never in Korea were implemented such regulations to suppress bandits, ad hoc court system for instant ruling, and surveillance system (a sort of neighborhood watch of guilt-by-complicity system) as were in Taiwan. Likewise, there was an advisory organ called the Privy Council, equivalent to Taiwan's arbitration board, under the Korean Governor-General, but the Privy Council in Korea was all membered by Koreans except for the speaker chaired by a political director-general, unlike the one in Taiwan which was only partially membered by Taiwanese.

In Taiwan, the "Act for Special Appointments for Government-General of Taiwan" was enacted in 1921 to open the door for the Tai-

wanese seeking high posts in the civil service, but in reality very few Taiwanese were appointed thereafter. In Korea, on the contrary, the Japan-Korea Annexation Treaty stipulated right from the start for appointment of Koreans in high posts of civil service in a much broader scale.

In media, Taiwan had only one Taiwanese-language newspaper *Taiwan People's Daily* was permitted to circulate as late as in 1927, while in Korea several national and local newspapers were allowed to circulate already in 1919.[3]

These facts evidence how much heavier the Japanese imperialism weighed on Taiwan.

Colonial rule, however successful its performance may be, is one thing to be unconditionally condemned from the moral point of view. Having had appalling experiences in the past, the author personally does not hesitate detesting and denouncing Japanese rule.

World history, however, has witnessed inevitably emerging at a certain point of its developing process a social, political economic system in the shape of colonial system. Analyses of colonialism from moral and personal points of view aside, we need to have elbow space to objectively study each individual policy strictly from the angle of comparative observation. Now, such comparative observation may be best made in two modes: horizontal and vertical.

By horizontal I mean to compare with colonies that emerged at the same time in different places: Britain in India, France in Indochina, US in the Philippines, Belgium in Congo, or Japan in Korea. Vertically, then, we compare the Qing rule and the Kuomintang rule.

The Taiwanese know too little about and have least interest in

......................................

3 Based on *Taiwan's Nationalist Movement under Japanese Rule* by Mukoyama Hiroo.

horizontal comparison, because preconditions differ from one subject of colonial rule to another.

What matters to the Taiwanese and the enlightened people of the world is vertical comparison. The bygone days under Qing rule aside, today's situation under Kuomintang rule should be the focal point of vertical comparison.

Why so? Because the majority of the 10 million Taiwanese have lived through these two eras. It's only natural of the Taiwanese to compare these eras, as would one, when moving to a new house, compare that with the old one. What if they ever conclude that Japanese rule was more agreeable to live under than the current Kuomintang rule? The matter is grave enough, is it not?

To those simple brains who see things superficially and say "...we are back to where we started" or "...are we not birds of a feather" or "...what colonial rule under the slogan of Free China?", the very idea of comparative observation makes no sense; much less, they can never ever believe in the slightest of possibilities that Japanese rule could have been much better off to live under. As for the Taiwanese, it never occurred to them that they would one day come to sit and compare, on the same plane, mind you, the era under Japanese rule with that under Kuomintang rule.

4. Hopeless Armed Resistance

The Taiwanese' anti-Japanese resistance movements may be classified by type into two periods: armed resistance in the early period and political struggles in the later period. Armed resistance lasted over 20 years or so from the battle to defend the "Republic of Formosa" to the Se-lai-an Incident in 1915. Political struggles lasted for some

30 years from the founding of the Assimilation Society in December 1914 to the end of Japanese rule.

Armed resistance could be further subdivided into three periods. The major incidents that took place in the course of the resistance movements are listed as follows:

First Period

Defense of the "Republic of Formosa" (May to October, 1895. See previous chapter).

Second Period

December 1895—Siege of I-lan by Lin Ta-pei and Lin Chi-ch'eng, attacking Ting-shuang-hsi and Jui-fang.

January 1896—Raid of Taipei by Ch'en Ch'iu-chu, Hu A-chin, and Chien Ta-shih.

June 1896—Chien Yi rebelled in Tou-liu, Yun-lin; in July raided Lu-kang to cut off link between north and south.

November 1896—Cheng Chi-sheng rose in Feng-shan.

December 1896—K'e T'ieh rebelled in Yun-lin.

January 1897—Cheng Chi-sheng raided Feng-shan.

May 1897—Ch'en Ch'iu-chu and Chan Chen raided Taipei.

December 1897—Ch'en Shui-hsien and K'e T'ieh waged guerrilla warfare in central Taiwan.

May 1898— Government office in *A-kong-tiam* (Kang-shan) was raided; in September, Ta-chia office was attacked.

December 1898— Lin T'ien-fu and Lin Shao-mao raided A-hou (P'ing-tung), Ch'ao-chou, Heng-ch'un and vicinity.

Jan. 1899—Chien Ta-shih, Lu Chin-ch'un, Hsu Lu raided the outskirts of Taipei.

Feb. 1901—Chan A-jui assaulted Taichung.

May 1902—Chang Lu-liang was killed in Yun-lin in the midst of the surrender ceremony.

May 1902— Lin Shao-mao, Lin T'ien-fu, and Wu Wan-hsing were arrested and killed.

Third Period

November 1907—Ts'ai Ch'ing-lin appointed himself "Commander of the United Renaissance" and inveigled Aiyuu (Taiwanese security guards in the reservation areas) and aboriginals into raiding Pei-pu Branch of Hsin-chu District. 109 were arrested and 9 executed.

March 1912—Liu Ch'ien and Lin Ch'i-shun raided Ting-lin Police detachment and attempted to take Lin P'i-pu Branch. 8 were executed.

June 1912—Influenced by Hsin-hai Revolution, Huang Chao attempted to rebel in T'u-k'u, Chia-yi, but were uncovered. 24 were arrested; 1 executed.

Oct. 1913—Lo Fu-hsing and members of the China Revolutionary Alliance attempted to rebel in Miao-li, but were uncovered. 921 were arrested; 20 executed.

Aug. 1915—At the height of tension between China and Japan Yu Ch'ing-fang, Chiang Ting, and Lo Chun rose at *Ta-pa-ni* (Yuching). 1957 were arrested and 866 executed (some commuted to life imprisonment).

The armed resistance had an interim period of five years between the second and third periods; thereby, both were unique in character and significance.

The second period was similar to the first period in motive and

strategy, the second period being more or less an extension of the first. The leaders, however, were not so naive as to be able to get the better of the sophisticated troops of the Governor-General. In fact, they were quite ready to succumb to Japanese rule. It was the brutality and ruthlessness on the part of the Japanese that awoke in them the "guts of a worm turning" and drove them to rise.

In his appeal Huang Mao-hsuan, one of the "rebels" rising in Yun-lin, declared:

"Never did we expect the Japanese to invade our land. The Qing and their officials gone, we longed for peace and stability and were about to surrender. Never did we expect how inhumane could those bandits be, doing evil and killing people at will, no questions asked, no plea to be heard, no heed to right and wrong. People were dealt with the moment they were caught. They set fire on villages; violated women. Their malicious deeds were far beyond imagination." [4]

The Japanese military police placed under strict control even relatively stable secure inner cities. A popular folk song then had it:

"Red-capped military policemen stroll downtown,
Rifles on the shoulder; blades in hand,
Should suspicious souls emerge, report right off they say,
Rewards are plentiful, don't you worry."

......................................

4 Extracted from *Historical Development of Yun-lin*.

5. A Thorough Carrot-and-Stick Policy

The Japanese had a hard time control-
ling armed resistance by the Taiwanese,
so staunch and widespread; so much so
that they stood still unable to embark on
development and construction. Interna-
tional community made a laughing stock
of Japan in predicament. Dissatisfied with
such turn of events in Taiwan, the Japa-
nese government appointed lieutenant
general Kodama Gentaro, Japan's pearl
of the army, the fourth Governor-Gen-
eral of Taiwan. To assist him, a brilliant
politician Gotoh Shinpei was installed as
civil affairs' chief. Gotoh had a unique
theory of his own called "biological prin-
ciple", which he employed in Taiwan to
conduct extensive and scientific stud-
ies. He brought his findings to Kodama
and helped draw up a legislative proposal
based on the findings. Kodama took his
advice and put his proposal into action.

Kodama Gentaro

Gotoh Shinpei

In June 1898, Kodama summoned
and briefed his regional directors. With reference to the term "ban-
dit" Kodama specifically commented as follows:

> "...the so-called bandits are not of a kind and should be sorted out
> and treated accordingly. Do not lump them together as bandits,
> or else we are bound to err in actual policy application."

He quickly promulgated a stern and rigid "Bandit Punishument Ordinance" and positively promoted policies to appease rebels and renegades. It consisted of seven articles, the core of which read:

Article 1 Irrespective of purpose, those who gather in numbers to achieve the set purpose by violence or threats shall be deemed bandits and subject to the following punishments:

1. The leader and instigator shall be executed;

2. Those who participated in the plot or commanded it shall be executed;

3. Those who associated, followed or assumed related duties shall be sentenced to imprisonment for a definite terms or heavy penal servitude.

Article 2 Such bandits as are specified in the foregoing three paragraphs and committed any of the following shall be executed:

1. Resisting civil and military officials;

2. Setting fire to or damaging buildings, trains, ships, or bridges;

3. Setting fire to forests, wheat fields, woods and bamboos piled outdoors or others articles;

4. Destroying railways, signboards, lighthouses, and buoys, whereby throwing in jeopardy services of trains and boats;

5. Destroying installations for postal communications and telephone services or hampering communication thereof by other means;

6. Murdering or injuring people, or raping women;

7. Kidnapping or looting people.

Article 3 Crimes under the foregoing article shall be subject to its application though unconsummated.

Article 6 Offenders of this law who voluntarily surrender to the government authorities shall, in consideration of the circumstances, be granted either reduction or exemption of penalty. Exempted pen-

alty shall be subject to probation up to five years.

How relentless was Japan in governing its colony in Taiwan is best evidenced in this law.

Appeasement measures were taken on the basis of the Article 6, whereby death penalty could turn not guilty overnight. Too good to be true. To show how he was true to his promise, Gotoh would often attend submission ceremonies in person and kept close eyes on local officials. Those who submitted voluntarily were assured of their social status or given financial benefits depending on their posts in the organization they served. The top preferential treatment was a medal, the so-called "Gentleman Medal", which was offered only to scholars and renowned citizens.

Apart from such appeasement measures, certain organizations were made vehicles of conciliatory measures. The "Seniors Banquet (Kyouroukai)" was one of them, to which were invite seniors over 80 years of age, in 1898 in Taipei, 1899 in Chang-hua, and 1900 in Tainan. The "Literature Promotion Society (Youbunkai)" was another which, founded in Taipei in 1900, invited all Confucian scholars from all parts of Taiwan.

Meanwhile, Japan's capitalism advanced well in Taiwan as the Bank of Taiwan opened and modern sugar factories started production, followed by currency system reform, the unification of weight and measurement system, land system reform and so on.

By then, resistance had lost its social basis and more and more bandits responded to the appeasement measures. And at last, as the last resistant Lin Shao-mao was suppressed in 1902, the second period of armed resistance halted.

The last days of two men, Chien Ta-shih and Ch'en Ch'iu-chu, bare the eventual predicament of resistance movements. One will

note a sharp contrast in the way they met their deaths.

6. Chien Ta-shih and Ch'en Ch'iu-chu

Chien Ta-shih operated in Chih-lan (*Chhau-soaN* Mountain) and often disturbed Taipei and its vicinities. He once surrendered on August 1, 1898 and rebelled again. His identity well in the hands of the Governor-General, he was easily cornered but barely escaped death and fled to Fu-chien. But then the Taiwan Governor-General's influence extended as far as Fu-chien and soon the Qing authorities arrested and deported him to Taiwan. Alas, in the spring of the following year, Chien Ta-shih was hanged in the Taipei Prison.

In his affidavit following interrogation at the Amoy authorities, Chien Ta-shih stated:

"I, Chien Ta-shih, am a citizen of the Qing Dynasty. The emperor unwillingly ceded Taiwan to Japan. The Japanese are ruthless, often search houses, and rape women. My wife was raped and killed herself. My sister also died. Mother and my brother's wife died also. My family of over ten was reduced to only 4 to 5. Those survived then were killed afterwards.

To take my revenge I led others to fight against the Japanese. In so doing I have done no harm to the Qing people. Regard us bandits might the Japanese, the Qing people should treat us self-sacrificing people. After Taiwan was ceded to Japan, Qing officials, high and low, have left for the mainland and none is left in Taiwan to proclaim justice. Humble as I am, I have led thousands of people in hundreds of battles but never once have I behaved to shame the Qing.

Last year I lost and fled to Chang-chou to seek the Qing citizenship. Chang-chou authorities ought to have protected Qing nationals; but now I find myself in such a predicament. Though no sense talking about what has happened, I beg you to kill me at this instance. I shall be a subject of the Qing Dynasty; dead, I shall be one of the spirits guarding the Qing. I still owe the Qing Dynasty a debt of gratitude. Please do not hand me over to the Japanese; otherwise I cannot close my eyes in death". [5]

Chien was motived to rise against the Japanese first and foremost to revenge his personal grudge against Japanese. It was more than natural of him to stalk the Japanese as a mortal enemy; while the Japanese had good enough reason to have the table turned on him. The problem is with the Qing whom Chien counted on, and that was a fatal lack of understanding on the part of Chien.

Ch'en Ch'iu-chu was born in Shen-k'eng near Taipei in 1855, a newly developed area where indigenes and bandits were rampant disturbing people. The residents were very bellicose and brave to deal with such disturbances. He joined defense campaigns of the "Republic of Formosa", after its collapse, he organized landless vagrants and courageous men to fight against the Japanese.

Of several dozens of large and small attacks he took part, Ch'en made himself known in an attack on Taipei city which lasted from New Year's Eve of 1895 until New Year's day and a surprise raid on Ta-tao-ch'eng on May 7, 1897, when he handsomely commanded his men on white-horseback.

......................................

5 Extracted from "Chien Ta-shih's Tragic Death" in *Collected Essays on the Sino-Japanese War* edited by A-ying published by Chung-hua Books in July 1958.

However, as the Japanese defense reinforced and his men either dropping out in numbers or fast losing morale, Ch'en saw no way out. In June 1899, he decided to start negotiating surrender with Taipei governor Murakami Yoshio and a compromise was reached in two months.

Gotoh Shinpei was very pleased and awarded Ch'en a "Gentleman Medal" and granted him the right to manufacture camphor. Ch'en employed his subordinates to wipe out the disobedient "bandits". That boosted the Governor-General's trust in him, and in two to three years of time he grew up to be a rich landowner with hundreds hectares of good land. At moments of depression he dispelled in women and opium, while generously offering funds for building schools and constructing roads.

Ch'en Chieh-sheng, his younger brother and his right-hand man, was ordered by the Governor-General to move to Ta-tao-ch'eng and engage in business there. He lived out his time and died in August 1922. His funeral drew many Taiwanese and Japanese to pay him tribute. An unprecedented funeral it was, they said.

Some might downgrade him today for having stained his late years, but a folklore ballad at that time tells he was evaluated otherwise:

"The brothers did well agreeing to peace talk;
Raising funds to start a camphor factory;
Eliminating bandits till the last soul,
They did well disbanding soldiers and stabilizing society." [6]

......................

6 Extracted from "Interview notes on Ch'en Ch'iu-chu's Anti-Japanese Deeds" by Huang Fan-wan in *Taiwan Documents* Vol. 10, No. 4, published in December 1959.

7. A Superstitious "Conspiracy"

Armed resistances in the third period, except for the Se-lai-an Incident, were all limited in scale and uncovered in advance, so that the Japanese regarded them "conspiracies". Rapid expansion of Japanese capitalism in Taiwan led to extensive annexation of land and exploitation of the so-called initiation right over forest and pasture land, threatening the livelihood of farmers and loggers. Rebellions ensued like mice in distress attacking cats. Revolutionary tides in mainland China at that time had spread to Taiwan, and rebel leaders took advantage of the atmosphere in instigating resistance drives.

In the Pei-pu Incident of November 1907, for example, a 27 year-old worker in the camphor factory, Ts'ai Ch'ing-lin from Pei-yueh-mei, Hsin-chu, agitated people by telling them that many Chinese troops would shortly land in Hsin-chu and that they cooperate with them to drive out the Japanese. Ts'ai called himself "Commander of the United Renaissance". In the course of that rebellion, dozens of Japanese were killed but 81of them died, 10 committed suicides, and 9 were executed.

In March 1912, the Lin P'i-pu Incident broke out led by a popular wizard and fortuneteller Liu Ch'ien of Sha-lien-pao, Nan-tou and a certain Lin Ch'i-shun who was driven out of the bamboo forest sold by the government to the Mitsubishi Co. and had no place to go. They agitated farmers in the neighborhood, saying:

"We have received an oracle of Koxinga pronouncing us King of Taiwan after the Japanese are expelled."

The rebels assaulted the Ting-lin Police Station, killing 3 policemen (one of them was Taiwanese), and attempted to attack the gov-

ernment office in Lin P'i-pu but were annihilated on the way. In the incident 12 were arrested, 8 executed, 3 sentenced to life imprisonment, and 1 termed imprisonment.

The Se-lai-an Temple

The Se-lai-an Incident broke out in August 1915 and grew larger and longer. The incident is remembered perhaps as the most serious of incidents in that the Japanese were rumored to have massacred many Taiwanese in the course of the incident and that staggering numbers were deliberately sentenced to death.

The ringleader Yu Ch'ing-fang, born in 1879 in A-hou, was a job hopper: a store clerk, police assistant, secretary in a government

Yu Ch'ing-fang

Lo Chun

Chiang Ting

office, and eventually a director of the Se-lai-an Temple. He used this position to agitate followers and helped raise war funds. His advisor was a vegetarian named Lo Chun, born in 1856 in Ta-li-mu, Chia-yi. A certain Chiang Ting, born in Chu-t'ou-ch'i, Tainan, organized the rebellion basecamp and provided manpower.

This incident was uncovered as a comrade, Su Tung-hai was arrested on a boat bound for Amoy and his secret note sent from prison was intercepted. The plot uncovered, Yu Ch'ing-fang hurriedly fled to Chiang Ting for protection. Subsequently, he carried out a preemptive attack assaulting the government office at *Kah-sian-pou* (Chu I-kui's birthplace of Lo-han-men) and a nearby police office. He also raided Yu-ching.

Among heaps of documents confiscated at Se-lai-an was an "oracle" by Yu Ch'ing-fang, which reads:

"I, Yu Ch'ing-fang, supreme commander by order of the Great Ming Dynasty to subjugate Taiwan hereby declare: ...Sacred and divine descended to this world to show continually without change right ways to tens and thousands of followers. In May this year, Japanese pirates that have ruled Taiwan over 20 years are about to breathe their last breaths. Heaven and earth, and God and man alike, are indignant. Our great Ming Dynasty hereby sends us to rise in arms in the name of heaven with heroes from the four seas to destroy the enemy..." [7]

7 Extracted from *A Short History of Rebellions in Taiwan* compiled by the Ministry of Justice, Taiwan Governor Office, published in 1920.

This seems to take one two centuries back to the days of Chu I-kui's.

What is most worthy of note is Lo Fu-hsing's Miao-li Incident in October 1913. Lo was a Hakka from Chia-ying, Canton. He moved to Taiwan accompanied by his grandfather in 1903. While in Miao-Ii, he once attended a public school. In 1906 his whole family moved back to the mainland; he became a primary school teacher in Chia-yin. He met a certain Ch'iu Feng-chia, who was passing his remaining years there, and with his help traveled to Southeast Asia, where he met Hu Han-ming and joined the Alliance Society. In 1912, one year after the outbreak of the Hsin-hai Revolution, Lo volunteered and sneaked into Taiwan with 12 comrades to join the rebellion. According to his personal notes, he had attracted support of tens of thousands of people—rich persons, officials, public servants, and students.

In the spring of 1913, the police seized information and after half a year of investigation began rounding up suspects. Lo was hiding in Tamshui, waiting for an opportunity to flee to the mainland. But he was arrested and was executed in the Taipei Prison in March 1914. He met his death calmly, it was told.

At the time the Kuomintang, formerly the Alliance Society, was in disarray under Yuan Shih-k'ai there was no power existent in Taiwan to plan and support resistance. It was only that Lo Fu-hsing was led by his own adventurism to act rashly and blindly. It was fatal that the power of the Governor-General's office was underestimated and that the complicated political ideology of the Taiwanese misconceived.

8. Lin Hsien-t'ang and Overseas Students

During the twenty long years of hopeless and feudalistic armed

conflict, generation shift took place among the Taiwanese. A new generation of Taiwanese, enlightened under the modern Japanese education system, emerged to acquire global vision and scientific mind.

That was what Gotoh Shinpei had feared might bud in the minds of the Taiwanese. Gotoh had stressed only elementary education be granted the Taiwanese and in higher levels only technical and medical orientation be offered them. (Taipei Medical School later medical college was established in 1899.)

Limited only to elementary education, the system was given life by an earnest Japanese educator Isawa Shuji, born in Nagano, Japan, 1851-1917. Isawa was the first academic director under Governor-General Kabayama and pioneered a zealous educational formula known as "Shizangan Spirit". The formula, together with Isawa's profound ideas, found its way far into the remotest mountainous areas and the teachers eagerly adopted it in the classrooms. (On the New Year's Day, 1896, the Shizangan school was raided by Chien Ta-shih and six of the Japanese teachers were killed.)

Taught right from the start in the Japanese education system of loyalty and patriotism, the Taiwanese wisely discriminated the essential from the trivial to study the difference between feudal and modern societies, the essence of right and duty as being the two faces of a coin, the position of Taiwan in world history, etc.

The visit to Taiwan of Itagaki Taisuke, an eminent advocator of the Freedom and People's Rights Movement in Japan, motivated organization of the Taiwan Assimilation Society in 1914 and in turn ignited emergence of modern organized political movement in Taiwan.

The target of the Taiwan Assimilation Society was to have the Taiwanese assimilated into Japanese society and ensure them equal rights as the Japanese. That was basically what the Japanese Governor-

General had envisaged; Japanese officials in Taiwan consented and the Taiwanese were attracted by the very notion of equal rights.

The double-edged sword turned a weapon for the Taiwanese. A movement in progress since spring of 1914 led by Lin Hsien-t'ang and Kan Te-chung (born in Chang-hua in 1883) toward installing a middle school for Taiwanese children thus gained momentum; the following year the school, latter-day Taichung First Middle School, was actually inaugurated.

Alarmed at the overwhelming enthusiasm of the Taiwanese, the Governor-General ordered immediate disbandment of the society the next year and ordered Itagaki and his troupe to leave. But the once lit flame refused to vanish; many Taiwanese awoke to the reality. Convinced that they were better understood by the Japanese back home than those in Taiwan, they eagerly sought ways to study in Japan.

Lin Hsien-t'ang, a major landlord in Wu-feng, Taichung, was a vigorous 34 year-old man at the time. He had not received Japanese education but was very well-versed in Chinese. In the spring of 1907 he traveled to Japan for the first time. He met with Liang Ch'i-ch'ao at a hotel in Nara and consulted with him on the future course of Taiwan. They could not communicate in spoken language, so they made each other understood in writing. Liang told Lin:

"China would not be able to help the Taiwanese win freedom in the course of the next 30 years. The Taiwanese should refrain from acting rashly and making unnecessary sacrifices. The most desirable is the way the Irish people dealt with Britain. The Taiwanese should deliberately befriend central high officials in Japan through whom to restrain the Taiwan Governor-General's

policy and to prevent any excessive suppression." [8]

Lin thanked Liang dearly and parted him leaving an invitation for him to visit Taiwan at an opportune time. Liang visited Taiwan in the spring of 1911 as a house guest of Lin and left many poems on current affairs.

Ts'ai P'ei-huo (*Chhoa Poe-hoe*), born in Taiwan in 1890, was a public school teacher and dismissed on account of his affiliation with Lin Hsien-t'ang and Itagaki Taisuke as their interpreter. Lin gave him a scholarship to study at Tokyo Normal School. In August 1918, Lin left Taiwan for Tokyo to dodge persecution. He made acquaintances with many Taiwanese students through Tsai and thereafter donated large sums of funds to support them over a long period of time.

It is ironical that students studying in their suzerain state stand at the frontline of colonial liberation movements. Taiwan was the case in point. Shunned access to full middle school education, much less advanced level education within the island, young Taiwanese chose to study in Japan from early 1910 and afterwards. In 1920 as many as 400 Taiwanese were studying in Japan. That year the diffusion rate of Japanese among the Taiwanese was 28.6 of 1,000.

In the winter of 1918, Lin Hsien-t'ang had some 20 students, including Ts'ai P'ei-huo, Ts'ai Shih-ku (born in Hsin-chu in 1885), and Lin Ch'eng-lu (born in Hsin-chu in 1887), join a gathering at a restaurant "Kanda Chuka Daiichiro" in Tokyo to discuss what Taiwan should strive for. Views were split wide from anti-assimilation, pro-assimilation, Pan Asianism, and to even reunification with China as if

..............................

8 Extracted from *Commemorative Book on Lin Hsien-t'ang* compiled by Lo Wan-ch'e et al. published in December 1960.

to vividly betray the agony of Taiwanese. Heated debates culminated in an immediate proposal to mount a movement toward abolishing the 63 Law which constituted the foundation of colonial despotism.

The movement subsequently led to the birth of an auxiliary body named the Enlightenment Society to help promote correct understanding in Japan of the current situation in Taiwan. However, since the movement for the abolition of the 63 Law was virtually an extension of the ideology of stretching the homeland of Japan, the nationalists were up against it.

At the end of World War I in 1918, as the tide of national self-determination became prevalent the world over, extremist students turned their back on the movement and organized the New Citizens Society advocating high level autonomy for Taiwan. (Lin Hsien-t'ang was elected president in March 1920.)

Meanwhile in Korea a movement broke out in 1919, the so-called 3-1 Independence Movement, to shock entire Japanese society. It was then that the first civil Governor-General, Den Kenjiro, assumed office in Taiwan. One day, the Great Japan Peace Society (president Baron Sakatani Yoshiroh) invited leading students from Taiwan and Korea to a gathering, where the Japanese participants advocated Taiwan and Korea be given autonomy soon enough. The Taiwanese students responded that was what they had wished happen, but the Korean students left the meeting in disgust as they had wished for nothing short of independence. The difference in their attitudes was at once the difference in their historical backgrounds. The episode does not portray the Taiwanese a bunch of wimps.

The New Citizens Society published a monthly *The Taiwan Youth* (publisher: Ts'ai P'ei-huo) after a revolutionary magazine in China *The New Youth*. Political movement will start with enlighten-

ing and propaganda. This is another formula. The magazine title "The Taiwan Youth" was later changed to "Taiwan" and again to "The Taiwan People's Weekly". As publication was made possible at the turn of era to Showa, in Taiwan, it grew into a daily called "The Taiwan New People Daily" (publisher: Lin Hsien-t'ang) in January 1929. The paper was to become the most powerful weapon for later political movements in Taiwan.

The Taiwan Youth

In 1921, the New Citizens Society began to promote a petition movement for establishing a Taiwan assembly and won resounding support in Taiwan among those who were conscious of the situation. The assembly was to conduct free elections in Taiwan and elected representatives were to exercise their right to review and approve the laws and budget unilaterally made by the Governor-General's office.

In the procession of petition to the Imperial Japanese Diet, the demonstrators chanted:

"World peace, new era;
Western style, new thought;
Human beings harmonious and full of joy;
Look up on the lofty Mt. Yu-shan (Mt. *Giok-san*);
Look up on beautiful Taiwan."

How much were the downtrodden Taiwanese encouraged by the Russian revolution, independence of colonies, and US president Woodrow Wilson's principle of self-determination! No more exploi-

tation, no more suppression. May the sublime Mt. Yu-shan be the symbol of unity and let the beautiful island Taiwan be a reality.

The petition was presented for the first time to the 44th Imperial Japanese Diet in January, 1921, with Lin Hsien-t'ang as the leading signatory; thereafter till the 65th Diet in 1934 the petition was consecutively presented with several hundreds to 2000 Taiwanese as signatories. The movement was kept up extensively and persistently.

9. Ideals and Realities of the Culture Society

Out of the groundswell of the day was born in Taipei an organization of a sizeable membership: the Taiwan Culture Society with Lin Hsien-t'ang as president, Chiang Wei-shui and Ts'ai P'ei-huo as secretaries. Initiated in October, 1921, the society, with a membership of 2,000, was a large body of Taiwanese intellectuals including landlords, businessmen, public servants, physicians, teachers, students, and salaried people—all above the middle class.

The society's objectives and activities were clearly stated in the declaration drafted by Chiang Wei-shui:

"The Taiwanese people bear the responsibility of acting as a medium of goodwill between Japan and China. Goodwill between Japan and China is the prerequisite for the Asian Alliance; the Asian Alliance is the prerequisite for world peace; and world peace is the greatest desire and happiness of mankind.

Therefore, we Taiwanese are motivated to act as a medium of goodwill between Japan and China and to promote alliance in Asia for the sole purpose of realizing world peace which is the great happiness of mankind. To put it straightforwardly, we Taiwanese

hold the maiden key to the gate to world peace. This is a truly significant and grave mission assigned to us Taiwanese.

Once we are aware of the gravity of the mission, we must be sure to discharge it. This society is founded to rear human resources to discharge the mission." [9]

Chiang Wei-shui was born in I-lan. He graduated from Taipei Medical College and opened his clinic in Ta-tao-ch'eng at the age of 32. If Gotoh Shinpei, himself a doctor turned politician, had made light of a Taiwanese doctor ever following his footsteps, he was grossly mistaken.

The society's objectives hoisted by Chiang were bold and full of spirits, worth boasting to the world. Acting as a medium of goodwill between Japan and China toward peace and prosperity in Asia is an ideal for the Taiwanese to pursue even today. After all, no other people in the world understand the Chinese and the Japanese better than do the Taiwanese.

But in order to attain the ideal, the Taiwanese must first drill into their mind, profess to and seek recognition of the rest of the world the notion that they were neither Chinese nor Japanese but a third nation. If they should behave like Chinese and employ the concept of goodwill between Japan and China as a means to anti-Japanese resistance, they would be unmasked in no time and subjected to pressure. Alternately, should they behave like Japanese and back up Japan's aggression into China while clamoring for goodwill between Japan and China, the Chinese would discover their identity soon enough and

..............................

9 Extracted from *Taiwanese Demands*, p. 16, by Hsieh Ch'un-mu published by "The Taiwan New People Daily" in January 1931.

shove them out of sight.

But then, Chiang Wei-shui and many other Taiwanese politicians obviously identified themselves Chinese in concept. Their knowledge of Taiwan and its history was painfully shallow and were currently a victim of Japan's exploitation and suppression.

They understood little of China and its reality; they had a nostalgic image of China, straightforwardly adoring a beautiful homeland. Some Taiwanese had been to China and were aware of its realities but they had a habit of seeing the sunny side and blowing up their stories, which in turn helped create a new set of tales about China. Though good of them to throw their bits of contribution for building goodwill between Japan and China, they were undeniably in favor of China in their behavior.

Now, how were they to accomplish the objectives of germinating goodwill between Japan and China? Let us follow what was said further in the declaration:

"However, the Taiwanese are actually ailing. Unless they overcome the sickness, it is not possible to rear human resources. This society must first and foremost do away with the root of this sickness. According to my diagnosis the Taiwanese people are suffering from malnutrition of intelligence. Intellectual nutrition is the only cure for this sickness. Cultural movement alone provides the only method to fundamentally cure this sickness. The Cultural Society is an organ that studies and practices methods for curing this sickness."

As Hsieh Ch'un-mu said sarcastically, the Society acted "like an unleashed rabbit" at the start and ended "like a restrained virgin".

It walked a long way, as it were, beating around the bush, as it was the only way left them to walk on. For a society of such a complex membership, that was perhaps the only way of survival dodging the Governor-General's pressure while avoiding intra-society feuds.

The Cultural Society actively led movements across the island establishing newspaper reading rooms, promoting cultural lecture meetings, arranging tours of dramas and movies, opening summer schools, and promoting a movement toward Romanizing the Taiwanese language. But the Governor-General's office pressure on the movement came a year later. First, the Governor-General's office forced government public enterprise employees to leave the Society threatening to fire them otherwise. They tried to discourage Lin Hsien-t'ang and landlords and capitalists like him implying bank loans would be terminated otherwise. Some members of the Society set up the Taiwan Alliance for Promoting Taiwan Assembly with its headquarters in To-

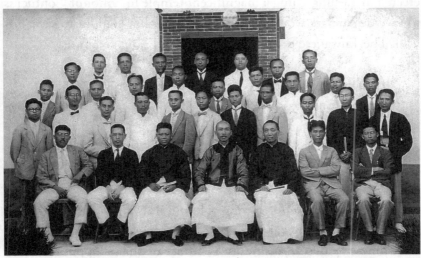

The Cultural Society held cultural lecture meeting in Ta'i-chung, 1925 (front row, fourth from left, Lin Hsien-t'ang)

kyo, outside the jurisdiction of the Governor-General's office, but that was disbanded on charge of a violation of the Security Police Law.

All that had to happen in a way because cultural movements within any colony are bound to become political drives and the Cultural Society did serve as the stronghold of anti-official, anti-government movements of the people of Taiwan.

10. "What's Wrong about Becoming a Japanese?"

In November 1923, Ku Hsien-jung, backed by the Government-General of Taiwan, organized the "Public Welfare Society" and started challenging the Cultural Society.

Ku denounced the anti-Japanese political movement as an offspring of the Jew's pernicious ideas of conquering the world and lamented several thousand years of Confucius spirit had died out. Ku erected in Ta-lung-t'ung a magnificent temple in honor of Confucius to save degenerate world and declared himself a Gandhi to save Taiwan. The Taiwanese people detested Ku and ridiculed him:

"If Ku were Gandhi;
A urinal would pass a jade jar;
Dried sweet potato chips a shark's fin."

Ku rebutted by saying:

"Some accuse me for having sold out Taiwan for personal fame and wealth. On what ground am I so accused? According to old Chinese tradition, disloyalty is an act of shame applicable only to public servants who, however trifle their duties, forsake their

lord in favor of another. If a commoner which I am, not a public servant which I am not, such allegation is groundless.

Prior to Japan's occupation of Taiwan, I was no doubt a Qing commoner but not a Qing public servant. It is then irrational that I be alleged to have served two lords and forsaken one in favor of the other. I have never betrayed the Qing dynasty; I have chosen to be a subject of the Empire of Japan upon the Qing's cession of Taiwan to Japan.

Having chosen to be a Japanese subject, I vow to serve the Empire of Japan and thereby to restore the livelihood of 3.6 million of my brethren. To get rid of the bandits I have done my best working devotedly for the Empire of Japan. I believed it loyal to serve the Empire of Japan; I believed the bandits were evils threatening the life and property of every one of my 3.6 million brethren." [10]

As Ku Hsien-jung did not know Japanese, this statement was obviously not written by Ku himself but should reflect his own thoughts. It would be easy to discard it as a "tongue of a purveyor to the government", but if one recalls the agonies of a Hung Ch'eng-ch'ou who had submitted to the Qing government and offered strategy to conquer the mainland, the anguish of the Chinese reformist government under Japanese occupation, and

Ku Hsien-jung

..............................

10 Extracted from *The Biography of Ku Hsien-jung* edited by Ozaki Hidetaro published in June 1939.

the sufferings of the Japanese government under the Allied occupation, one might somewhat sympathize with Ku's own agonies.

What then was Ku's assessment of Japanese imperialism?

"A glance at the achievements made during the past 30 years from the day Japan occupied Taiwan until this day clearly show that the people of Taiwan must be one of the most fortunate nations in the world. The reason is obvious if one looks at what is happening in China across the strait.

The Qing Dynasty fell and a republic emerged; the country is in total chaos ever since. The republic is only by name; each province has its own army operating freely inside its jurisdiction split into sides perpetually struggling for control within themselves. Taxes are extremely heavy; merchants groan under demands for extraordinary funds.

How does Taiwan compare with other nations? It has been twenty years since the last bandit was wiped out of the island; not a single war has been fought since. The island lies in peace and prosperity; the Taiwanese are exempted from military service. Where on earth can a nation be so fortunate as the Taiwanese?

In short, Taiwan today is several hundred times richer than under the Qing Dynasty as evidenced clearly in the elevated standard of living of the people." [11]

Speaking of comparison, Lin Wei-yuan must have compared in his own way the paths he had traced. Lin had declined to assume the post of speaker of the "Republic of Formosa" and left Taiwan for

..

[11] Extracted from *The Biography of Ku Hsien-jung* cited above.

Amoy. There, every time he learned from visiting tourists of the situation within Taiwan he betrayed mixed feelings and nodded without words. His huge properties left in Taiwan and many of his descendants ironically flourished under Japanese rule and were doomed to decay under the Kuomintang.

11. Division in Prosperity

The unlawful oppression of the Taiwan Alliance for Promoting Taiwan Assembly was a preemptive strike by the Governor-General's office planned to prevent the Cultural Society's cultural movements from turning political movement. But, contrary to expectations, it served to encourage the Taiwanese and in turn stirred up Japanese intellectuals into supporting the Taiwanese cause. The 18 leaders who were put to trial were:

Chiang Wei-shui, Ts'ai P'ei-huo, Ts'ai Hui-ju, Lin Yu-ch'un, Lin Ch'eng-lu, Shih Huan-ch'ang, Ch'en Feng-yuan, Wang Min-ch'uan, Ts'ai Shih-ku, Wu Ch'ing-po, Lin Po-t'ing, Ts'ai Nien-heng, Lin Tu-hsun, Cheng Sung-chun, Han Shih-ch'uan, Wu Hai-shui, Shih Hsi-hsun, Ts'ai Hsien-yu.

Han Shih-ch'uan, Ts'ai Hsien-yu, Wang Min-ch'uan, Wu Ch'ing-po, Wu Hai-shui were found not guilty, the rest sentenced to up to four months imprisonment. The moment they were released from prison, people welcomed them like homecoming heroes. The extremely shaky conditions in China and Japan caused repercussions in Taiwan, where the people begun calling aloud "to get back to practical campaigns". Practical campaigns suggested then included:

1. Granting Taiwanese students in Japan unrestricted use of the Takasago Dormitory (in Tokyo).

2. Cutting electricity charges in Tao-yuan and Miao-li areas.

3. Permitting free sale of Bananas.

4. The New Citizens Society's proposal to improve local autonomy.

5. Promoting the women's movement by the Women's Mutual Encouragement Association.

6. Promoting campaign to eliminate undesirable customs.

7. "Down with old literature" campaign led by Chang Wo-chun.

The most serious was the rise of a farmers' movement. The Cultural Society opened a farming seminar in Erh-lin in central Taiwan in December 1924, which helped awaken the minds of the local sugarcane farmers. A report read at the seminar on a successful trial plantation of Horai rice gave a serious impact on all sugarcane farmers across the island. The farmers keenly felt an immediate need to unite themselves and protect their interests against the exploitation by the sugar company.

In June 1925, the sugarcane famers in Erh-lin organized a union under the leadership of Chan I-hou, Liu Sung-fu, Ch'en Wan-ch'in, Hsieh T'ieh, Hsieh Tang, Li Ying-chang, and Tai Ch'eng. They collided head on with the sugar company but the police interfered to turn them back. The incident, however, left a tremendous impact on the minds of both sugarcane farmers all over Taiwan and the sugar company.

In the same year, in November, Chien Chi, Huang Shih-shun, Ch'en Chen-hsien, and Liang Kuo led 95 local tenant farmers in Feng-shan to set up their own union. They challenged Ch'en Chunghe Commodity Company over land confiscation and won the fierce battle.

Later in June 1926, the Erh-lin Sugarcane Farmers' Union and

the Feng-shan Farmers' Union merged to create anew the Taiwan Farmers' Union with a total membership of 24,100.

Stimulated by a swelling tide of farmers' movements, the Cultural Society, which had long since felt a need for structural change, called a special assembly to discuss reform issues; it so happened, however, that certain conflicts among the leaders over ideological differences bared to eventually break up the Society.

Lin Hsien-t'ang and Ts'ai P'ei-huo strongly advocated sticking to the authentic course of cultural movement, while Wang Min-ch'uan and Lien Wen-ch'ing contended to switch to farmers' movement. Chiang Wei-shui insisted that the society should strive for mounting an all-people movement or a comprehensive national liberation movement. Wang and Lien had learned from the newly imported Marxist revolutionary theory, while Chiang was inspired by the Kuomintang-Communist collaboration in January, 1924.

Wang and Lien's proposal passed the general assembly on the strength of the organized votes from the "proletarian youths" mobilized in advance by Weng Tse-sheng. Old leaders felt the society had been taken over by the "proletarian youths" and withdrew from the society en masse.

In July that year, some former leaders of the society organized in Taichung the first and last political party throughout the days under Japan and the Kuomintang: the Taiwan People's Party. Huang Wang-ch'eng was elected president and 21 central and 14 standing committee members appointed. The party had a membership of 439 across the island. The party platform advocated building a democratic system of government, a rational economic system and rectifying defects in the social system. The party called for a "unity of all compatriots toward generating power" or, in Taiwanese, "*Tong-pau su toan-kiat.*

Toan-kiat chin u-lak."

Lin Hsien-t'ang was deeply hurt to see the Cultural Society split. He embarked on world tour in May. Ts'ai P'ei-huo, his double in the Taiwan People's Party, confronted Chiang Wei-shui on almost every issue; eventually, the party leadership fell in the hands of a "third man", Hsieh Ch'un-mu of Tainan. Hsieh is none other than Hsieh Nan-kuang himself who is currently active in Communist China.

Lin Hsien-t'ang

The People's Party succeeded in a race with the Cultural Society to win the support of farmers and workers. In February, 1928, a new

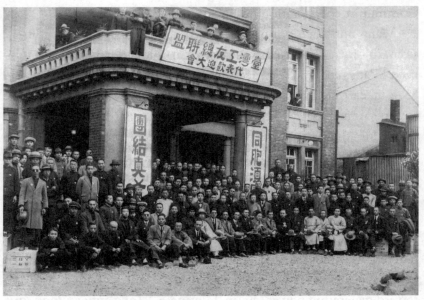

The General Workers Union was inaugurated in February 1928

labor union emerged in Taipei under the sponsorship of the People's Party: the General Workers Union with a membership of over 6,000 workers of 28 unions.

The General Workers Union led the strikes against Asano Cement in Kaohsiung, a salt company in Tainan, and other major and minor labor-management disputes, stepping up lagging labor movement. The fatal defect of Taiwan's labor movement in those days was the scarcity of manpower in modern industries.

Among the disputes led by the Taiwan People's Party the most memorable were the cases of "New Opium License" (May 1929), "Cemetery Relocation" (May 1928) and "Unlawful Land Transfer" (October 1927).

The People's Party split again in August 1930, as such mainstream leaders as Hsieh Ch'un-mu, Chiang Wei-shui, and Liao Chin-p'ing shifted farther to the left, and moderate members such as Ts'ai P'ei-huo, Ts'ai Shih-ku, Hung Yuan-huang, Ch'en Feng-yuan, and Yang Chao-chia feared the Government-General of Taiwan would step up pressure on the party. The moderates deserted the party; the party disintegrated.

Sure enough, the Taiwan People's Party was ordered to disband in February 1931; Hsieh fled to the mainland and Chiang died of sickness in August.

The moderates returned in August 1931, set up the Taiwan Local Autonomy Alliance, and invited Lin Hsien-t'ang to serve as advisor. They kept on appealing for local autonomy and a Taiwan Assembly. In July 1937, the war between Japan and China broke out and the alliance hastened to disband itself.

A poem of Lin Hsien-t'ang composed in 1940 "Reminiscences of Sixty Years" strike a chord in one's heart:

"Preserve rights and freedom for mankind,
Restrict speech with dignity,
Rally kindred spirits to petition for reform,
Call on masters amid the heaviest of snowfalls,
Cry over ignorance of some; sight a glimpse of treachery in others.
May Heaven decide success or failure; why for Heaven's sake grudge sacrifices,
Over thirty stormy years my innermost heart kept sincere,
Why, I ask, have I reaped but these strays of white hair?" [12]

12. Taiwan Communist Party and its Counterparts in Japan and China

The founder of the Taiwan Communist Party was Hsieh Hsueh-hung (aka Hsieh A-nu). She was born in a poor family in Chang-hua in 1900. At the age of 13, both of her parents died and at 15 she was sold to be a concubine. She worked a while in sugar company. In 1917, she followed her lover to Kobe, Japan. She learned Japanese and Chinese while working. She returned to Taiwan in 1920, joined the Cultural Society and participated in a women's movement. In 1925, she fled with Lin Mu-shun (author of *Taiwan's February Revolution*) to Shanghai to evade suppression. She entered Shanghai University where Chu Ch'iu-pai and Teng Chung-hsia had a base for their activities. They were active out in the frontline of the May Thirtieth Movement, which drew the attention of the Chinese Communist Youth Corps. On their recommendation, the two were admitted to

12 Extracted from *Commemorative Book on Lin Hsien-t'ang.*

the Oriental Workers' Communist University in Moscow. Initially they were put in the Chinese students' class and later transferred to the Japanese students' class on account of Taiwan being a Japanese colony. That was when they met Tokuda Kyuichi who happened to be in Moscow to receive orders.

In November 1927, Hsieh and Lin received an order from the Communist International to organize a communist party in Taiwan and returned to Japan with Tokuda. In December, they were instructed by Watanabe Masanosuke and Sano Manabu, members of the central committee of the Japan Communist Party, to draft organizational and political theses of the Taiwan Communist Party.

In February the following year, Hsieh and Lin went to Shanghai to make necessary preparations and in April managed to set up the Taiwan Communist Party in the French Concession in Shanghai, with Lin Mu-shun, Lin Jih-kao (killed in the 228 Incident), Ts'ai Hsiao-ch'ien (discussed in detail later), Hou Chao-tsung[13] , and Chuang Ch'un-huo as central committee members and Hsieh Hsueh-hung and Weng Tse-sheng as Central committee candidate-members.

Hsieh/Lin and Tsai/Weng had heated debates over whether the Taiwan Communist Party should be under the Japan Communist Party or the Chinese Communist Party; Hsieh and Lin persisted on their points and had their way on the strength of the Comintern directive. The following four-point party platform was adopted:

1. Overthrow Japanese imperialist rule and to achieve independence of Taiwan;

2. Confiscate properties, lands, businesses, banks in Taiwan owned by Japanese imperialists;

............................

13 Popularly known as Liu Ch'i-kuang, born in 1905 in Chia-yi.

3. Implement land reform and eliminate the feudalistic system of exploitation;

4. Build an independent and democratic government in Taiwan.

Note that the Taiwan Communist Party clearly advocated an independent government in Taiwan.

As soon as the party was set up, Lin Jih-kao, P'an Ch'in-hsin, and Hsieh Yu-yeh immediately smuggled into Taiwan and started underground operations. Those left in Shanghai were arrested by the Japanese consulate police and sent to Taiwan. Hsieh, Lin, and Tsai skillfully talked their way out and got released, but the rest of them were sentenced to one to two years' imprisonment.

Upon release Ts'ai Hsiao-ch'ien fled to the mainland and via Fuchien entered the Soviet zone in Chiang-hsi and won the trust of Mao Tse-tung. Till he was instructed to smuggle into Taiwan after the defeat of Japan in 1945, Ts'ai had kept a vital position as the only Taiwanese in the Chinese Communist Party.

Meanwhile, Weng Tse-sheng who had escaped arrest in Shanghai later organized the Taiwan Youth Corps in Shanghai and engaged in anti-Japanese propaganda work. His ability was highly praised by Chinese communist leaders, but he died of illness shortly afterwards.

We must be aware that Tsai and Weng were Taiwanese working as Chinese communists and their activities had nothing to do with the activities of the Taiwanese Communist Party which we will discuss shortly.

Upon release Hsieh Hsueh-hung and Lin Mu-shun went to Taichung immediately and took part in the activities of the Cultural Society and farmers' unions. Having cemented close contact with these groups, they moved to Taipei and opened a bookstore there. They operated secretly to recruit new party members while undertaking

underground work. The Taiwanese Communist Party infiltrated in the leftist Cultural Society, farmers' union, and labors' union. Poverty-stricken Taiwanese and farmers and workers in distress were a welcome hotbed for communism. With a meager membership of several tens, the party had a widespread potential membership in key posts of various organizations.

As a result, in November 1929, at the 3rd All Taiwan Representatives Assembly of the Cultural Society held in Chang-hua, Lien Wen-ch'ing, Li Kui-chen and other socialists who were under the influence of the socialist Yamakawa Hitoshi were expelled from the society. The year 1930 saw the Taiwanese Communist Party at the peak of its strength. In August 1930, at the fifth World Conference of International Red Union Alliances in Moscow, Lin Mu-shun represented Taiwan's organized laborers to attend the conference together with the Japan Labor Union's representative Konno Yojiroh and others. There, Lin vowed to collaborate with the working class of Japan. Affiliated organizations hoisted high and clear slogans opposing imperialism, took part in May Day activities at various points and led strikes and other radical campaigns.

In June 1931, unable to put up with the situation any longer, the Government-General of Taiwan made a wholesale arrest of communists, 108 of them in all, including Hsieh Hsueh-hung, P'an Ch'in-hsin, Wang Wan-te, and Su Hsin. Ch'en K'un-lun and Chien Chi of the Farmers' Union and Chan I-ch'ang and Chang Mao-liang of the Cultural Society, escaped arrest and in August set out to reorganize the party. The attempt leaked and 91 more were arrested in November. Twice rounded up, the Taiwan Communist Party collapsed; both the Cultural Society and Farmers' Union were also heavily hit and ceased to function. They were sentenced up to 15 years of imprisonment.

The Japanese Communist Party had tried various ways to help out the hard-fighting Taiwanese Communist Party, installing a National Division to publish articles in the party organ *Red Flag* to encourage the comrades in Taiwan. But the Japanese Communist Party was too preoccupied with its own predicament and underground operations to amply support its counterpart away in Taiwan.

While in China, the first of the Kuomintang-Communist collaborations collapsed in the summer of 1928. The conventional line of Ch'en Tu-hsiu was repelled as rightist opportunism and the leftist opportunists Chu Ch'iu-pai and Li Li-san took over. Mao Tse-tung and Chu Te split out and settled in Ching-kang-shan and Jui-chin to carry on guerrilla warfare (1928-1934).

That is to say that the Taiwanese communists had no relations with the current leaders of the Chinese Communist Party, linked with Chu Ch'iu-pai, Li Li-san, P'eng P'ai, Ch'en Shao-yu, and Ch'in Pang-hsien who lay hidden in the French Concession then. Their contacts were scanty and sporadic. Hsieh Hsueh-hung and Lin Mu-shun sought refuge in the mainland after failure in the 228 Incident, but the current Chinese communist leaders received them with bitterness and contempt calling them "aborigine communists" and "local nationalists", and in the end ruthlessly purged them.

13. Criticisms and Evaluations of the Two Japanese Scholars

Before analyzing the process of how fascism demolished all political struggles of the Taiwanese people and the way a fanatic movement of "Japanization" changed the mentality of the following generation of Taiwanese in a rather complex manner, the author presents here for

the benefit of the readers the criticisms and evaluations of two leading Japanese scholars.

Yanaihara Tadao PhD criticized in his celebrated masterpiece thesis *Taiwan under Imperialism*[14]:

"Socialist movement in Taiwan has just turned its first page. Strictly speaking, due to its rural and colonial restraints, Taiwan still lacks social conditions on which a pure form of proletarian movement can develop. Naturally, capitalist enterprises had succeeded in monopolization, though basically limited to sugar industries. Most of the islanders in the employ of such industries are farmers with very low level of education. Members of the farmers' union may exceed 20 thousand but the way they are organized and trained is probably far from appropriate.

According to the Marxist theory of social struggle, the industrial working class should assume leadership. Yet in Taiwan where purely large industries do not exist the working class has not yet fully developed. Furthermore, as earlier mentioned, actual economic struggles are directly over the land and industrial policy of the Government-General of Taiwan. Where various classes of the islanders are in a position to operate jointly vis-à-vis the Government-General of Taiwan and big industries a purely exclusive proletarian movement cannot find a social basis to emerge on.

The split of the Cultural Society and farmers union's conversion to Marxism were more the product of a concept influenced by foreign ideas than social phenomena arising from the realities of Taiwanese society.

.............................

14 Published by Iwanami Books in October 1929.

Therefore, the social movement in a colony Taiwan cannot inevitably be but an extra-class, all-people movement. The question is which class should take the initiative; the same social circumstances alone decide this.

Thus in Taiwan, the livelihood of farmers being low, education not yet grown enough and superstitions persistent, the middle and intellectual classes are bound to maintain high position and ability. This is a sort of phenomenon one cannot find in Korea.

Therefore, in Taiwan the islanders have not yet a daily newspaper of their own and not a word on suffrage, and as a matter of course the middle class will probably take the initiative in binding both bourgeois and proletariats into an all-people movement, which will in turn lead to struggles for political freedom. That done, Taiwanese society will be a proper modern society and intra-class confrontation will be simplified and develop on a more apparent basis. A similar process is found in the history of Ireland and this seems a rule of political development in colonies."

Taiwan under Imperialism thenceforth became the bible for Taiwanese intellectuals; Taiwanese youths studying in Japan would hunt for this book in libraries and seminar rooms and avidly read it. The author still vividly remember the excitement in turning the pages of the book.

Yanaihara Tadao (front row, third from left) and Lin Hsien-t'ang (front row, second from left), 1927

What is discussed here is the state of political movement in Taiwan forty years ago, but the situation is regrettably not any different in Taiwan today. [15] Doubtful as many might be, the following chapter should substantiate the author's point of view.

In his impressive 2000-page thesis *Taiwan's Nationalist Movement under Japanese Rule* Mukohyama Hiroo PhD evaluates the fifty-one years of nationalist movement of the Taiwanese, as follows:

"Over half a century throughout the entire period under Japanese rule, the people of Taiwan persistently developed their nationalist movement, like a line of red thread, starting with a total resistance movement for the defense of the 'Republic of Formosa', resisting Japan's cession of Taiwan; a series of anti-Japanese movements recurring at the time of capital buildup needed for capitalism to settle in; then the development of bourgeois nationalist movement followed by proletarian movement as its spin-off; and lastly anti-Japanese resistance in mainland China throughout the period of war. The Taiwanese nationalist movement followed the path typical of colonial nationalist movements.

Though their anti-Japanese nationalist movement failed to culminate in Taiwan's liberation from Japanese rule, the people of Taiwan can recall with pride forever their colonial nationalist movement."[16]

It is a tragedy in a sense that both the Taiwanese and Japanese today are hesitant to readily accept such a meaningful evaluation of Professor Mukohyama, due to sheer lack of understanding of histori-

........................

15 Ref. *Face of Taiwan* by Hosono and Nukaya published by Kokin Books in May 1963.
16 Ref. Chapter 8, Conclusion.

cal facts and a sense of prejudice prevailing all along. Further, unable to correctly evaluate facts, such as raised in the following chapter, they keep on living with complex feelings of dissatisfaction.

14. Agonizing while Transfiguring

Beginning with the Manchurian Incident of 1931, Japan's imperialism forced through a war of aggression in China over the ensuing 15 years tremendous sacrifices on the people of Taiwan as well, and left scars, tangible and intangible, that remain unhealed still today.

The war killed in an instant the buds of all the open political struggles in Taiwan. What followed was a tide of hardships: taxes went up sky high, forced savings, war bonds and donations of all kinds. On top of such financial burdens, people were forced to make manpower sacrifices such as utility men, translators, civilian workforce[17], involuntary workers[18], volunteer soldiers, and draftees[19].

In the meantime, the Taiwanese were compelled to use Japanese and to live by Japanese traditions and customs. Assimilation policy was the basic guideline for ruling Taiwan and was in full swing at that time, popularly called "Kominka Campaign", a drive to make the Taiwanese subjects of the Emperor of Japan. Out emerged a generation of Taiwanese known as "The sons of Taisho"[20] with a complete language education strictly in Japanese.

"Fine those not learning the national language."

..................

17 Sent to Japanese-occupied areas in Southeast Asia, 92,748 Taiwanese including indigenes, 8,000 working in military factories in Japan.

18 Total 270,000 to 300,000.

19 Begun in January 1945, totaled 22,000.

20 Era (1912-1926) between Meiji and Showa.

"Fire those using Taiwanese while at official work."

"Get rid of Taiwanese and Chinese; Expel to China those do not comply."

The penetration rate of Japanese language rapidly rose:

Year	Percentage
1905	0.38
1915	1.63
1920	2.86
1930	12.36
1937	37.86
1941	57.02
1944	71.00

The compulsory use of Japanese affected the Taiwanese beyond their everyday speech. Language is a medium of communication but, as one comes to reach a certain level of mastery, it effects qualitative changes to the point of restricting one's pattern of thinking and even his worldview. Needless to say, it vitally depends on how predominant would the effects be of cultural system the language has in its background; for better or worse the Taiwanese broke themselves, through Japanese, out of a feudal society into a modern society. It would be correct to say, therefore, that Japanese has brought a considerable qualitative change in the life of the Taiwanese.

But, to say that Japanese education was itself an essential part of the Kominka Campaign would miss the point. Some liberal-minded people in Taiwan did put up courageously against the wave of fascism just as did the people in Japan.

For example, the Taihoku High School, established in 1926, was

the bastion of Taiwan's liberalism. Until it was closed after the end of the war, the school had turned out several ten hundreds of graduates, where several hundreds of Taiwanese students, wearing the double white-lined cap and weather-beaten coat, were given liberal education shoulder to shoulder with Japanese students.

A number of Taiwanese intellectuals were active in Japan and Taiwan in the same way as the Japanese. Those Taiwanese who had advanced in China, Manchuria, and Southeast Asia were regarded by the locals as Japanese and had a sense of their own superiority.

Taiwanese literary men had probably mastered Japanese the best. Such eminent Taiwanese writers as Yang K'ui[21] , Lu He-jo[22] , Lung Ying-ts'ung [23] wielded their facile pens against imperialism and feudalism. The irony is that they had to write all in Japanese. It must have been so extremely agonizing a practice. Lest some should misunderstand, the author might add that the Taiwanese language had no complete writing system of its own, except to Church Romanization, probably because it had stuck too rigidly to Chinese letters.

The Kominka Campaign had impact on the intellectuals and the common people each in different degrees. Let us meet some figures portrayed in literary works. Wu Cho-liu [24] wrote in the preface to his novel *Hu T'ai-ming* [25]:

"The life of Hu T'ai-ming was that of a person victimized in a

...................................

21 Born in Shin-Hua, arrested in the 228 Incident.

22 Born in Feng-yuan, died in fleeing after the 228 Incident.

23 Born in Pei-pu, Hsin-chu.

24 Born in Hsin-pu, Hsin-chu.

25 Also known as *A Twisted Island* published in Taiwan after the war and reprinted in Japan in 1956.

twisted history. He left his homeland to find mental repose; he wandered in Japan and drifted on to the Chinese mainland, but no where could he find an Eden to settle in. So, he kept on living in lightless melancholy, constantly searching for and constantly betrayed by ideals; at last he was thrown into the hard realities of a war and ran mad."

In "Voluntary Soldier" by Chou Chin-po[26] , a certain Kao Chin-liu, a petty primary school graduate, "Japanized" himself by naming him Takamine Shinroku, rebuffs in response to Chang Ming-kui who had just returned to Taiwan from Tokyo:

"That's where you are ignorant. Clapping your hands leads you to God. Theocracy is the essence of imperial government, not so? Wasn't unison of politics and religion the root of the Emperor's rule? We, members of the Patriot Youths Corps, clap out hands to feel and experience the heart of the Japanese sensibility. This is a precious experience that the Taiwanese youths of bygone days cannot wish to experience."

Darian, leader of the Bakuhyo Youth Association in Chao-chou, Kaohsiung, left a message written by blood, which reads:

"Long live the Emperor! I am a Japanese man with the Japanese spirit. For the emperor and the country, I would bear any hardship however harsh. Please let me be a military laborer." [27]

..............................

26 Published in *Taiwan Literary* in September 1941.

27 In *The Scars of Recent Literary* by Ozaki Hotsuki published by Pu-ton sheh in February 1963.

Darian was only a petty soldier but, like other 800 indigenous volunteers who fought in the South Sea, he fought just as courageously as Japanese. [28]

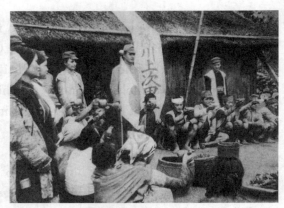

The Indigenous Volunteers

These examples suggest not only that Japan had succeeded in conciliating the Taiwanese just as had the Dutch done 300 hundred years before but that Japanese education had somehow transfigured the mentality of the indigenous people.

The Japanese, however, were not at ease with the Taiwanese; the Taiwanese likewise, not trusting the Japanese in heart. When Japan embarked on a military adventure against the United States and Britain, the Taiwanese reacted with a sense of anxiety and a feeling of anticipation: anxiety for a confusion following Japan's defeat and a highhandedness of the Japanese after their victory; anticipation for just off the grip of Japanese rule after Japan's downfall and for Japan's development following her triumph. Most Taiwanese thought they could only trust to Providence, but it was only natural that some had gone out of their way to take part in history. A spy incident in November 1941, the so-called "Tung-kang Incident" involving Ou Ch'ing-shih, Kuo Kuo-chi and others, the conspiracy incident of a

..............................

28 "The Story of the Indigenous Volunteers" by Fukumoto Kazuya in *All Readers* published in July 1963.

Taihoku Imperial University student, Ts'ai Chung-shu, in 1943 and the spy incident of fishermen of Su-ao in 1944, are cases in point.

Some Japanese reacted sensitively to such movements. General Ando Rikichi, commander of the Tenth Army and later became Governor-General of Taiwan, told leading Japanese in Taiwan without reserve:

"We have occupied Taiwan for 50 years; now is the time the performance of generations of our Governors-General will be put to scrutiny. In other words, if Japanese rule has truly won the confidence of the Taiwanese, they would come forward to help our imperial army crush the enemy should they land in Taiwan. That will be a brilliant accomplishment of the Kominka Campaign. On the contrary, if the Taiwanese collude with the enemy and assault our army from behind, we will have some grave situation. I have neither courage nor confidence to have an absolute trust in our brethren in Taiwan." [29]

After the sea battle of Leyte Island in the autumn of 1944, Taiwan became an easy target of violent air raids by the American air force and Japan's defeat seemed certain. People whispered when Japan would surrender, whether Taiwan would be made a territory of China, and what would ensue if that should happen.

[29] Extracted from *The Record of Facts in Taiwan* by Itoh Kinjiroh published in 1948.

Chapter 7

ALL-OUT CONFRONTATION WITH THE CHINESE
—Kuomintang period (1945-1963)

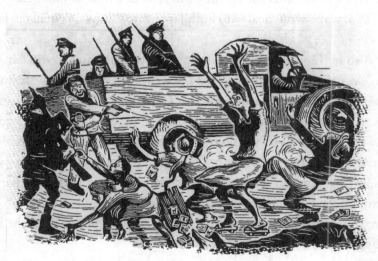

Taiwanese killed by KMT soldiers

1. Dogs Gone; Pigs Come

Looking back on those days, the Taiwanese sensed what would ensue once under Kuomintang rule; not every Taiwanese was blind in seeing through Taiwan's future.

Ozaki Hotsuki recalls in his report that barely three days after Japan's surrender a Taiwanese junior student at the Department of Literature and Politics, Taihoku Imperial University came to him and confided in him:

> "Japan has lost. Taiwan is to return to the homeland; probably Chiang's army will come. But, Taiwan is a lot higher in living standard, thanks to the fifty years under Japanese rule, and we cannot follow their footsteps. What should we do then? Well, we have another alternative: the third road or a road to independence. That way we can deal with both Japan and China on equal terms."[1]

Also in Taiwan, leading Taiwanese frequently met to discuss Taiwan's future and the way the Taiwanese should tread. They were unanimous in visualizing Taiwan for the Taiwanese, a Taiwanese Monroe Doctrine, but could not figure out ways to proceed. Little was known how the Allied powers would treat Taiwan, nor what policy would the Kuomintang adopt on Taiwan. One thing was clear: there was no way of soliciting support from Governor-General Ando and the Japanese Army under his control. A wait-and-see policy seemed the best option; thus, a rising momentum for independence withered in the face of opportunism.

What made the signs of independence a mere shady plot? For one

1 *The Scars of Recent Literary* by Ozaki Hotsuki, p. 100.

thing, the anti-Japanese and pro-Japanese Taiwanese were opposed in the backyard and there was no sense of solidarity between them. More serious still was that the Taiwanese had no means of mass-communication; the Taiwanese elites were isolated far from the general public. [2]

Initially the general public was simply overjoyed at the turn of events, unaware of the mentality of the elites, let alone their worries and anxieties. They were excited, if not ecstatic, to the point of making the Chinese feel uneasy and the Japanese lament the fallen fruits of their "Kominka Campaign"[3]. The Taiwanese people themselves were not quite aware of the psychology that propelled them to behave as they did. The situation at that time might be summed up as follows:

"First, a naive sense of relief and joy that, win or lose, the war is over; second, a sense of joy that the ruler has fallen and the 50-year-long state of subordination is now a thing of the past; third, a sense of joy that China has released us from the spell of Japan; fourth, a sense of joy that hereinafter they can equally exercise political rights in the political sphere of China." [4]

What happened in postwar Taiwan was quite another story. No sooner had the war ended than prices rose sky-high and society fell into pieces—everything contrary to what had been expected. Sorely perplexed, the Taiwanese grumbled: "This is not the way it should be..."

..

2 See "815 Independence Movement" in *Taiwan Youth* Issue No. 6 published in February 1961.

3 An attempt to convert the Taiwanese into subjects of the Japanese Emperor.

4 Extracted from "An Advocate of Taiwan Independence Speaks" by Ong Iok-tek in the magazine *Sekai* published in April 1962.

The first batch of Chinese landed in Taiwan onboard junks, a type of boat the Taiwanese had not seen for quite some time. They were strangely fashioned, spoke a strange language, and indulged in most extraordinary behaviors. The Chinese soldiers at the Keelung pier were meagerly uniformed and helplessly undisciplined. All those scenes certainly made the Taiwanese feel uneasy about what would await them ahead.

Yet, the Taiwanese were obsequiously generous to the Chinese because the Taiwanese knew they had played no part in liberating themselves and they had a deep complex over their supportive role in Japan's invasion of China. The Chinese took advantage of that mixed feelings of the Taiwanese, landed in Taiwan as conquerors and behaved defiantly:

"The newly-appointed governor, namely Taiwan Administrative Chief and Taiwan Garrison Commander Ch'en Yi, who had far more legislative, executive, judicial and military powers than had any Governor-General during the Japanese era, landed in Taiwan with his entourage. Ch'en's entourage, so arrogant and crafty, resorted to every possible means to constantly exploit Taiwan. Moreover, a number of former residents in Taiwan were removed from key positions, public and private, and it appeared as though a new conqueror had just resumed his rule. Ch'en Yi and his entourage were merciless, corrupt and greedy in their behaviors and chose every resort available to exploit the peace-loving people of Taiwan. The military behaved like a band of conquerors; the secret service openly bullied people and prepared loopholes for the central government officials to exploit through." [5]

......................................

5 *China White Paper (1949)* translated/published by Asahi Shimbun, pp. 308-309.

The Chinese messed up Taiwan in less than a year and half. An eminent Taiwanese entrepreneur "L", anonymized here, contributed a note to his in-house magazine, in which he wrote on the situation in Taipei:

Ch'en Yi (right), before Administrative Executive Office

"Day after day one would walk on and on, and yet never can get out of a swamp of the poor and jobless. It is a town of coolies living like beasts of burden by the day. Work not one day; starve to death the next day. It is a town of dust, gutters, and rows of half-torn houses. Loitering about are money-hungry, neurotic bureaucrats, bankers, merchants, etc. etc. If all those products of culture had not been brought in, this island would have been a peaceful, though primitive, quiet place to live. We won the war; we restored our country. Yes, we did win the war, but do not let inflation break us down." [6]

A modern city of 300 thousand citizens built strenuously by the Japanese and Taiwanese was falling to ruins right before your eyes—a

[6] Extracted from "The Rich Live Lavishly While the Poor Freeze to Death on the Streets" in *Taiwan Youth*, No. 6.

heartbreaking sight no Taiwanese could bare to see.

The Taiwanese resented the Chinese. Their pent-up anger grew as the days went by. Those Taiwanese who had returned from the mainland, some forty of them in Chung-ch'ing, could have served as such lubricant but all but a few, like Li Wan-chu and his companions, haphazardly treated the Taiwanese harshly just to curry favor with the Chinese bosses. Most of them indulged in squabbling spoils the Chinese way. Such Taiwanese were despised as *PoaN-soaN* or Half Chinese, a term to despise people from Tong-soaN or the mainland.

The Taiwanese yearned for the bygone days under Japanese rule. They had scornfully called the Japanese "dogs"; the dogs barked at them but guarded them. The Chinese are pigs; the pigs devour food and do nothing else.

The Japanese heard not a few Taiwanese whisper to them, "You people are lucky. You've lost the war but still have a home country to return to. We've got no such thing as home country."

2. The Great 2.28 Rebellion

All major historical events are triggered by trivial incidents. On the night of February 27, 1947, an aged Taiwanese woman was clubbed down at Ta-tao-ch'eng. That night, a team of the Chinese Tobacco Monopoly Bureau was in action tracking tobacco smugglers down to Ta-tao-ch'eng, Taipei, where they spotted and clubbed a woman fleeing behind. A crowd of Taiwanese was shot at and one died. That incident threw the whole starving and chaotic city of Taipei into a state of feverish excitement.

The following day, February 28, a crowd of Taipei citizens gathered in protest; the crowd grew soon into an unprecedented size of

demonstrators. In no time the Tobacco Monopoly Bureau was deluged with them demanding an immediate arrest and punishment of the criminal and assurances for the future. The Chinese officials quickly fled. The demonstrators rushed into the compound, threw all stocks of tobacco and wine out into the streets and burned them. Not knowing how to give vent to their pent-up resentment, the demonstrators headed for Administrative Executive Office, formerly Taipei City Hall, to lodge a petition. What awaited them there was an intense volley of machinegun fire. The toll of dead and injured was high indeed.

Angry citizens of Taipei flew into a rage, burning Chinese-owned stores and beating every Chinese in sight. A group of protestors seized the broadcasting station in Taipei and announced nationwide what was happening in Taipei and urged the entire Taiwanese population to stand up and drive the pigs out of the island. That was how the much-talked-about Great Rebellion of February 28th broke out.

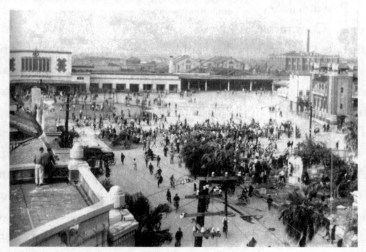

Taipei train station, February 28, 1947

The rebellion spread overnight to all towns in Taipei, then to Keelung. On March 1st the heat wave reached Hsin-chu, Taichung and Chiang-hwa, and on March 2nd expanded as far as Chia-yi, Tainan, Kaohsiung, and P'ing-tung. The following day, March 4th, the people in eastern Taiwan knew all about the Rebellion up north. The rebellious Taiwanese took over government offices and public enterprises, injuring and killing several Chinese left behind.

In order to maintain order and to secure food supply, the Taiwanese set up local Settlement Committee nationwide to deal with matters related to the February 28th incident, and by March 4th a Provincial Settlement Committee

Chung Shan Hall, where the Provincial Settlement Committee assembled

was installed in Taipei, with a standing committee on top of two bureaus i.e. Management Bureau in charge of general affairs, security, investigation, transportation, food supplies and financial matters and Political Affairs Bureau in charge of negotiation and planning.

The Provincial Settlement Committee was to be the parent body of a new executive structure of the Taiwanese themselves to replace the Administrative Executive Office and its dictatorial government. The commission members were elected from among the members of local assemblies and local magnates. Among the candidates, however, were secret agents in disguise, who often frustrated the functions of the commission.

Meanwhile, the ex-Japanese military men, youth bodies, and student organizations saw no point in negotiating with Ch'en Yi, the Chinese Governor, and asserted an immediate all-out armed confrontation.

Poked at where it hurts him most i.e. shortage of troops, Ch'en Yi had to act in the initial stage as if ready to compromise, and some Taiwanese were nearly toasting to victory. The Provincial Settlement Committee was now lost in the illusion of a peaceful settlement, began silencing belligerent moves and came to pose as a mediator between the Taiwanese and Ch'en Yi.

However, Ch'en Yi outsmarted them all. While "negotiating peace" with the Taiwanese, he kept Chiang Kai-shek thoroughly informed of the development. He asked for reinforcements; Chiang readily approved. Then came Chiang Kai-shek's stringent order for a crackdown.

Secret agents operated behind the scenes; all sorts of rumors flew about. On March 7th, the Provincial Settlement Committee passed the 32-Point Demand drafted by Chief of the Publicity Section Wang T'ien-teng, demanding on creating a political system: one, a high-level autonomy be recognized in Taiwan; two, Taiwanese be appointed governors, heads of various departments and judicial officers; and three, the army be organized mainly with the Taiwanese. The Demand also pointed out in its second part that the Taiwanese be guaranteed such fundamental human rights as freedom of speech, press, and assembly, the right to strike included.

Ch'en Yi delayed his response for one day, and on March 8th he categorically rejected the 32-Point Demand. A secret cable had reached his office in the afternoon of March 6th to the effect that the two divisions already deployed to the northern front in China were

hurriedly being rushed to Taiwan. Ch'en Yi had deliberately delayed his response to earn time for the reinforcements to land.

Sure enough, the reinforcements from the mainland had no sooner landed on the night of March 8th than they opened fire indiscriminately at every Taiwanese in sight. Ch'en Yi placed the entire island under martial law, disbanded the Settlement Committee and all other civil groups and started arresting people concerned en masse.

On March 10th Chiang Kai-shek broadcast over the radio his so-called Guidelines, in which he concluded that the incident was incited by the communists and made no comment on Ch'en Yi and his tyranny. Meanwhile, the *Taiwan Shin Sheng Daily News*, the official newspaper of the Taiwan Provincial Administrative Executive Office, revealed in its editorial on April 1 the true sentiment of the Chinese:

"We do not work in this fringe area in the same manner we would in other provinces. Besides discharging our duties we have a special mission to accomplish, the mission to relieve our compatriots in Taiwan from the bonds of the Japanese spirit, to cleanse them of the poison of the Japanese way of thinking, and to lead them to perceive and appreciate our fatherland. This incident is neither a demand for political reform nor a civil revolt of any kind. It is merely a byproduct of Japanese education, if not a curse of the poisonous Japanese spirit."

Thus, the Kuomintang systematically targeted those Taiwanese elites who grew up in the Japanese era. Among those brutally murdered then include:

Wang T'ien-teng, born in 1901 in Taipei, president of Taiwan Tea Merchants' Association and Taipei City assemblyman.

Lin Mao-sheng, born in 1887 in Tainan, graduate of Tokyo Imperial University, National assemblyman, dean of the College of Liberal Arts at Taiwan University, and president of *Bin-po* (*Min-bao*, or *Citizen's Daily*).

Ch'en Hsin, born in 1894 in Ta-chia, graduate of Columbia University, Board chairman of Taiwan Trust and Ta-kong Enterprises.

Wu Hung-ch'i, born in 1901 in Chung-li, graduate of Concord University in Shanghai and Nihon University, judge of Taipei Higher Court.

Ong Iok-lim (Wang Yu-lin), born in 1919 in Tainan, graduate of Tokyo Imperial University, Prosecutor at Hsin-chu District Court, teacher at Chien-kuo High School, and legal advisor to *Bin-po* (*Min-bao*, or *Citizen's Daily*).

Lin Hsu-p'ing, graduate of Tokyo Imperial University, section chief at Taiwan Monopoly Bureau.

Lin Lien-tsung, born in 1905 in Chang-hua, graduate of Chuo University, National assemblyman, lawyer.

Li Jui-han, born in 1906 in Chu-nan, graduate of Chuo University, vice president of Taipei Lawyers' Association, Taipei City assemblyman.

Shih Chiang-nan, born in 1902 in Lu-kang, graduate of Kyoto University, professor at Taihoku Medical College and practicing physician.

Wu Chin-lien, born in 1913 in Taipei City, graduate of Tokyo Cultural College, reporter for *Taiwan Sinminpou* (*Taiwan New Citizens Daily*), and chief editor of *Taiwan Shin Sheng Daily News* Japanese Edition.

Ng Tiau-jit (Juan Chao-jih), born in 1900 in Tung-kang, graduate of Fukushima Vocational High School, supervisor of *Taiwan Sinmin-*

pou (*Taiwan New Citizens Daily*), and general manager of *Taiwan Shin Sheng Daily News*.

Yang Yuan-ting, Deputy Speaker of Keelung Assembly.

Thng Tek-chiong (T'ang Te-chang), born in Tainan, graduate of Chuo University, lawyer, and director of Tainan Human Right Protection Committee.

Altogether several tens of Taiwanese were killed then; some corpses destroyed. Some hundreds of local eminent figures and intellectuals were arrested, tortured and released only after paying huge sums of ransom.

All those people were to take over their forerunners active in the late Taisho and early Showa Eras. They were valuable resources and a public symbol expected to lead a new political movement in Taiwan. No accurate figure is available still today as to the number of common people killed or injured in the process, but it is estimated to total from ten thousands to scores of thousands.

Chinese casualties, according to the Garrison Command, were 398 killed, 2,131 injured and 72 reported missing. The Command made sure that whatever damages done, lives and goods alike, should be compensated by the Taiwanese.[7]

The 2.28 Rebellion was indeed a crucial incident that left a decisive effect on the relations between the Taiwanese and the Chinese. True that there were no explicit cries for independence heard in the process, the 32-point Demand was a de facto demand for independence. Had the Rebellion succeeded, it would have been a matter of course for high-level autonomy to further lead to secession and independence.

..

[7] Refer to the *Taiwan Youth*, Issue No. 6, for detailed record.

However, the revolt was crushed to miserable pieces at an expense so enormous for the Taiwanese. The Taiwanese learned in the hardest of ways the craftiness of the Chinese, their meanness and brutality. They loathed the Chinese to the point of utter hatred and hostility, so bitterly that they pledged to themselves to achieve independence at all costs.

3. The League for Re-liberation of Taiwan in Hong Kong

It was none other than the Chinese communists that tied fast at the last minute the distrustful Taiwanese from drifting away from China. They belatedly published on March 8 an editorial "Taiwan's Autonomy Movement" on the *Liberation Daily* in Yen-an and broadcast it over Radio Hsin-hua:

"We hereby address to our compatriots in Taiwan. You have attempted to win autonomy by peaceful means and resorted to arms in self-defense against armed oppression by Chiang Kai-shek. We extend our heartfelt sympathy toward your efforts. Your struggle is our own struggle; your victory is our own victory. We in the liberated areas, military and civilian alike, will make every effort to encourage and support you."

The broadcast was hampered due to poor reception and hardly received in Taiwan. If received, it nonetheless came much too late. Besides, the mere distance between Yen-an and Taiwan made any message practically meaningless.

Aware of their lack of ability and of the bitterness of defeat for lack of organization, many Taiwanese youths eagerly responded to

the call for a comeback from the underground Chinese communists. The Chinese communists were well organized and experienced in underground operations and effectively launched propaganda for self-autonomy and self-determination. Not a few Taiwanese supported them.

Neither the nationalists nor the communists had any clear enough concept of China and Taiwan and the differences in their standpoints were obscured by the common goal of overthrowing the Kuomintang.

Hsieh Hsueh-hung, who had lived years of struggle under Japanese rule, set out to reorganize the communist party in Taiwan hand in hand with underground operatives sent by the Chinese communists, among whom was Ts'ai Hsiao-ch'ien who was arrested in his hideout in October, 1950. When the 2.28 Rebellion broke out, Hsieh organized a band of young students, called "27 Squad", to fight against the Nationalist army. The reinforcements arrived; the tides changed. Her comrades dispersed; she dissolved the squad and fled with Lin Mu-shun and other close staff to Hong Kong. She must have thought that continental guerrilla warfare would not work in an island like Taiwan transportation networks were closely knit.

In November that year, she inaugurated in Hong Kong the League for Democratic Autonomy in Taiwan, maintained contact with the Chinese communists and led underground operations in Taiwan.

Meanwhile, Liao Wen-i, PhD in engineering, Ohio State University, born in 1910 in Hsi-lo, who had kept distance with Japan during the war published a magazine, the *Vanguard*, in which he harshly attacked Ch'en Yi. Blacklisted, Liao fled to Shanghai. The 2.28 Rebellion broke out; Liao was put on the wanted list. Dangers afoot, he moved to Hong Kong.

In Hong Kong, Hsieh Hsueh-hung and Liao Wen-i formed a

united front, the League for Re-liberation of Taiwan, and drafted a petition in the name of seven million Taiwanese and sent it to the United Nations on September 1, 1948. It was the first petition ever drafted proposing that Taiwan be placed under UN trusteeship and that thereafter the people of Taiwan be allowed to conduct a national referendum to decide the independence of Taiwan.

The Chinese communists' swift victory caused Hsieh and Liao to split. It was natural that a communist Hsieh had dreamed Taiwan's liberation by the hands of the Chinese communists. In the spring of 1949, Hsieh accepted the invitation from the Chinese communists to go up north to attend the Political Consultative Conference as head of the League for Re-liberation of Taiwan and was subsequently elected to the National Committee. The nationalist Liao Wen-i left for Japan in February, 1950, with intent to reorganize the League for Re-liberation of Taiwan. There he met Wu Chen-nan[8] who had already advocated independence, rallied a few Taiwanese and organized a party, the Taiwan Democratic Independence Party, and had himself elected chairman.

4. Fleeing to Taiwan

On April 22, 1947, the Kuomintang dismissed Ch'en Yi, closed the Administrative Executive Office and made Taiwan a province. Wei Tao-ming[9] was appointed governor.

It looked as though Ch'en Yi was held accountable, but later on as Ch'en was promoted to Governor of Che-chiang Province in China,

........................

8 Born in 1914, who practiced medicine in Yokohama.

9 Born 1899, Chiang-hsi, later ambassador to Japan and promoted to foreign minister.

the Taiwanese felt dumbfounded. Dumbfounded were they again in June, 1950, when they heard Ch'en shot to death in Hsin-tien in the suburbs of Taipei. It was reported that his subordinate T'ang En-po had discovered at the last moment Ch'en's plot to defect to the Chinese communists. The Kuomintang later retold the story to say that Ch'en was held accountable for the 2.28 Rebellion and killed by way of apology to the Taiwanese. No Taiwanese was naïve enough to believe the story retold.

Wei Tao-ming's mission was to heal the scars opened in the minds of the Taiwanese after the massacre of 2.28. Instead, he handpicked a few "Half Chinese", or the so-called "*Ko-soaN*" (Chinese Leaners) who had sided with the Kuomintang in the rebellion, to head high government posts and continued exploiting the Taiwanese amid a flaring inflation. Among them were Huang Chao-ch'in, born in 1897 in Tainan County, long time speaker of Taiwan Assembly, board chairman of the First Bank, general manager of the Ambassador Hotel; Lin Ting-li, born in 1908 in Yun-lin County, a spy for the Japanese army, who organized special forces during the 2.28 Rebellion, deputy speaker of Taiwan Assembly; Lien Chen-tung, born in 1904 in Tainan, son of poet Lien Ya-tang, secretary general of Taiwan Assembly, member of National Assembly, Minister of the Interior; and Liu Ch'i-kuang who converted and fled to the mainland, allegedly incriminated many political enemies.

From then onward, Nanking government officials frequented Taiwan, implying quite vividly that the ongoing civil war in China would involve Taiwan soon enough. The Taiwanese were deadly anxious how to keep away from the civil war and turned their eyes eagerly to the United Nations and the United States.

Immediately after the 2.28 Rebellion, the US Ambassador to

China John Stuart handed over to Chiang Kai-shek a memorandum, known as the "Memorandum on the Situation in Taiwan" which is a part of the US White Paper on China. That was an expression of America's indignation toward Chiang Kai-shek, a strong note of protest against the Kuomintang's tyranny in Taiwan. The US Special Envoy Albert Wedemeyer visited Nanking in July and managed his itinerary to arrange an inspection tour of Taiwan. It seemed as though the Taiwanese saw a ray of hope in such US reactions to the situation in Taiwan.

However, Taiwan was the last hideaway for the Nationalist Chinese, and they were dead set on building a stern enough ruling machinery in Taiwan. So, on January 1, 1949, Wei Tao-ming was dismissed and Chiang's right-hand, Ch'en Ch'eng, took his place. Simultaneously, Chiang Ching-kuo, the son and heir of Chiang Kai-shek, was appointed chairman of the Taiwan Provincial Party Head-quarters and the armored divisions under the command of Chiang Wei-kuo, another son of Chiang Kai-shek, arrived in Taiwan.

Meanwhile in the Chinese mainland, Generalissimo Chiang Kai-shek was fast losing public support. Clamors demanding his resignation were harsher than ever. On January 21, Chiang Kai-shek finally announced to have Li Tsung-jen take his place. Li began to negotiate peace with the communists. One of the conditions put forward by the communists was the arrest of Chiang Kai-shek, Ch'en Ch'eng and many others as war criminals. The communists demanded that such war criminals be handed over to them.

The peace negotiation was to the Nationalist Chinese a mere trick to gain time after all. They opened fire again. Chiang Kai-shek had no intention to go on fighting in the mainland; he fled via Shanghai to Taiwan.

On July 20, the Kuomintang opened the Presidential Office in Taipei, and later on December 7, the Kuomintang officially announced that the Nationalist Chinese government had moved to Taiwan. Thus began the latter period of the Kuomintang rule of Taiwan. In the first period of its rule of Taiwan, the island was a de facto colony of the Nationalist Chinese who had a homeland in China. In the latter period, the Nationalist Chinese, having lost their homeland, fled into Taiwan, formatted it as a colony and began living the life of parasites. The paradigm still survives there ever today. This, indeed, is an unheard-of political system, the like of which non-existent anywhere, anytime in the history of mankind.

5. Great Oppression and Wu Kuo-chen's Downfall

The Kuomintang had no sooner settled in Taiwan than they set out to crack down, in a most bloody manner, on local Taiwanese nationalist and communists operating underground in the island. The Communist China without navy and transport vessels was no immediate threat to them.

From 1949 to 1951, Chiang Ching-kuo and his special agents arrested and killed thousands of young Taiwanese. A hundred suspects would be killed just to locate a single resistant. One would be shot to death on account of a volume of book in his possession; the other would be clubbed to death just on account for his membership in a college choir. When one was arrested; his friends would eventually be. Classrooms would be assaulted, students arrested at study; midnight house visits would be frequented. No justice; no fair trial. One execution followed another; luckier ones were sent to the prison on Green Island.

Such a reign of terror that followed the 2.28 Rebellion only augmented the animosity already smoldering in the minds of the Taiwanese. The Kuomintang could not care less. Stability under terrorism—that was what they desperately wanted and that is what they got.

Success of terrorism in sight, the Kuomintang then coupled it with conciliatory means. A minority in the island, the nationalist Chinese realized, for one, that it would be impossible to make an enemy of the whole of Taiwan and the Taiwanese; for two, that it would be essential to curry favor with the United States and, lastly, that Kuomintang needed to publicize democracy in Taiwan just to win America's sympathy and support.

While the special agents operating under Chiang Ching-kuo and P'eng Meng-chi, commander of Kaohsiung Port at the time of the 2.28 Rebellion and later commander of the Garrison Command, secretly kept on arresting and executing Taiwanese activists, the Kuomintang craftily appointed the former mayor of Shanghai, Wu Kuo-chen, born 1903 in Hu-pei, graduate of Ch'ing-hua and Princeton Universities, Governor of Taiwan Province, to try to attract the attention of the US government. Aware of the predicament of the Kuomintang as well as the intention of the US government, Wu dared promote a few Taiwanese to key posts, thereby coming in contact with the Taiwanese for the first time.

Governor Wu Kuo-chen (second from left) and Civil Affairs Officer Yang Chao-chia (first from left), 1952

Thus, Yang Chao-chia, born in 1892 in Taichung County, a Waseda University graduate, director of the *New Citizens Daily*, was appointed head of the Civil Affairs Office; Wu San-lien, born in 1899 in Tainan County, graduate of Tokyo College of Commerce, head of Tokyo Bureau of the *New Citizens Daily*, Mayor of Taipei. Both of them as-a-matter-of-factly promoted Taiwanese to staff their offices.

The Kuomintang leadership felt danger afoot and purposely powered up higher offices, namely the Executive Yuan, the party apparatus and the authorities of special agents—all in order to water down the functions of Governor of Taiwan Province. Furious, Wu resigned and fled to the US. Wu disclosed and criticized the corrupt and incompetent nature of the Kuomintang.

6. A Refugee Regime; A House of Contradictions

With and after the flight of Chiang Kai-shek to Taiwan a huge Chinese population made its way to Taiwan. An aggregate inflow of Chinese refugees then, including those later born in the island and those sporadic escapees, is said to have run up to nearly two million. The total number of Japanese, soldiers and civilians put together, was half a million or so at the end of war—quite an exodus.

Meanwhile, the Taiwanese were made to dance in their own way to the tune of "Counterattack". The Kuomintang addressed that such an offensive called for human resources. Such a dim-witted policy did work, however, to boost Taiwan's population by as much as 3.5% per annum. By early 1963, Taiwan's total population had reached over 12 million. Nowhere else in the world had a national population nearly doubled in the post-war 18 years.

Population explosion by nature slows down and distorts the de-

velopment of a nation. In the case of Taiwan, the situation is aggravated by the presence of 2 million Chinese parasites feeding on 10 million Taiwanese. On top of that, these parasites are exploiting and tormenting the hosts. Development is too distant a target; what one witnesses in Taiwan today is dilapidation and decay. A sorrowful catastrophe is well in sight.

The 2 million Chinese refugees are grouped roughly in three types, each embodying contradictions within.

The first group comprises several scores of families flocked around the Chiangs forming the nucleus of the Kuomintang regime. The Executive Yuan stays unchanged no matter how often it is reshuffled; the higher positions of power machines and financial organizations are constantly tossed around among the chosen few. It is a replica in smaller size of the four-family monopoly [10] of the Nanking government. As a matter of fact, the Chiangs, father and son, have boosted their grip over the regime, sending their sons, daughters and a fabulous wealth to the United States—the land they intend to flee the next time.

This group embodies a serious internal contradiction: a strife for power between the "Prince" Chiang Ching-kuo and Vice President Ch'en Ch'eng who has long been regarded Chiang Kai-shek's heir apparent since and during World War II.

Chiang Ching-kuo spent his ideology-forming days in the Soviet Union as a student. He was a member of the Communist Party and had long nursed a hatred of his father and mother-in-law, Soong May-ling. Then came his father's defeat in the civil war against the communists. His own subordinates had betrayed him; Chiang Kai-shek

10 Chiang Kai-shek and his wife Soong May-ling, Soong Tzu-wen, K'ung Hsiang-hsi, and Ch'en Kuo-fu and Ch'en Li-fu.

was at the nadir of his fortunes. That was the time Chiang Ching-kuo made up with his father and took full advantage of flesh and blood and paternal authority to spread his wings, threatening the old power structure built around Ch'en.

Ch'en was poor in health and had his own worries, but had behind him a power structure of the military, party and political cliques who resented Chiang Ching-kuo, an impertinent upstart. Here lies one of the key factors that could well determine the future of the Nationalist government.

The second group of Chinese refugees consists of bureaucrats, assembly members and high-ranking officials of the central government and its affiliated offices, and Kuomintang party leaders, military, police, secret agents, businessmen with friends in politics and their families. They have plenty to complain, mental and physical alike, but owe it to the Kuomintang to stay within the power structure. So they have no other option but to cooperate with the Kuomintang and, without means to attempt another exile, they have a perpetual nightmare of Taiwanese uprisings.

The third groups comprises low-ranking soldiers, prisoners of war of the Korean War (1953), all the residents of Ta-ch'en Islets (1955), part of the residents of Kinmen (1958), the troops left behind in Thailand and Burma (1961), refugees from Hong Kong (1962), etc. All these account for one half of the total Chinese refugees. Down at the bottom are nearly 200 thousand soldiers discharged on account of age and disease.

In the last group are those who were just dragged into Taiwan not knowing why. No income to live on; nor any family to count on. They have lived long poverty-stricken years all alone; many suffer from mental disorders.

They categorically hate anyone who is better off. One committed a double suicide with an unwilling Taiwanese girl, the so-called "carbine gun love"; another killed his superior officer; or those attacked the US Embassy (May 24, 1957); etc. Bloody incidents of all kinds erupt all over the islands and there is no telling when the underlying malcontent among such Chinese refugees might explode. This is indeed one of the deciding factors suggesting the future of the Kuomintang.[11]

7. Land Reform in Disguise

Whatever the contradictions, the Chinese have one common interest—that is, to live off the Taiwanese. No sooner had the Kuomintang landed in Taiwan than they embarked on a series of land reforms. In fact, it was indispensable for the Kuomintang to be the one and only mega landowner in Taiwan just to secure an abundant supply of inexpensive food. Such land reforms were made a sample of the Kuomintang's benevolent policy and highly praised as such by the ill-informed foreigners.

"'To the tiller the land belongs'—the land is for the farmers to own; the harvest is for the farmers to enjoy. That is the dying instruction of Sun Yat-sen, the father of our country, and our land policy faithfully lives up to his teaching", the Kuomintang sang its own praises. Why in the world had they not done so in the mainland and could do so in Taiwan now? The reason is simple enough: the land in Taiwan belongs to the Taiwanese and the Kuomintang has nothing to lose. [12]

....................................

11 Ref. Special Issue on "Chinese Refugees", *Taiwan Youth*, No.10, September 1961.

12 The Chinese share the same view as in *The Inside Story of How Chiang Ching-kuo Usurped the State* by Sung Chia-chi, published in Hong Kong in November, 1961, p.16.

A year after the 2.28 Rebellion, the rice famine still lingering, Wei Dao-min implemented an urgent policy to adopt a surplus rice legislation. All large and middle-sized landowners with over ten hectares of land (35.8% of all arable land, 2.7% of all landowners, or over 9,000 farming households) were ordered to deliver surplus rice at low prices. The landowners were furious but had to comply to avoid imprisonment.

Subsequently in the year 1949, in April, the so-called "375 Rent Reduction" was implemented to reduce the traditional rent from 50-60% down to 37.5%. The land prices dropped by a third to a half; the landowners suffered another blow. Lin Hsien-t'ang did not object to the "375 Rent Reduction" but was greatly indignant at the surplus rice legislation. Lin left Taiwan on the pretext of medical treatment never to return. He died in Tokyo in 1956.

In June 1951, the Kuomintang implemented the "Public Land Release" to make public 74,531 hectares of the total of 181,490 hectares of land taken over from the Japanese and to have the rest sold to tenant farmers. The price was set at 2.5 times of annual yield payable in installments over ten years in kind (crops) in the case of rice paddies and in cash for dry fields equivalent to the total value of sweet potatoes. The "Public Land Release" was a kind of demonstration to the landowners.

Finally, in January, 1953, the "Land-to-the-Tiller Act" came into force and took full effect within that year. Landowners were allowed to retain 3 hectares of paddy field (6 hectares of dry field) including both self-farmed and tenant-farmed land, and the rest compulsorily bought up by the government at a price 2.5 times of annual yield at the time of the "375 Rent Reduction", 70% payable by the "crop coupon" (exchangeable to unhulled rice in 20 installments over 10 years) and 30% by the bonds of the four semi-government-owned

companies in cement, paper mill, forestry and mining (worth 10 Yu-ans at face value but quickly depreciated). The tenants were required to pay for the land they bought in kind in over 10 years in 20 install-ments at an annual interest rate of 4%.

Thus, the landowners vanished. But then, were the tenants better off with the land they had acquired? In his interpellation at the pro-vincial assembly, Hsu Hsin-chih, a non-Kuomintang member elected from the Tao-yuan country, revealed that already 20% of the farmers had sold land titles and became tenants again and that the ratio would rise to 50% in ten years' time.

As of 1962, farming households in Taiwan number some 810,000, or 5,400,000 to 5,500,000 in population, slightly over 50% of the total national population.[13] Farm products and processed goods ac-count for 80% of the total export of US$150,000,000. The figures show the vital role of farmers in Taiwan as the mainstay of its economy.

The arable land in Taiwan is reduced to 800,000 hectares [14], less than in the Japanese era, and has remained unchanged over the last twenty years. However, the number of farming households has increased every year, notably during 1947-1959 when the farming population soared by 22.84%.

While the farming area per household has decreased over the years, the number of petty farmers with less than one hectare increased from 46% in 1936 to 63% in 1956, and today, such minor tenant farmers account for nearly 70% of the total farming population. The average number of heads per farming household was 6.1 in 1949 rose to 8.39

......................................

13 [The number of professional farming households is 219,889 in 2012, and 554,000 in population in 2015.]

14 [The arable land is 799,830 hectares in 2013.]

in 1957. [15]

As a matter of course, the livelihood of Taiwanese farmers kept on deteriorating. Some scholars point out that at least a million of the potential jobless pose a threat to the farming community. They cannot eat the rice they harvest, mix it with sweet potatoes at best or, at worst, live on potatoes for days on end. They of all ages and both sexes will go out to town to work for extra income; some will sell off their daughters to brothels in Taipei, Kaohsiung and elsewhere. The misery of their livelihood was such that even provincial assemblymen pointed it out. The Kuomintang, however, paid no heed to the situation.

The Kuomintang has steadfastly clung to its two major food policies: "Production Increase" and "Stable Rice Price", obviously out of sheer necessity to feed an enormous number of bureaucrats and soldiers at the expense of the farmers' livelihood.

The Kuomintang has always maintained the rice price down to approximately 70% of the market price as a means of stabilizing commodity prices. The government has monopolized chemical fertilizers and livestock feed, both of which account for 64% in terms of production cost. The Kuomintang forced exchange of the products with rice at a ratio of one to one: an "exchange of equivalents" between rice and fertilizers worth less than one third in the cost. What else is this but an obvious exploitive system? Furthermore, redemption in kind and heavy taxes tormented the farmers. The more you try to borrow, the higher the interest rates imposed by the Farmers' Association under the Food Bureau and the Land Bank.

Drowning in debt with no more zeal to work, crowds of farmers

..

15 Ref. "Taiwan's Rice Economy" by the Bank of Taiwan, published in September, 1959, and "Taiwan's Land Reform" by JCRR in October, 1954.

loiter around; commerce and industry can no longer count on farmers' spending and break down fast. Taiwan's economy is deteriorating; a financial crisis is in sight.

8. The Trick of "Counterattack"

In March, 1950, Chiang Kai-shek dismissed acting president Li Tsung-jen and resumed presidency again. He declared, as a pretext for his return to power, that he would "recover the mainland" with his own hands, advancing a rhythmic slogan of "First Year Prepare, Second Year Counterattack, Third Year Eliminate and Fifth Year Achieve".

In those days, Chiang hopefully anticipated the cold war between the east and the west to drag into World War III. Once a war broke out, Chiang hoped against hope, that the United States would eliminate the communists and help return the Kuomintang back to the mainland.

The cold war, however, took a reverse course and the communists gained power by the year. Today, only the gravest of monomaniacs believes a counterattack on the mainland will ever succeed.

Lei Chen, referred to later, was bold enough to publish in the semimonthly *Free China*, August 1, 1957, an article on the hopelessness of recovering the mainland. In the article, Lei attempted an objective analysis of the counterattacking plan and labeled it "a pie in the sky":

"Chances are slim for the counterattack operation to succeed. First, the current international situation to consider: the international situation is, as it were, a combination of 1) world-wide trend of popular sentiments, 2) the advancement of weaponry, and 3) the

growth of middle-of-the-roaders. All these factors are currently working against such an operation i.e. 'Counterattack'. Second, the question of preconditions for a modern war: namely 1) the size of population, 2) the availability of resources, and 3) the level of available scientific technologies. In none of these factors, the nationalist Chinese can vie with the communist Chinese.

Call it as you may a civil war quite outside foreign intervention, how can the Kuomintang transport their soldiers to the mainland to begin with, without the United States helping them? In short, they are contemplating such an operation at the outbreak of World War III.

Spirit overcomes material resources, some assert, but a modern-day warfare basically differs from the Northern Expedition some thirty years ago. Furthermore, there is nothing to prove that our spirit is superior to the communists."

So furious were the Kuomintang leaders that Lei Chen and his *Free China* were subjected to the fiercest of persecutions and they beefed up the counterattack propaganda to externally impress the international commu-
nity the legitimacy of the Kuomintang and to internally brew an air of emergency to cement its dictatorial rule of Taiwan. Thus, the constitution was brazenly overridden, the central govern-

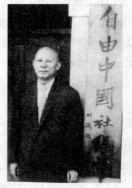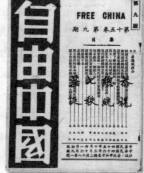

Lei Chen and his *Free China*

ment machinery put atop the government of Taiwan Province, special agents rampant and human rights trampled on.

Worse still, the Kuomintang's propaganda of an "approaching counterattack" threw the entire populace of Chinese refugees into a queer state of psychological instability where they would even take for granted the government's irrational ways "for the time being". Such an air is fast decaying public morals.

In the spring of 1962, the counterattack propaganda showed a delicate shift in nuance. Instead of deliberately stressing on the positive significance of such an offensive, the focus was turned more, as it were, to its negative aspect. What the Kuomintang fears most is a situation in which the Chinese refugees plunge into despair over the offensive bid, grow restless, act willfully and, at worst, turn against the party leadership, rising in riots seeking its responsibilities. Thus, the Kuomintang warned the Chinese refugees that they were faced with a common enemy: the Taiwanese:

"Taiwan is no land for us to live on forever. We must by all means return to the mainland. President Chiang, and he alone, can make this possible; he is the one and only omniscient and omnipotent leader. Let us all stand bold together under President Chiang."

In the spring of 1962, there was an event that made the Kuomintang jump for joy. The Chinese communists would corrode from within—that was the line of propaganda the Kuomintang had self-conceitedly promoted thus far. Then spread the rumor—that a major famine was badly hurting China for over three years and that numerous refugees were flooding the road to Hong Kong. The Kuomintang thought up a wishful scheme: a small band of guerillas with mission

to harass the rear should trigger the Chinese populace to respond.

Thus resumed another round of counterattack propaganda. A small band of guerillas, several hundred of them, did join the operation as a matter of fact, only to be annihilated in no time. Nothing earned for the Kuomintang but a total disgrace.

What irritates the Kuomintang is the communists' nuclear test. Should they succeed, the Chinese refugees, however reluctant to admit the inevitable, would at last give up the fantasy of counterattack. The Kuomintang now turned around and bluffed: "the test is doomed to fail and, should it ever succeed, will have no military significance whatsoever."[16]

While propagandizing a counterattack, the Kuomintang craftily kept watching how the United States would react. They had initially expected the United States to single-handedly eliminate the Chinese communists; then afterwards they busied themselves trying to somehow find ways to drag the United States into their struggle with the communists.

But, even the anti-communist incarnate John Foster Dulles would not approve of any counterattack to recover the mainland. In October, 1958, Dulles had Chiang Kai-shek pledge to forfeit any armed attempt to recover the mainland. It is still vivid in memory today that the late President Kennedy, in a presidential TV debate with his counterpart Richard Nixon, went further to say that he would withdraw US troops from Kinmen and Matsu. The Kuomintang's cry for counterattack was so persistent that President Kennedy, in his press conference on May 22, 1962, declared that any armed attempt to recover the Chinese mainland would have a direct bearing on US policy

16 Refer to last several paragraphs of Section 1, Chapter 8.

and that any relevant action would require US approval in advance.

There is no way the United States approves an armed counterattack, nor could the Kuomintang succeed in such attempt without US support. This the Kuomintang is fully aware of; why then the persistent cry for counterattack? Apart from the aforesaid circumstances, the Kuomintang has a grand, crafty plot in mind: if and when the counterattack fails, the Kuomintang will hold the United States accountable, turn the refugees' discontent against the United States, stabilize its own political position and, at worst, venture on a Nationalist-Communist Alliance.

9. An Ugly Face behind the Mask

The Kuomintang today has a huge army to maintain—some 600,000 as compared with 600,000 of South Korea vying against North Korea and 500,000 of South Vietnam bitterly confronting the Viet Cong—just for the purpose of a "counterattack" on the mainland and nothing else.

However, of the 600,000 only 400,000 or so are combat-worthy, the remaining 200,000 virtually enlisted petty public servants, deployed in Kinmen (100,000), Matsu (25,000) and the rest within the island of Taiwan.

Chiang Kai-shek brought along a patched-up army of abnormally many officers than soldiers. Most of the troops are aged, mostly 40 to 50 years olds no longer fit for combat. At the US request to refresh the military, the Kuomintang removed the sick and aged and recruited young Taiwanese to replace them. Today, the combatants are mostly Taiwanese who have little or no chance of promotion to ranks above major.

Besides, they will risk their lives for the defense of Taiwan but have no volition to fight with the communists in the mainland. Taiwanese college graduates are posted to various forces as reserve officers for a certain period of time. Only after that period are the Taiwanese youngsters granted their diplomas. The Kuomintang constantly keeps a close watch on the interactions of the reserve officers and regular Taiwanese soldiers, mixing them with Chinese soldiers and frequently relocating them.

Wages are generous above and meager below; so morale is perpetually low. The Commander-in-Chief of the military receives a fat pay and living allowances plus a monthly expense account of NT$200,000, while a private is paid just NT$28 per month and nothing more. [17]

A report has it that certain high-ranking officers in Kinmen and Matsu indulge in feasting and banqueting day in and day out on riches made out of smuggling with Hong Kong and petty soldiers survive only on bean-curd and greens in dilapidated hutches. [18]

So, one can see that the 600,000-strong army is not really geared to fight, but merely an unemployment relief agent and a concentration camp put together. Just imagine this army downsizes itself or vanishes altogether; one can easily foresee what will happen.

Be it as it may, some 80% of the national budget is put aside for the military just to maintain this huge army. Details of how the military budget is executed are known only to a limited few. As the central government budget should run up to NT$10 billion, these limited

..............................

[17] See "Simplifying Organizations and Adjusting Salaries" by Liu Chung-lin in *The Assembly*, published in April, 1958.

[18] "What I Saw in Matsu" by Huang Pu-shieu, in *Taiwan Youth* No.32, published in July 1963.

few control its 80% or NT$8 billion. The good old Four Clique families still today hold the key to the money-making machinery.

And, of course, there also are provincial budgets. The revenue and expenditure for the year 1964 (July 1963-June 1964), was 5.5 billion, of which some 58% or 3.2 billion is put aside to subsidize central and provincial governments, leaving merely 2.3 billion for the provinces to spend. Taiwan is about the size of Kyushu, Japan, with a population over that of Tokyo. Tokyo annually budgets Yen 250 billion; Taiwan not even one tenth thereof.

Of the annual revenue of NT$5.5 billion, the sales of such monopolized products as tobacco and cigarettes account for 54.56% (less than 10% in Japan), taxes 23.93% and profits from public works 12.75%. A glance at the figures will tell that indirect taxes weigh lopsidedly heavy. Meanwhile, the prices of those monopolized products were raised in rapid succession to provoke a sort of negative resistance in general public to quit drinking and smoking, thus frustrating the Kuomintang's revenue plan.

An economy that would have died off long ago somehow survives in Taiwan on a massive financial aid from the United States. The Kuomintang economy today leans on the United States and lives on its purse. The US aid in the past ten years has totaled US$100 million per annum, the largest in terms of population ratio ever given out by the United States in Asia. Yet, the Kuomintang cannot balance its economy without issuing short-term government bonds (repayable in 2 years) to the tune of NT$200 million annually since 1958 and constantly increasing money supply. An inflation is running chronically but not to the extent of a catastrophe. Why? Because, the public purchasing power is almost nil.

What about education—another key point of Kuomintang's pro-

paganda next to land reform? The enrollment rate of school-age children in Taiwan reached 95.44% in 1960, second highest in Asia after Japan, boasts the Kuomintang. But that in the last phase of the Japanese era was already quite high enough, over 71%, and the Taiwanese had always had a passion for education. That is to say, the high enrollment rate the Kuomintang boasts about is something accomplished on a solid basis already built.

When it comes to the quality of education, it is disappointing. A Chinese member of the Control Yuan, T'ao Pai-ch'uan, said in his report of an island-wide tour of educational institutions that the current status of education in Taiwan may be summarized in three words: congestion, poverty and void.[19]

The total number of school-age children annually increasing and education budget being forever meager, classrooms are chronically short in supply and the level of education keeps on declining. Classes of 100 children each are not uncommon; elementary schools with several thousand to ten thousand children are not rare either. Grades up to four are split into two or three shifts; grades five and six are over-flooded to the extent of having to open ill-timed preparatory courses, often early in the morning and late in the evening, to ready them for entrance exams.

The number of colleges and universities was only seven in the Japanese era and has increased to over 25 and the door to high education may seem opened wider, but not a few of them are dubious low-grade institutions by-named "college shops". The Taiwan University, formerly the Taihoku Imperial University in the Japanese era, is commonly regarded Taiwan's top university but its facilities basically for

..........................

19 *Cheng-hsin News*, November 11, 1962.

no more than 500 students are today catering for as many as 9,000 students.

Lack of facilities aside, freedom of thought is totally banned and nowhere in sight there, nor freedoms of research and publication, to make the institution no ground for educational advancement. Chinese intellectuals sitting behind the second group of Chinese refugees ridicule Taiwan a "cultural desert".

Lastly, let us observe another symbol of "Free China", that is local autonomy. Each of the provinces, counties, cities and towns has its assembly to which local representatives are elected. It looks as though the political framework exists intact. In every election the Taiwanese outnumber the Chinese each time, so the Kuomintang resorts to all plausible tricks to control elections. Well-known Taiwanese are handpicked to run for the Kuomintang to alienate the voters; active antagonists are hedged round with a series of restrictions—never to discuss national policy matters, nor to attempt to estrange the Chinese and the Taiwanese, etc. etc.

That way, non-Kuomintang candidates have hard time winning elections. The Kuomintang cracks down on each and every independent candidates likely to win, openly and/or indiscreetly interfering with their campaign, for instance drafting them into military service in the eve of the election day, mobilizing soldiers' votes, recruiting invalid votes, switching ballot boxes, etc. etc.

Pro-Kuomintang or non-Kuomintang, winning candidates are never to have political power to exercise. The power rests with Chinese sitting above in the positions of chief secretaries. The difference is only that pro-Kuomintang members are less exposed to harassment.

Provincial assembly members are relatively higher in political standing, as they are fewer in number and better in quality. In May

1963, when the third provincial assembly was inaugurated, Taiwanese sat in 68 of the total 74 seats, Chinese 6 and independents 12, all of whom were naturally Taiwanese. However, the provincial assembly is equally powerless. The provincial governor is a political appointee reporting to the premier sitting above. Such is no local autonomy when the governor is not elected by popular vote. Should a Taiwanese be elected to governor of Taiwan, head of the Executive Yuan would have no work to do. The Kuomintang therefore, can never let the Taiwanese fill the post.

10. Ultimate Struggle

The Kuomintang's way of oppressing and exploiting Taiwan is intolerable and far beyond the limit of perseverance. Why is it that no visible sign of revolt surfaces since the 2.28 Rebellion?

True, the police and secret agents are highly cautious in checking minor buds of riot, but it is also true that the Kuomintang machinery is to a certain extent functioning well to mentally emasculate the Taiwanese. They will stress China being a land of everlasting history and great civilization to help awaken the Taiwanese to the long-forgot Chinese ethnocentrism. They will appeal to the Taiwanese to free their minds from the petty island of Taiwan and look out to the world—to the great continent of China: a sort of agitation that works well with naïve youths.

The 2 million Chinese refugees in the ruling class have permeated in Taiwan a weird air of decay: corruption, neglect, irresponsibility. This air spread fast into Taiwanese society; not a few Taiwanese, out of frustration of powerlessness, quickly learned to live the Chinese way—never kicking against the pricks.

Thus, those Taiwanese aspiring after freedom and independence had to fight first against the mental degeneration within before fighting against the Kuomintang without.

Champions of the fighting Taiwanese are independent Taiwanese provincial assemblymen. In the assembly hall, through elections campaigns, and on all available occasions, they speak up. They speak to criticize the Kuomintang and encourage the Taiwanese public not straightforwardly but with fine shades of ex-

Brave Taiwanese provincial assemblymen (from left: Li Wan-chu, Kuo Yu-hsin, Hsu Shih-hsien, Kuo Kuo-chi, Wu San-lien, Li Yuan-chan)

pression in every word they speak. Their speeches are recorded on the spot, they are tailed wherever they go; to their homes are mailed bullets, excrements and what not. At worst, their houses are set on fire.

Some of them risked their lives to speak up. But now that the *Free China*[20], the *Public Forum*[21], and the bi-monthly *Autonomy*[22] were banned, the Taiwanese were deprived of their eyes and ears. Let us read some scathing statements made in those days. For instance, here is an excerpt from a speech during the interpellation

20 Ceased publication in September 1960.

21 President Li Wan-chu; taken over by secret agents in March 1961.

22 Later permitted to resume.

in the first session of the third provincial assembly in the autumn of 1957, made by the interpellator Kuo Yu-hsin, born in 1907 in I-lan, amply nicknamed "small cannon", posing 19 questions to Governor Chou Chih-jou. In one of the questions he said:

"It has been some time since the need for promoting qualified Taiwanese to proper positions was first discussed, but the situation is far from being improved. True, not a few Taiwanese are now employed in police service, but no Taiwanese is appointed chief except in Miao-li—only, mark you, only one out of 21 county and city police departments. Of the 95 branch chiefs only 3 are Taiwanese. I understand that in the Chung-ch'ing era many police officers in Ssu-ch'uan were Ssu-ch'uanians. In the same context, would it not be fair, now that you are all in Taiwan, to promote more local Taiwanese?"

Nicknamed "stubborn scholar", Li Wan-chu, born in 1902 in Yun-lin county and educated in France, submitted 15-point questionnaires, in one of which he criticized land reform, thus:

"Landowners in Taiwan, large and small, have acquired what small space of land they own today through painstaking labor over years from their ancestors down to this day; the situation here is totally different from that in the mainland where local tyrants merely annexed their land through power and influence. The concept of land reform was significant but the way landowners were compensated was hardly rational. The face value of the bonds issued by the four major public companies was 10 Yuans to start but fell in overnight to 4-5 Yuans and farther down to 2 Yuans.

Landowners are furious. Is the government prepared to offer some sort of compensation?"

A "fast shooter" Wu San-lien drilled the irrationality of budgeting process, thus:

"In this small island, Taiwan, the two governments, central and provincial, are wrestling over financial resources. The Legislative Yuan (of the 500 or so members only several are Taiwanese) is planning to transfer the public monopolized companies and the forest and railway bureaux under the jurisdiction of the central government. This gives an awfully bad impression. Why? Because, though the Japanese had exploited the Taiwanese, they invested all the proceeds from such enterprises fully to the development of Taiwan. The present government followed the practice for a few years after the restoration of Taiwan, but a plan is underway to transfer the proceeds to the central government budget and craftily double them into the provincial government budget as well. How does the government account for this situation?"

Kuo Kuo-chi, born in 1904 in Kaohsiung, a graduate of Meiji University who had won himself a nickname "big cannon" and failed in his re-election bid for the provincial assembly in 1963, was a notable public agitator but too vulgar to enjoy due support from among the intellectuals:

"When I made my speech in Taiwanese, the Chinese audience tried to stop me. So I rebutted, 'You are like beggars chasing away the temple abbot. We let you taste the soy sauce, and you took

away the soy saucer.' " [23]

"Ladies and gentlemen, you might say that Taiwan is the smallest of the 35 provinces of China, but, remember, Taiwan ranks above the middle among the 82 member nations of the United Nations."[24]

This is about as far as the Taiwanese can go in their public utterances. They are internationally renowned personalities and the Kuomintang cannot carelessly meddle with them. Had common Taiwanese said all that, they would have been liquidated on the spot. The Kuomintang is said to already have complete blacklists of persons of classes A, B and C, ready to strike at the first chance available.

11. Lei Chen and Opposition Party Movement

As mentioned on various occasions thus far, Lei Chen is a by-product of internal contradiction within the second group of Chinese refugees.

Born in 1896 in Che-chiang, Lei Chen joined the Kuomintang at age 20 and had ever since devoted himself to the cause of the party and when back in the continent had cemented himself as one of the meritorious members of the Kuomintang. Even after the party moved to Taiwan, Lei Chen was qualified enough to be a member of the first group, if he so wished.

But then, Lei was as much an ardent constitutionalist as a zealous

..

23 He was prosecuted on charge of attempting to estrange the Taiwanese from the Chinese in his election speech at the Taipei Police Academy, April 14, 1957, but tactfully talked himself out of it.

24 From speech in front of Lung-shan Temple, January 13, 1958.

anti-communist. Lei was apprehensive of the future of the Kuomin-
tang, much less the Republic of China, if a dictatorship kept on tram-
pling the constitution underfoot under hollow slogan of counterat-
tack. He rose, as it were, to roll back the tide of falling fortune. In
1954, Lei Chen was expelled from the Kuomintang and ever since
made a target of incessant persecution.

The *Free China* was Lei Chen's weapon. It was inaugurated in
1949 with Hu Shih (1891-1962), an An-hui, as its publisher. Soon
afterwards Hu fled to the United States; Lei took over in January
1953. The magazine had thus far analyzed international affairs and
stood critical toward the Chinese communists. But in October 1956,
in its commemorative issue in honor of Chiang Kai-shek just turned
70, the magazine opened fire against the Kuomintang and its policy.
The way Lei Chen risked his own life to confront the Kuomintang
was phenomenal in stark contrast to the way Hu Shih was bought off
into the office of the president of the Academia Sinica and voted in
favor of Chiang's unconstitutional bid for presidency in May 1960.

Lei Chen was known a man of virtue and his *Free China* was
reputed internationally, so much so that the Kuomintang could not
readily take any hasty action against him. Lei Chen on his part was
aware of the limits of the pen and contemplated organizing an oppo-
sition party to initiate political movement.

The Kuomintang primarily had certain enlightened elements
within itself looking for chance to spin off and form an opposition
party to check from without any dictatorial moves of those in power.
They appeared ready to elect Hu Shih leader of their party and mobi-
lize all anti-communist and anti-Chiang Kai-shek Chinese in exile in
Hong Kong and the United States. However, having learned the taste
of one-party dictatorship, the Kuomintang bought off Hu, banned all

anti-communist, anti-Chiang Chinese from reentering Taiwan and uprooted the plan for good.

Meanwhile, the Taiwanese, encouraged by the turn of events at home and abroad, began openly attacking the Kuomintang's unlawful interference with local elections. In May 1957, non-Kuomintang Taiwanese assemblymen planned to organize a Taiwan Association for Studies of Local Autonomy [25] in an effort to vie with the Kuomintang. The Kuomintang was quick to ban the plan in budding. Li Wan-chu, Kuo Yu-hsin, We San-lien and Kao Yu-shu[26] , however, persisted on the plan and finally managed to tag with Lei's *Free China*. Thus, in 1960 an action surfaced to form an opposition party.

Now, a grave situation cropped up for the Kuomintang. The Chinese to whom a monolithic unity was indispensable for ruling the Taiwanese were now split wide open and one side was about to join force with the Taiwanese against the

Kuo Yu-hsin (first from left) and Lei Chen (second from left) visited Yang Chao-chia (first from right)

Kuomintang. Further, there were ample signs of the United States forsaking the Kuomintang in favor of the rising opposition movement.

So frustrated was the Kuomintang that general surveillance was immediately stepped up and a series of restrictions fast imposed on

25 Later forcibly renamed to Chinese Association for Studies of Local Autonomy.

26 Born in 1903 in Taipei, graduate of Waseda University, former mayor of Taipei City.

the opposition movement. The circumstances at that time are vividly depicted in an urgent statement issued by Lei, Li and Kao, "Urgent Statement of the Electoral Reform Forum":

"...the Garrison Command interferes with every session of the forum. We believe the government should not use overextended martial law to deprive the people of their constitutional freedoms. For instance, one of our initiators, Wu San-lien had to briefly leave the country as the Kuomintang had applied pressure on a certain business he was involved in.

Lei Chen is placed under constant watch and tailed wherever he goes. The Kuomintang set up a special surveillance post, staffed with scores of agents, within its party office right across from the office of the *Free China*.

One jeep and three buses are on duty around the clock to individually check and tail whoever enters and leaves the building. Day after day from morning to night, vehicles shadowed Lei from his home in Mu-cha to Taipei, from his office to downtown eating joints, every minute of the day." [27]

Lei Chen and his colleagues, however, never ceased to operate as they continued canvassing across the island. Threats and harassings in vain, the Kuomintang forged a charge on Lei Chen of hiding communists and arrested him on that account. He was sentenced to ten years imprisonment. He was made a scapegoat because the Kuomintang thought it essential to oust him as head of the opposition and the *Free China* thereby to avert the antipathy of the Taiwanese away

..............................

27 From the *Free China*, September 5, 1960.

from the ruling regime.

The defeat of the opposition party was an evidence of the Kuomintang's steadfast intention to uproot any symptom of democracy. It was natural of the Kuomintang to have had to nip every anti-Kuomintang move in the bud; they knew well that one compromise would lead to another, and then still another to eventually threaten the very basis of its dictatorial system of government.

12. Overseas Independence Movements

The political climate within the island deteriorating, the overseas Taiwanese had to shoulder heavier responsibilities. Overseas Taiwanese were mostly in Japan, 25,000, and sporadically in the United States, 3,000 or so mostly students. The 25,000 Taiwanese in Japan were quite diverse in the way they lived and how they expressed themselves. They may be classified by age roughly in two groups: old and new.

During the war the Taiwanese living in Japan were businessmen, drafted workers and students. After the war, part of them left Japan for Taiwan and the rest, 15,000 or so, stayed behind. The second-generation Taiwanese of those who had stayed behind grew up in postwar 18 years and now number several thousand.

Living in Japan as they did, they escaped the calamity of the 2.28 Rebellion; they also escaped the Kuomintang's tyranny and oppression and enjoyed the benefits of being the citizens of an allied power, financially as well as politically. No wonder then that they were inspired to uphold Chinese consciousness and pray long life for China.

Watching the Kuomintang fade, some Taiwanese in Japan turned around and prayed long life for Chairman Mao Tse-tung. Overseas

aliens all shared a common sentiment to flock under the umbrella of great homelands in order not to be looked down upon. Not a few young Taiwanese responded to a call from the Communist China to join in the "construction of a great motherland" only to fly back broken-hearted.

When Liao Wen-i and his Taiwan Democratic Party for Independence embarked on launching an independence movement outside Taiwan in 1950, the environment was just as abominable. The party was made a target of ridicule and its initiator a swindler. Liao's movement thus failed to pick up momentum.

Wartime fire having subsided in Indochina in July 1954, dark clouds now spreading over the Strait of Taiwan, Liao set up in September 1955, the Temporary Taiwan National Assembly and in January the following year, declared establishment of the "Temporary Government of the Republic of Formosa". He primarily aimed, first, at creating an instrument, its contents aside, with which to regain momentum of his independence movement and, second, at making a public display of the movement's political goals.

Liao Wen-i's *Formosanism* (1956)

His efforts did pay off in part. The whole world came to learn from the way the Red Chinese denounced Liao a puppet for the United States and the Nationalist Chinese smeared him a product of the Comintern's conspiracy, that both Chinas entertained concern and suspicion over the movement of Taiwanese overseas.

Liao Wen-i, or whoever else attempting independent movements in Japan, should first seek understanding and support of the Taiwan-

ese resident in Japan. Prerequisite in the process will be tireless efforts to convince them of the truth about the Kuomintang rule of Taiwan, fundamental differences between the Taiwanese and the Chinese, and the benefits of independence for the Taiwanese.

First of all, however, they are decisively affected by Japanese society where they live day to day and engage in economic activities. Japanese society is divided in its reaction to Taiwan: some Japanese adore Communist China while others cherish Chiang Kai-shek and his "return good for evil" message and in-between a large number who pay little or no attention to Taiwan—hence, a rather complex fabric of sentiments it is, the Taiwanese in Japan.

Into the 1960's and up until this day, there are signs of change observed in conformity with the developments within Taiwan and international reactions to its affairs. Eminent Japanese critics voice their views in favor of Taiwan's independence and quite a few theses published stressing the inevitability of independence. All these developments have brought about a profound impact on the Taiwanese populace in Japan.

Several thousands of Taiwanese traders, invitees, illegal immigrants and students came to Japan following the signing of the Sino-Japanese Peace Treaty, April 1952. The inflow of such Taiwanese had a tremendous impact on the resident Taiwanese in Japan; the new wave of Taiwanese helped arouse in the resident Taiwanese populace a genuine love for their motherland. The 800 Taiwanese students, in particular, are worthy of attention in that they are de facto exiles in disguise as students.

The Kuomintang has stepped up surveillance and special agents are rampant to watch over the resident Taiwanese; constantly under close surveillance, they hesitate to initiate any active movement.

In the spring of 1960, a new group of independence-oriented Taiwanese inaugurated the Taiwan Youth Society and ushered in a new phase in the Taiwan independence movement. The Society was an organization to seek Taiwan's independence, initiated by *Ong Iok-tek* (Wang Yu-te) with a score of Taiwanese students rallying round him. It targeted a comprehensive movement based on the students to draw the general Taiwanese populace in Japan into the drive for Taiwan's independence and to cover the area the "Temporary Government of the Republic of Formosa" cannot reach out. The Society aimed, with foreign observers in mind, at making scientific and thorough analyses of the essence of the Kuomintang rule in Taiwan, studying and publishing thesis to pave the way to Taiwan's independence and mount-

ing propaganda drives to promote the independence movement which is often frowned upon. The Society published the *Taiwan Youth*[28] in Japanese and the *Formosan Quarterly* [29] in English. Both journals were highly acclaimed as authoritative sources of information on the Taiwan affairs.

In its issue of June 18th 1962, the US magazine *The New Republic* commented on the Taiwan independence movement in Japan as follows:

The inaugural issue of *Taiwan Youth* (1960)

"An aggressive but not yet sufficiently effective movement is under way in Tokyo aiming at establishing a genuine republic of

............................

28 Inaugurated in April, 1960, first bi-monthly and later monthly after November 1961.
29 Inaugurated in July 1962.

the Taiwanese. One of its publications, the *Taiwan Youth* is well edited and clearly states the interests of the vast majority of the Taiwanese."

In the United States, a body was formed in January 1956, aptly named the "Committee for Formosan's Free Formosa", or 3F in short, mainly by a group of Taiwanese students on the east coast. This body grew up in 1958 to be the "United Formosans for Independence", or UFI, with *Tan I-tek* (Ch'en Yi-te) as president. They picketed in front of the UN against the visiting Ch'en Ch'eng in August 1961 and made international headlines.

Overseas independence movements are in close touch with the Taiwanese at home and constantly expanding.

Needless to say, their primary mission is public enlightenment and propaganda. Let us now proceed to discuss the powers that the Kuomintang is most closely related to and, therefore, the Taiwanese need to pay closest attention to: the United States and Communist China.

13. Between the United States and the Kuomintang Regime

Over the past two decades, the United States has tackled Taiwan on the spur of each moment as dictated by the Kuomintang.

Everything began when the Cairo Declaration made Taiwan a booty for the Kuomintang to claim. The allied powers needed to keep the Kuomintang on their side without consulting the will of the people of Taiwan. Amply concerned with the interests and wishes of the Taiwanese in the course of the civil war in China, they sat back and watched the Kuomintang flee into Taiwan and gradually cement its

dictatorial regime there.

Thereafter, the United States stuck to its wait-and-see policy while the mainland China fell into the hands of the communists and the need appeared eminent for the United States to review its policy on the relations between China and Taiwan. Then, a war broke out in Korea, and, at long last, the United States bared its new policy over Taiwan and its status. President Truman stated that "The determination of the future status of Formosa must await the restoration of security in the Pacific, a peace settlement with Japan, or consideration by the United Nations".[30] The US 7th Fleet quickly moved in to blockade the Strait of Taiwan.

As hostilities dragged on in the Korea peninsula, the Kuomintang somehow recovered its position in Taiwan, while its lobbying campaigns in the United States paying off, the US policy toward Taiwan took a strange twist. Chiang Kai-shek's supporters in Washington now demanded to call off neutrality over the straits of Taiwan, let Chiang act at his will, and let his military attack the mainland.

The problems of Chiang's dictatorial rule of Taiwan and his oppression on the Taiwanese populace were put aside; Chiang Kai-shek's fantasy of liberating China instead began drawing undue attention.

Truman stepped out and in came Eisenhower. President Eisenhower, to Chiang's delight, lifted the US policy of neutralizing the straits of Taiwan. Chiang Kai-shek and his supporters elated but Eisenhower did not go so far as to back him up in this attempt to eradicate Chinese communists.

The US policy on Taiwan marked a turning point on December 2, 1954 as a mutual defense treaty was signed that day with the

..

30 Statement on June 27, 1950.

Kuomintang. The US Congress clearly made it a point that the treaty was merely to stipulate mutual defense obligation of Taiwan and Penghu and not to recognize the Kuomintang's sovereignty over Taiwan. Most importantly, the treaty stipulated in Article 2 that "in the event of attack on Taiwan and Penghu by the Chinese communists, be it from within or without, shall be defended jointly or separately".

The Taiwanese deeply resented the treaty as the United States thereby guaranteed the Kuomintang's rule in Taiwan and provided over the past ten years a vast amount of military as well as economic aid, to the tune of US$3 billion to help the Kuomintang survive in Taiwan.

The leftists might hastily conclude that that alone should make the Taiwanese anti-American. It is not necessarily so, and here is the reason why:

On how tensely the Taiwanese feel the threats from the Chinese communists, let us discuss in the following section. Let it suffice for now that the Taiwanese are fully aware that the real intention of the United States is to defend Taiwan, not to protect the Kuomintang. The so-called "Two China" policy is merely a passage to "One China, One Taiwan" as indicated in the Conlon Report of November 1959.

The concept of "One Taiwan" was clearly expressed by the former Under Secretary of State Chester Bowles in his "An Independent Sino-Formosan Nation":

"Although most of them speak the Fukien dialect of southeast China, they were educated in Japanese schools. Because the island prospered, many of them had come to feel closer to Tokyo than to the mainland. But 15 years of Nationalist rule have brought significant changes. Time, proximity and education are creating,

among the younger ages in particular, a gradual amalgamation of the island's Chinese and Formosan communities. There may slowly be emerging a new national identity predominantly Chinese by culture but Formosan in outlook....

Let us accept the fact that Formosa's adoption of an affirmative new role in non-Communist Asia cannot be stage-managed by American policy-makers, however well supplied with good will and dollars. Nor can it be arbitrarily imposed on the Formosan majority by the Nationalist refugees from the mainland. Our role must be that of a genuine friend. The native Formosans, the Nationalist Chinese and the world generally must be convinced that our objective is not to create a military base for the invasion of the mainland but to encourage the orderly growth of a new, independent nation." [31]

Here, the author witnesses in his statement a sound expression of the United States' frontier spirit and good conscience, but, unfortunately, he subsequently left his post.

14. Between Chinese Communists and the Kuomintang

China's position toward Taiwan was clearly revealed by Chou En-lai, China's foreign minister, in his rebuttal of the statement by President Truman on June 27, 1950, made immediately the following day:

"I solemnly declare on behalf of the central government of the

31 From "The 'Chinese Problem' Reconsidered", *Foreign Affairs*, April, 1960.

People's Republic of China that the US imperialists can not forever change the fact that Taiwan belongs to China, whatever obstructive tactics may be employed. This is not only an historical fact, but also well confirmed by the Cairo Declaration, Potsdam Declaration and the status quo after the surrender of Japan. The people of China will fight to the end for the liberation of Taiwan from the grip of the US imperialists." [32]

Chou En-lai made the statement immediately following the US Seventh Fleet blockaded the Strait of Taiwan to assert that Taiwan was a part of China and to openly declare that China would liberate Taiwan. Further, in the "Declaration for Liberation of Taiwan issued by Various Parties in China" of August 23, 1954, Chou En-lai stated as follows to object to UN trusteeship and to underscore the liberation of Taiwan is purely China's domestic affair:

"Taiwan is an indivisible part of China. The United States can never be allowed to occupy Taiwan, nor can it ever be placed under the United Nations trusteeship. It is China's sovereign act and a matter of domestic affairs to liberate Taiwan and to annihilate Chiang Kai-shek and his treacherous clique."

Just then, in September, the Kuomintang provoked China on the sea near Kinmen obviously in response to China's declaration. Furious, China countered with a fierce barrage on Kinmen causing casualties including US advisory personnel. Behind the incident was a wish-

...................................

32 From "Oppose the US Occupation of Taiwan and its Conspiracy to Forge 'Two Chinas'", Peking Foreign Language Press, October 1958.

ful thinking on the part of the Kuomintang that the wars in Korea and Indochina should lead to World War III—"third time luck". The United States would not budge; instead, it signed a mutual defense treaty to restrain the Kuomintang from maneuvering.

The following year, China captured Yi-chiang-shan Island to sound out the United States' stance on the offshore islands. To the dismay of the Kuomintang, the United States took the opportunity to withdraw from Ta-ch'en Island. It was about then that the Kuomintang began voicing criticism on the United Sates' "Two China" policy.

In April, 1955, China scored a major point at the Bandung Conference in its peace offensive on the Asian and African countries. The Chinese communists extended the offensive even to the Kuomintang; they offered to pardon Chiang Kai-shek and the Kuomintang leaders. The rumor flew about then of a third Kuomintang-Communist collaboration.

The Taiwanese noted with suspicion that China's declaration for the "liberation of Taiwan" had made no reference to their position. The Taiwanese witnessed in the way China had offered to pardon Chiang Kai-shek and to bargain with Chiang Kai-shek that China was no ally of the oppressed. Why bargain with Chiang Kai-shek— why not call out direct to the Taiwanese?

But then, the Chinese communists had their own revolutionary strategy. After the Kuomintang fled to Taiwan, China shifted the "fundamental conflict" from against the Kuomintang to the United States. The "liberation of Taiwan" was to be looked upon as part of the blow targeting the United States.

Armed "liberation of Taiwan" unrealistic, China had only to depend on calls from within; within are Chiang Kai-shek and 2 million Chinese refugees and 10 million Taiwanese.

China chose the former. The Taiwanese were incompetent; even Hsieh Hsueh-hung and Lin Mu-shun, members of the communist party for over 30 years, were untrustworthy dissidents in support of high-level autonomy of Taiwan. On the contrary, the Kuomintang were closer related and better known; they actually were in a position of power. Collaboration or whatever, it only meant the Kuomintang's surrender at the mercy of the communists. Thus, China's relationship with the Kuomintang transfigured itself from a hostile contradiction to a non-hostile contradiction.

That was why China purged Hsieh Hsueh-hung (autumn of 1957 to February 1958) who would otherwise have played the role of a spearhead of Taiwan's liberation and forged a patriot of Chiang Ching-kuo who had suppressed an opposition movement under Hu Shih and trampled down Lei Chen, Li Wan-chu and Kao Yu-shu and their opposition party movement. In August, 1958, China deliberately shelled Kinmen and Matsu to stir up the Chinese refugees' deep-seated anti-US sentiment and urged them to keep united under the Kuomintang. The queer presence of Kinmen and Matsu itself served the political interests of both China and the Kuomintang to check, as mentioned earlier, "One China, One Taiwan".

The essence of Kuomintang-China collaboration was best outlined in the scoop by the British journal *Observer* dated August 11, 1962:

1. Neither side will launch fierce attack while Chiang Kai-shek is alive;

2. After Chiang's death, the Chiang family will work out details with China; Taiwan will remain under the rule of the Kuomintang but will be made in formality an autonomous region of China;

3. A decade or two later, national referendum should determine

whether Taiwan will secede and declare independence or be part of China; and

4. Meanwhile, Kinmen and Amoy on the other side will be administrative buffer zones accessible from both Taiwan and China.

The Kuomintang categorically denies the rumor each time it spreads out for fear of alerting the democratic camp. But, it is no surprise to those who know well the Chinese. The two collaboration attempts with the Chinese communists, a secret peace mission sent during the Sino-Japanese War, Chou Fo-hai of the Wang Chao-ming regime in constant touch with the Kuomintag in Chung-ch'ing—all these moves are still vivid in memory. Further, vice president of the People's Republic of China, Soong Ching-ling, and Chiang Kai-shek's wife, Soong May-ling, are sisters; more often than not, parents and brothers live apart, so do relatives and friends—blood is thicker than water. Of course, there is always Hong Kong to provide perfect contact points.

Thirty years of anti-communist campaign cannot be completely reversed overnight, some might argue. Let it suffice to say that the good and evil of communism is but a piece of glass accessory before the tradition of Sinocentrism. The recent antagonism between the Soviet Union and China is rooted in the conflict of nationalisms; quite a few of the Chinese refugees in Taiwan must at heart applaud China for having enhanced Sinocentrism.

Chapter 8

FROM 1960's to 1970's
—1964 ~

黄文雄除暴義舉專刊

台湾青年

114

"Let me stand up like a Taiwanese!"

1. Harassed from Within and Without

A certain high-ranking Chinese official is said to have confided: "We are in the theater without admission tickets, so to speak, constantly nervous when they come and drag us out."—an episode vividly depicting the psychology of the Kuomintang regime. And that was exactly the way the Kuomintang must have survived the days in the first half of the 1960's.

In the fall of 1962 onward, China stepped up its maneuvers toward Japan, signing the well-known LT traded pact on November 9. On August 20, 1963, the Ikeda cabinet startled the Kuomintang by approving deferred-payment export of a polyvinyl plant to China.

The Kuomintang had counted on the United States pressurizing Japan on the matter while trying to induce Kurashiki Rayon's vinylon plant through the office of the Japan-Republic of China Cooperation Promotion Committee[1] . The negotiations were momentarily suspended for reasons of technical complications. Then the "communist bandits" sneaked in to outwit the Kuomintang. Put out of countenance, the Kuomintang now had another pounding headache — the likelihood of Japan having decided to recognize the Chinese communists.

The Kuomintang resorted to every means available to condemn the Ikeda cabinet; they recalled their ambassador to Japan, Chang Li-sheng, to imply their readiness to break-off diplomatic relations with Japan.

While impatiently waiting for Japan's response, the Kuomintang learned with joy of an incident breaking out on October 7: a member of China's hydraulic machinery mission, Chou Hung-ch'ing, disappeared on the eve of his scheduled return to China. Chou said once

..............................

[1] Installed in April, 1957.

he would come to Taiwan but changed his mind the next moment alternately either to stay in Japan or to return to China. Perplexed, the Japanese government eventually deported Chou to China.

The Kuomintang humiliated itself and, as if to vindicate its honor, boosted its criticism of Japan blaming the Ikeda cabinet for "repaying a debt of gratitude with infidelity". The Japanese embassy and the ambassador's residence in Taipei were surrounded by Kuomintang-recruited demonstrators who threw stones and used violence in protest—all portraying the degree of exasperation on the part of the Kuomintang.

At the turn of the year 1964 came the news of France's move to recognize China; out of curiosity, the entire world turned to the Kuomintang. De Gaulle's style of diplomacy was gaining support the world over and had already exerted some influence among the Brazzaville states in Africa.

France formally recognized China on January 27 but stated that it had no intention of severing relations with the Kuomintang—a blatant indication of its "Two Chinas" policy.

The Kuomintang waited briefly till February 10 to break off relations with France. For the Kuomintang whose national policy had unshakably been never to breathe the same air with the Chinese communists, the two-week interval was unprecedented. During the two agonizing weeks, the Kuomintang wracked its brains out to review its overall foreign policy. The Chinese nationalists concluded the only means of survival would be to continue dodging the notion of "Two Chinas" and to maintain peace with Japan. At that critical moment came an opportune offer from Japan to break the stalemate and to help save the face of the Kuomintang. The Kuomintang was thenceforth to survive at Japan's mercy.

On February 23, former Prime Minister Yoshida of Japan shot a joke "how about sun bathing" and visited Taiwan, where he met and talked with Chiang Kai-shek and Ch'en Ch'eng three times.

Yoshida is said to have persuaded Chiang Kai-shek not to bluff about his counterattack plan and instead to create a "realm of peace and prosperity" in Taiwan. Yoshida stressed that the Soviet Union and China should be kept apart, that advanced economic relations between the free camp and China would not necessarily strengthen China's communist regime, and that Japan would offer him a yen-based credit and extend further economic cooperation.[2]

Chiang Kai-shek reportedly fought back on the first point but Yoshida kept grinning ironically. In May, the so-called Yoshida Letter was delivered, in which Yoshida promised Chiang Kai-shek not to use government funds via the Export and Import Bank to subsidize long-term exports to China. A piece of compromise by the Japanese government thus settled the deal. In June, a new ambassador, Wei Tao-ming [3], was appointed and the bilateral relations were restored.

The year 1964 saw the Kuomintang regime roughly rocked within for three times by the Taiwanese and enlightened Chinese.

In the fifth elections of mayors and county heads held late April, the Kuomintang suffered setbacks in 4 of the 21 electorates including the City of Taipei, where the Kuomintang candidate, a Taiwanese incumbent mayor Chou Pai-lien, bowed to a non-affiliated candidate Kao Yu-shu.

The Kuomintang employed its usual insidious means to interfere with the elections. But, the public support for Kao boosted so rap-

2 See *Around the Republic of China's International Relations* by Shinkichi Eto, published by the University of Tokyo Press, March, 1967.

3 Refer to first paragraph of Section 4, Chapter 7.

idly that the Kuomintang had to hold off its election campaigns. A tourist confided in the author that the day of ballot-counting was in some state of excitement reminiscent of the eve of the 2.28 Rebellion. The excitement that engulfed the Taiwanese that day was not unrelated to the harassment that had assaulted the Kuomintang from without. France, with all her influence, having recognized China and the Kuomintang having jeopardized its relations with Japan, the Taiwanese sensed that the Kuomintang' days were numbered.

In September, an incident broke out involving P'eng Ming-min, a PhD, at Taiwan University. Professor P'eng, an internationally renowned authority on space law, was arrested on charge of preparing propaganda materials professing his conviction to the intellectuals at large that there was no alternative left for the Taiwanese as well as the Chinese but to reject the Kuomintang and declare independence of Taiwan. The arrest of a man of his caliber came a shock at home and abroad.

The P'eng Incident took a dramatic turn afterwards, as discussed in the subsequent section [4].

At the climax of the Tokyo Olympics in 1964 reached Taipei on October 16 the devastating news of China's successful nuclear bomb test. That was another fatal blow to the Kuomintang regime. Everybody believed that the fantasy of "Counterattack" on the mainland was done away with for good. The Kuomintang's party organ, *The Central Daily News*, ridiculously commented that nuclear science was no longer secret today and the nuclear test of the "communist bandits" would be of no immediate military value. What worried the Kuomintang the most was whether or not the outcome of the communists' nuclear test would have a landslide effect on the already precari-

..............................

4 See Section 4, this chapter.

ous question of Chinese representation in the United Nations.

On December 17, Ts'ao Te-hsuan, a member of the Control Yuan, published in the *Independence Evening Daily* an article entitled "Do Away with Hypocrisy and Dishonesty", in which an enlightened Chinese friend of Lei Chen's[5] boldly advised the Kuomintang to adopt a "Two Chinas" policy. The article drew the attention of the Japanese media [6]:

"Before and after the Korean War we objected to the notion of 'Two Chinas' to our advantage. Because, all Western nations regarded the People's Republic of China an aggressor.

Now, the international political climate has changed. France has openly recognized 'communist bandits'; Japan, West Germany, Canada, Italy and other countries are trading with them and building harmonious relations with their country. In a practical sense, those nations have recognized Communist China.

Further, Communist China has just succeeded in their nuclear test. The event is significant in the sense that the United States is now inclined to change its China policy to recognizing the communist bandits. That is why the communist bandits now avail themselves of this golden opportunity to oppose 'Two Chinas', because it is now Taiwan's turn to be rejected.

The communist bandits were denied entry successively in the 17th and 18th sessions of the UN General Assembly, but the situation might possibly reverse in the forthcoming session. Naturally, we ought to go on striving to prevent the communist bandits from

......................................

5 See Section 11, Chapter 7.
6 February 8, 1965, the *Asahi Shimbun* and February 14 issue of the *Asahi Journal*.

entering the United Nations; but we ought to be prepared to draw a step back. We should never let a fit of anger lead us to any rash act, much less to walk out of the United Nations."

The Kuomintang was furious and dismissed Ts'ao Te-hsuan to once again silence the voice of enlightened Chinese.

2. The Vietnam War and the Cultural Revolution

A war in Vietnam, or the "Second Korean War", broke out to salvage the Kuomintang. A skirmish in the Tonkin Gulf in September 1964 developed into major hostilities in Vietnam. The following year 1965, the United States bombed North Vietnam on February 7 and deployed in the summer huge troops of 100 thousand.

The Kuomintang was overjoyed at the development in Vietnam and the United States' active war strategy. They held their breath and watched the fantasy of counterattack on the mainland reviving. When a New York journal proposed an attack on the Hainan Island, the pro-Kuomintang newspapers reacted as if a substantial strategy for a counterattack on the mainland had been mapped out. The Kuomintang had all the newspapers publish a common editorial:

"We Kuomintang troops will launch an initial attack on the Hainan Island; then the US troops advance into North Vietnam and support our troops to land on the mainland. We will then assault and destroy the communists' nuclear facilities."

However, the United States had no intention of blowing up the hostilities onto the mainland. The Kuomintang was disappointed but

never gave up. The Kuomintang appealed to the United States for permission to send its troops to Vietnam. The United States, however, declined the "generous offer"; Chiang Kai-shek then invited Vietnam's Prime Minister Nguyen Cao Ky to Taiwan. He told the Vietnamese leader his intention to send his troops to Vietnam. But of course Nguyen could hardly accept such an offer on his own initiative.

The United States solicited dispatch of troops from Korea and the Philippines at its expense. However, the United States adamantly declined the Kuomintang's repeated offer of troops for two reasons: one, the US was reluctant to harden Communist China and; two, they knew a debt to the Kuomintang at that point would backfire later on. The US decision not to involve the Kuomintang in Vietnam was quite in agreement with the stance of most countries of the free camp, that is to say, not to get involved with the Kuomintang.

The Kuomintang, however, hoped against hope for escalation of the hostilities in Vietnam. The irony was that escalating hostilities in Vietnam prompted US Congress to totally review the US's China policy. The once buoyant China lobby had waned and the Kuomintang was forced to fluster in the position of the accused.

On March 16, 1966, Secretary of State Dean Rusk proposed in his testimony before U.S. House Committee on Foreign Affairs an epoch-making policy toward the People's Republic of China: "Containment without Isolation."

The proposal comprises ten items. Items 1 to 4 stipulated for aids to be offered to the Asian countries under threats from the People's Republic of China and confirmed a policy of containment with assurance for Taiwan's defense and its seat in the United Nations. In items 5 through 10, the United States underlined its open policy toward China and openly made clear that the United States had no intention

of attacking China, stressing the need of formal as well as informal diplomatic contacts with China.

The US policy of "containment without isolation" met an immediate rebuff from both Communist China and the Kuomintang, but the international community welcomed it as a wise alternative.

In fact, the Kuomintang flared up more at the statements made, prior to the Rusk statement, at a Senate hearing by such eminent experts on China as A. Doak Barnett, John K. Fairbank, Donald S. Zagoria, Robert A. Scalapino, etc. They had professed each in his own words that the United States should support the principle of national self-determination.

All Kuomintang-affiliated newspapers categorically denounced the views expressed by the experts as "defeatism", "vicious neo-isolationism", "superficial fallacy", "fallacious arguments of the leftists", and so on.[7]

Then, an event cropped up to save the Kuomintang.

In November 1965, Yao Wen-yuan published an essay to criticize Wu Han's *Hai Rui Dismissed from Office*. That piece of writing triggered a major revolutionary movement in China—what was to shock the world from the summer of 1966 onwards: the Cultural Revolution. It was thunderclap for the Kuomintang which had long boasted of its thorough knowledge of all happenings in the Chinese continent.

The Cultural Revolution certainly furnished the Kuomintang a piece of golden propaganda ammunition. In July, 1967, Ambassador

7 See *US Taiwan Policy* by Tanaka Naokichi and Tai T'ien-chao, published by Kajima Publication, May 1968 and *US Policy Concerning the People's Republic of China*, Vols. I and II translated by Nozue Kenzo, published by Institute of Japan International Studies, December 1966.

Chou Shu-k'ai grandly claimed that by September or October the People's Republic of China should have vanished "from the surface of the earth". It seems as though the Kuomintang was dead certain that the communist Chinese regime would disintegrate from within and collapse soon enough.

But, the Chiangs, father and son, made a laughing stock of themselves in Hong Kong as they appealed to the anti-communist forces on the mainland that "if they cooperate with the Kuomintang, reinforcements will rush in within six hours".

Having insisted over a decade on its legitimacy as the authentic government ruling the whole of China, the Kuomintang could not seize that opportunity of a lifetime to take prompt action. Instead, they naively waited for some power to emerge in the mainland to receive them and oddly made empty promises to send troops to neighboring countries, etc. The Kuomintang simply revealed their true character.

Far from falling into the bottomless pit, Communist China somehow managed to survive the Cultural Revolution and regained its confidence. It was obvious to everyone's eye that a counterattack on the mainland was an unfinished dream after all.

Yet, it is true that the Vietnamese War and China's Cultural Revolution did help, though momentarily, strengthen the basis of the Kuomintang.

The Kuomintang first screamed to counterattack the mainland but, even though the United States had backed them up, they could not have done any better than dispatching troops to Vietnam.

The Kuomintang's armed forces are roughly the same in size as South Korea's. Should they send troops to Vietnam, they would operate more or less the same way as South Korea—a couple of divisions at most. But then, the Kuomintang forces could hardly match the

Korean troops in morale and combat potential—not that the Taiwan-
ese soldiers are lesser than the Koreans but that the Taiwanese are not
in a position to fight earnestly in Vietnam. The Kuomintang aside,
the Taiwanese soldiers would find themselves in a cruel predicament.
It was proper of the United States to have rejected the Kuomintang's
offer of troops; it was fortunate for the Taiwanese that the United
States had done so.

The Kuomintang criticized the US policy of "containment with-
out isolation" as an appeasement policy toward Communist China
but they must have felt relieved to learn that the United States had
recognized its presence and promised to retain its seat in the United
Nations.

Meanwhile, the Cultural Revolution has damaged the prestige of
Communist Chinese regime. The whole world has learned that Com-
munist China is a mysterious country, a country capable of doing
anything it pleases. The Kuomintang has, as it were, scored a point
on the opponent's error.

Further, one cannot ignore the fact that the free camp has
strengthened its solidarity in the process, while the communist bloc
has suffered a grave setback. Japan and South Korea signed a treaty in
June 1965 and a ministerial conference was successfully held encom-
passing the entire Asia-Pacific region, while a coup d'etat of February
1965 nulled the Asia-African foreign ministers' conference in Algeria;
a communist revolt in Indonesia in September 1965 failed and Su-
karno regime collapsed. The irony is that the whole chain of events
indirectly helped Kuomintang consolidate its position.

True, the Kuomintang regime has strengthen its psychological
backbone as the outcome of the Cultural Revolution has taught the
Chinese under their rule that the continent is no longer what it was

before and that a better future awaits in Taiwan.

The contradiction is that the Kuomintang cannot quite rejoice exuberantly over the turn of events. Such a psychology does not tally with the Kuomintang's authentic slogans of "legitimate China" and "counterattack on the mainland". The Kuomintang can no longer spur on these Chinese; rather, these Chinese will some day tear the Kuomintang apart.

The biggest contribution of the Vietnam War was a "special procurement boom" it had brought the Kuomintang. The so-called Vietnam War boom boosted their trade and trade-related revenues to US$200 million in 1967 and stabilized the economy. With the full-scale advance of Japanese capital in and after 1965, Taiwan's economy was fast changing its features, and the Vietnam boom now added to the momentum and entirely changed the structure of the Taiwanese economy.

3. The Advance of Japanese Capital in Taiwan

As Japanese passengers approach Taipei onboard a jet from Haneda, the stewardesses will remind them that Japanese newspapers and magazines be banned in Taiwan.

But, en route from Song-shan Airport to downtown Taipei, they will find through the cab windows nothing but cars, buses, taxies and motorcycles either Japan-made or jointly manufactured. Along the streets, they will see on the billboards familiar Japanese products from television, fridges to vitamin pills. The number of Japanese tourists to Taiwan is increasing by the year: 103 thousand spending US$15 million (1968)[8] . They will find to their astonishment a copy of To-

......................................

8 [Over 1.6 million Japanese tourists visited Taiwan in 2014.]

kyo's gayest nightspot in Taipei, the capital of supposedly Chiang Kai-shek's sacred bastion of anti-communism. They will enjoy every minute of the "Night in Taipei" to the accompaniment of "kuniangs" or pretty girls, just as reported in popular magazines.

The Kuomintang has over the past two decades tried hard to eliminate residual traces of Japan. They had wiped out Japan's old power and interests and now wanted to cleanse the last smell of Japanese culture off Taiwan.

The Kuomintang's real aim, however, was clearly elsewhere. As a New York correspondent Fox Butterfield put it, the Kuomintang was motivated by militarism on one hand but, on the other, they were driven by an urge to thoroughly control the Taiwanese.[9]

Nevertheless, the Kuomintang could not succeed to make that happen, as the Taiwanese, in passive resistance against their oppression, chose to consistently favor Japan and cling closer to things Japanese. Some Americans say half out of jealousy that Japanese capital made its way into Taiwan in late 1960's partly because Japan had had a favorable investment environment ready in Taiwan to begin with.

Needless to say, Japan's capital advance was motivated by more sophisticated reasons. The Kuomintang in the 1950's was dependent entirely on the US military-financial aids. The United States had given out a total of US$1.4 billion of financial aid until it was terminated in June 1965, the largest per capita aid ever given out by the United States. [10]

It was the US aid that provided weapons to the Kuomintang, covered trade deficit, built schools, and helped build basic industries, road

9 *New York Times*, September 28, 1969.

10 US$9.7 to the Kuomintang; US$2.00 to the Philippines and US$1.30 to Thailand.

network, bridges, dams, harbors and sewage systems and what not.

Had it not been for the huge US aid, the Kuomintang could not have existed; but it was the US aid that made them overdependent on the US. The Kuomintang had grown to believe that the US was obliged to help them fight the Chinese communists and to cover the balance of costs needed to sustain their effort. The Kuomintang argued that Taiwan was not big enough and needed to "recover" the mainland to stand on their own feet.

In early 1960's, the US balance of payments waned and its financial aids drastically changed. Now the government's give-away aids made way for direct private investments. In 1962, the US give-away aids were officially cut off and development aids and grants were trimmed down. The Kuomintang followed the US advice to enact the "Statute for the Encouragement of Investment" (September 1960) and installed a "Council for International Economic Cooperation and Development" to improve investment environment.

The United States then made its first investment in Taiwan as the two US private corporations, Socony Mobil Oil and Allied Chemical Corporation, established jointly with China Petroleum a plant at Hsin-chu to produce uric acid fertilizer products on the guarantee of both the US government and the Kuomintang.

That investment, however, was not expected to be profitable; it was a political measure to cheer up the Kuomintang in Taiwan and a lure to induce Japanese capital.

The new US policy met resistance in Taiwan; the Kuomintang wanted only give-away aids, not capital investments that could potentially entail "economic invasion" common in most emerging countries. That was why the Kuomintang suddenly in the spring of 1962 began clamoring a counterattack on the mainland and their relations

with the United States aggravated.

The turmoil subsided but the policy of introducing foreign capital never materialized. As earlier pointed out, the relations with Japan cooled off over the period 1963-64.

It was only after former Prime Minister Yoshida's promise materialized in a loan to the tune of US$150 million in April 1965 that Japanese industrialists and traders turned their attention squarely to Taiwan.

Into the 1960's, Japan's economy expanded in size and industries faced shortage of manpower and ever-rising wages. They turned to Taiwan for high-quality manpower. The Kuomintang had over time banned labor disputes, kept wages low and minimized regulating working hours. Taiwan was, therefore, an attractive manpower market for Japanese corporations.

Japanese products had already infiltrated into Taiwan over the high tariffs and strict import regulations. Aware of the limits of such frontal breakthrough tactics, Japanese entrepreneurs switched to expanding and maintaining an export market in Taiwan by installing joint ventures, taking advantage of the Kuomintang's policy of inducing foreign investments. The Japanese entrepreneurs deliberately handpicked Taiwanese as their partners for joint ventures.

Naturally, the upcoming preferential tariffs helped prompt Japan's investment drive. If preferential tariffs were to apply to all export commodities from developing countries to advanced countries, Japanese industries could and would find ways to enjoy the benefits of such tariffs through its joint ventures in Taiwan.

Japanese corporations advanced in Taiwan first with electric home appliances and pharmaceuticals and then textiles, foodstuffs, papers, etc. Resistors, precision coils, electronics, machinery parts etc. fol-

lowed suit. Tools and other production materials also advanced in Taiwan. Japan first targeted the home market but now gradually shifted to the third countries.

In early 1970's, a total of 307 cases worth US$63 million, investment (in cash, goods, technology and patents) and loans put together, were approved (end 1969) mostly for joint ventures. The share of Japanese capital is 50% or thereabouts. The total amount should run up far larger, as the machinery and equipment imported from Japan are deliberately undervalued and shares are acquired accordingly.

As more joint ventures emerge in Taiwan, Japanese trading companies are now gaining their control over Taiwan's trade activities. Textiles, for instance, top all exports from Taiwan to Japan amounting to some US$200 million, of which 60% to 80% are handled by Japanese trading firms. Sugar, rice, pineapples are things of the past.

Basically, the state-owned Central Trust Bureau has monopolized the Kuomintang's trade activities. But, if left in the hands of the bureaucrats who only practice jobbery, Taiwan would never survive the harsh international trade war. So the Kuomintang reluctantly approved such joint ventures just in order to earn much needed foreign currency.

Taiwan's gross trade in 1969 aggregated US$2.315 billion, of which exports US$1.110 billion and imports US$1.250 billion, respectively. The deficits ran up to US$100 million, which had to be covered somehow.

The exports comprised US$400 million worth to the United States and US$180 million to Japan, while the imports US$340 million worth from the United States and US$500 million worth from Japan. There obviously was a huge trade deficit against Japan.

Naturally, the Kuomintang detests Japan's trade offensive of such magnitude but had to lean on Japan, because the Unites States had

an Asian policy of its own to have Japan share the responsibilities and also because no immediate way out was in sight for Taiwan to rejuvenate itself. But then, the Kuomintang has in store a crafty design in mind. The closer are Japan's relations with Taiwan, the tighter the ropes around the Japanese financiers. That should help prevent Japan from approaching Communist China, figures the Kuomintang.

Sure enough, it looks as though Japan's capital investments are taken hostage by the Kuomintang. It is true that the Japanese politicians and financiers have been reluctant to expand Japan's trade with Communist China out of consideration for capital investments so far made in Taiwan.

In all fairness, this is a meaningful observation. The both markets, Communist China and Taiwan, are there for Japan to access not singly but simultaneously. The Chinese market is definitely larger in size and more tempting, but in terms of the current volume of trade it is slightly smaller than Taiwan.[11] Besides, the difference in political system between Japan and Communist China and the reality of a rivalry between the two split in the opposing camps makes it unlikely for Japan's "dream in the continental market" to ever come true as would a kids' balloon inflate.

Now, the Kuomintang's policy of inducing foreign investments is, as a Chinese saying that goes, to "drink poison to quench thirst"; it serves to corrode its despotic system from within and inevitably create another greater contradiction.

The basic concept of the Kuomintang's economic policy is rooted in Sun Yat-sen's theory of national livelihood built on two pillars, namely "equalization of land rights" and "regulation of capital".

..................................

11 Japan-China approximately US$630 million; Japan-Taiwan US$780 million in 1969.

Equalization of land rights, or a land reform, was initiated after the Kuomintang's flight into Taiwan and carried out by stages till it was provisionally completed in 1953.[12] Regulation of capital was implemented after Ch'en Yi took over the power.

"Regulation of capital" means promoting state capital while restraining private capital; that is to say, it is a call for regulated economy in place of free economy based on Sun's humanitarianism. Sun's concept was later tailored by Chiang Kai-shek's Kuomintang to his own temperament, namely a total monopoly of capital by the "four grand family cliques". Taiwan's capital, both state and party, was fed into a machinery owned and operated privately by the party leadership.

In Taiwan, Kuomintang party leaders disputed over the ownership of banks, major industries, and land, and eventually put them all under the party factions on the pretext of state-owned, province-owned and party-owned establishments.

This pulled the legs of Taiwan's economy on the whole, but by so doing the Kuomintang maintained for the Chinese refugees food, clothing and shelter and wielded absolute power over the Taiwanese.

Yet, the Kuomintang's capital-inducing policy and its export-oriented economic policy or what one might call an "island economy" are doomed to undermine its policy of nationalization and controlled economy. And any change in the lower structure will inevitably change the upper structure as well.

Despite certain frictions arising in the course of competition between joint ventures and local industries, Taiwan's private enterprises are flourishing to help boost the Taiwanese political presence. So much so that Chiang Ching-kuo had to promote talented Taiwanese and

..

12 See Section 7, Chapter 7.

send Taiwanese entrepreneurs, though only a few, into the Kuomintang's central committee to sit with Chinese economic bureaucrats.

Taiwan's politics and society stand at a grave crossroad today. Wealth is ill distributed; the disparity between the rich and the poor is widening. This goes for the Chinese and Taiwanese alike and presents a new, complex problem.

The state revenue depends on indirect taxes and the income is not redistributed in the absence of social security system. It is, therefore, hopeless to rectify the existing mal-distribution of wealth. The unemployed flood the island; the workers are exploited without any labor legislation to protect them; most farmers are forever poverty-stricken. Those young Taiwanese women who devotedly "serve" the Japanese are mostly sold off from local villages. *The Credit News* reported on September 25, 1965 the story of a 16-year-old girl who was sold to a brothel for NT$36,000—a sad story indeed but it is only one of many.

In Taiwan today some important issues await immediate attention of the Kuomintang: intensive public investment, anti-pollution measures, uplifting the level of education, etc. etc. However, the Kuomintang cannot afford to handle any of them. Claiming to be the "legitimate Chinese government" and clamoring a "counterattack on the mainland", the Kuomintang must maintain its complex government system, its huge military machinery and intricate secret service network. All that requires funds; the Kuomintang puts aside for that exercise 85% of the central government budget or 50% of total government budget, central and provincial put together, to the tune of US$300 million (1968).

On top of that, the Kuomintang must achieve trade-based national development. What a contradiction! How long can this grand contradiction be covered up?

4. Chiang Ching-kuo and the P'eng Ming-min Incident

In March 1965, Ch'en Ch'eng died of liver cancer at age 67. His death meant a door opened for "Prince Chiang", or Chiang Ching-kuo, son and heir of Chiang kai-shek, to smoothly succeed his father's "throne".

In March 1966, Chiang Kai-shek assumed presidency for the fourth time for a 6-year term. Yen Chia-kan[13] was elected vice president and concurrently premier by a close margin. Elderly Chang Chun and Sun K'e were favored choices but young Yen was elected reportedly because Chiang Ching-kuo needed someone easy to manipulate.

Chiang Ching-kuo was born in 1906 and served the offices of defence (1965) and vice premier (1969); now, he is ready to ascend to the throne.

However, Chiang Ching-kuo carries with him a gruesome image of a Soviet-trained ex-communist and the big shot of the secret police. He tried hard to shake off the image by making frequent visits to the United States, Japan, Korea and Thailand, stretching his awkward bull neck and beaming at everyone in sight. An eminent political critic snapped out to the author that the Japanese feel indebted to Chiang Kai-shek for his favors extended right after the war, but his son Chiang Ching-kuo is a total stranger.

At home, Chiang Ching-kuo sorted out the economic bureaucrats of Ch'en Ch'eng's faction, retained some and dismissed others; he faked compromises to the Taiwanese to give an impression of an "enlightened prince".

But then, like the earlier mentioned Japanese critic, the Taiwanese are not yet bewitched.

13 Born in Chiang-su in 1905.

On October 23, 1964, the Garrison command arrested on charge of treason Professor of Law P'eng Ming-min of the National Taiwan University and his students, Hsieh Ts'ung-min, 32-year-old editor of the *Today's China* and Wei T'ing-chao, 29-year-old assistant at Academia Sinica. This news shocked all at home and abroad.

They were arrested a month before, on September 20. A certain American resident in Taiwan was alarmed at Professor P'eng's disappearance and immediately informed universities and scholars in the West. The news flew fast and began to assume serious proportions, finally to a point where the Kuomintang could no longer shove it off into darkness as many other cases.

Professor P'eng Ming-min was born in 1923 at Feng-shan, educated at the Tokyo Imperial University and Taiwan University. He further studied in Canada and France, where he obtained a PhD in law. He was appointed chairman of the Political Science Department at National Taiwan University.

An eminent scholar of international space law, Professor P'eng was made a propaganda tool of the Kuomintang targeting the United States. He was appointed advisor to the UN delegation in 1961 and representative of US-Taiwan Science Education Committee. The Kuomintang exhibited him as a live testimony of its pro-Taiwanese stance. Chiang Ching-kuo publicly commended him one of the "model youths".

Why was a model youth P'eng Ming-min arrested on charge of trea-

P'eng Ming-min

son? As his arrest was officially made public, there had to be an open public trial. In March 1965, the military court revealed that the three had prepared a propaganda pamphlet titled "Declaration of Formosan Self-Salvation" and was about to distribute the pamphlet in the name of the "Formosan Self-Salvation Alliance".

The 2800-word Manifesto states in the outset that "One China and One Taiwan" is an indisputable fact and denounces the Kuomintang's claim of the "legitimate government of China". The manifesto goes on to expound that "the counterattack on the mainland" is absolutely impossible and analyzes the psychology of the Chinese and Taiwanese soldiers as follows:

> "It is incorrect to say that the Chinese who came from the Chinese continent earnestly aspire to return home and that they would do whatever Chiang Kai-shek dictates.
> ...All Chinese nationalists who have lived a century of humiliation under the threat of foreign powers takes pride in the strength of Communist China today and are convinced that it is something the corrupt, incompetent regime of Chiang Kai-shek can never achieve.
> For whom and for what do they fight?
> ...Young Taiwanese draftees all remember how more than 20,000 Taiwanese leaders were massacred in the 2.28 Rebellion; they harbor enmity against the Kuomintang; and, though completely wordless, they forever remain 'silent enemies' of Chiang Kai-shek.
> ...Their uniforms cover their inner thoughts, but they cannot possible regard the burglar their own father; they cannot be made to move at Chiang' will."

The manifesto proposes three-point goals and eight-point principles to appeal to the 12 million islanders in Taiwan, regardless of origin, to join force in earnest in building anew a democratic nation that strives to contribute its share to world peace as a member of the free world.

The manifesto concludes:

"For several decades, China has lived with only two criteria of value: one, an ultra-rightist criteria of the Kuomintang and, two, one of the communist party far to the left. Wisdom was buried deep and never manifested. We must rid ourselves of the shackle of these two criteria of value and stand independent of either regime. We must construct a third road of our own in Taiwan, neither the Kuomintang nor the communist party but a regime of our own conceived on the concept of self-salvation."

The military court examined evidence in only one day and, on April 2, sentenced the drafter of the declaration, Hsieh, to 10 years' imprisonment on charge of treason and P'eng and Wei to 8 years on the same charge.

The Kuomintang would have hoped to hang them all but applied lighter sentences out of regard to public feelings. Yet, the international community strongly condemned the verdict an "inhuman oppression of the freedom of speech". In November, 1965, Chiang Kai-shek pardoned P'eng and halved the terms of Hsieh and Wei.

P'eng was pardoned but not permitted to resume his classes at the university. He was put under semi-house arrest at his home in Taipei (AP report).

To say that international reactions alone pardoned P'eng is likely

to view only one side of the truth.

A month and half prior to the military court in March, Chiang Ching-kuo had hosted an unprecedented event, inviting all members of the provincial assembly to view the armed forces for three full days. The assembly members are mostly Taiwanese and so are most combat troops. The event was thus Chiang's way of placation to calm down the Taiwanese populate in the aftermath of the P'eng Incident.

In May that year, "President of the Temporary Government" Liao Wen-i flew from Tokyo alone to Taipei and surrendered to the Kuomintang. The Kuomintang was overjoyed. Liao was assured of his life and freedom; his confiscated assets were immediately returned to him—another episode of the Kuomintang's benevolence performed to impress on the international community.

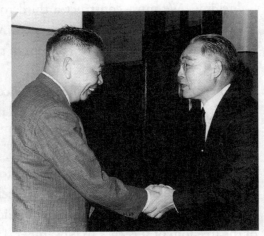

Liao Wen-i (right) surrendered to the Kuomintang

Liao's surrender was evidently a point scored by the Kuomintang secret agents. The Taiwanese students and residents had left him and his "temporary government" and Liao was deep in despair. He was craftily talked into surrendering by the secret agents.

His surrender did serve to muffle the reputation of overseas independence movements. But, it worked just the opposite way within the island.

Provincial assemblymen Li Ch'iu-yuan (elected from Taipei Coun-

ty), Kuo Yu-hsin [14] and Hsu Shih-hsien (female, elected from Chia-yi City) demanded the government: "If Liao was pardoned for actually participating in independence movement, why not P'eng who merely printed propaganda materials?"

What Hsu Shih-hsien said of P'eng's "pardon" is suggestive: "The government's generous measure is quite in tune with the time."[15]

It is worthy of note that in the spring of 1966, the year Chiang Kai-shek was elected president for the fourth time, Ch'en Chung-kuang[16] and a group of some 40 provincial assemblymen jointly signed a proposal to demand reelection of the "representatives of public consensus"[17] who had stayed on for 19 years. It was an indirect challenge to the Kuomintang's political system by the Taiwanese members of the provincial assembly who had grown increasingly daring over time.

On January 23 of this year, 1970, the Taiwan Independence Alliance announced through its chapters in the United States, Japan, Canada, and Europe (West Germany) that P'eng Ming-min had succeeded in getting out of Taiwan and safely settled in the place of exile. The news aroused a sensation the world over.

The Taiwan Independence Alliance[18] was formally inaugurated on January 15 with five regional headquarters including Taiwan under its general headquarters in New York. Ts'ai T'ung-jung (Trong Chai) was appointed to lead the general headquarters; Ku K'uan-min

.............................

14 Refer to paragraph 6, Section 10, Chapter 7.

15 See *Autonomy*, Vol. 148, published on November 16, 1965.

16 Born in 1912, elected from Taipei City.

17 Over 3,000 of the members of the National Assembly, 400 odd Legislative Yuan members and some 100 Control Yuan members.

18 Latter-day of the Taiwan Youth Society.

the Japan headquarters, Lin Che-fu Canada; Chien Shih-k'un Europe and Ch'iu I-fa Taiwan, respectively.

In the 1960's, students primarily took the initiative in carrying on overseas independence movement in various places [19]. But, the arrest of P'eng Ming-min prompted a tide to unite the movement. Most of them were P'eng's students.

The Kuomintang's Central News Agency reported on January 24, the day they learned P'eng had chosen Sweden for the first place of exile that "P'eng has joined the treacherous organization".

P'eng's flight from Taiwan has a dual political meaning: one, that P'eng safely got out of Taiwan in spite of his obvious physical features—he had lost his left arm in an air raid in Japan—which evidenced that the underground network for the independence movement was already so well knit that some even suspected "certain outside force" could have assisted his escape [20]; two, people were made to suspect that the situation in Taiwan must be pressing, enough for P'eng to run the risk of being shot to death when exposed.

P'eng Ming-min told Robert J. Korengold in his interview in the February issue of the *Newsweek*:

"Give me one month for free talk, and I will overthrow the Chiang regime without fail", he said calmly and assuredly. "Anyone can do that if only given freedom to speak rationally. Let people ask to themselves: Whom does the present government represent? That is enough. This government is not that of China, much less of the Taiwanese", he said. He went on to say, "If I am to exert any influence

..

19 Refer to the last few paragraphs, Section 12, Chapter 7.

20 The *Tokyo Observer*, February 8. [Engineered exclusively by the Taiwan Independence Alliance in Japan.]

on the future of Taiwan, I must first start changing the policy of the United States. But I cannot do that in Sweden, can I?" His words are strikingly powerful.

On January 13, the Kuomintang briefly announced that P'eng was put on the wanted list and immediately imposed a strict news blackout. Noteworthy at that time was that Communist China took over and repeatedly criticized the "maneuvers of the reactionary governments of the United States and Japan". The Radio Beijing aired on February 2:

> "The US imperialist leader Nixon and the Japanese reactionary government leader Sato Eisaku met last November and ever since they stepped up their criminal act of backing the 'Taiwan Independence Movement'. The reactionary leaders of the United States and Japan are reported to have indiscreetly invited one of the henchmen and one of the leaders of the 'Taiwan Independence Movement', P'eng Ming-min, and are encouraging his activities..."

The *Beijing Weekly* reported in its March 10 issue an article of the same content to betray Communist China's keen interest in this problem.

Communist China's comments are loaded with malicious slanders and only invite sniggers of contempt in informed circles, but one might understand it an evidence of Taiwan's independence movement drawing international attention.

The Japanese government is falsely accused to have instigated the Taiwan independence movement. It is still fresh in memory that in March, 1968, the Japanese government deported to Taiwan a member of the Taiwan Youth for Independence, Liu Wen-ch'ing, aged 33

then, by agreement with the Kuomintang.

However, when Japan and the United States concluded on the return of Okinawa in November 1969 they irritated Communist China by expressing in the communiqué their grave concern over the stability of Taiwan.

Since its commitment to the peace talk in Vietnam in Paris, May 1968, the United States switched its Asia policy in line with the so-called Guam Doctrine. The US 7th Fleet now reduced its mission over the Strait of Taiwan (December 1969) and the US-Communist China talks were resumed—all toward relaxing the tension.

Communist China should welcome such moves of the United States toward relaxation of tension but cannot altogether do so. Why? Because, the road, they suspect, leads to the Kuomintang's natural extinction and, in turn, to Taiwan's independence.

Chiang Ching-kuo is to Chiang Kai-shek, what Lin Piao to Mao Tse-tung: both are nominated successors of dictators. The successors are buoyant in the shade of the dictators; successors are in their best days only while successors. The successors can never inherit the power of the dictators as it is.

Lin Piao is suffering from chronic lung trouble and there is no guarantee he outlives Mao Tse-tung. Likewise, Chiang Ching-kuo is disturbed by a severe case of diabetes and there is no telling he dies before his father. On April 24, 1970, the world was shocked at the news of the visiting Chiang Ching-kuo shot at a New York Hotel by two of the members of the Taiwan Independence Alliance, Huang Wen-hsiung and Cheng Tzu-ts'ai. Terrorist bosses are always the targets of terrorism; the position of dictators is never stable.

CONCLUDING CHAPTER

Taiwan's Independence

Taiwan Youth (1970)

In the previous chapters, the author has briefly traced the history and reality of Taiwan.

The readers have hopefully understood that the history of the Taiwanese is a process of the Taiwanese' desperate struggle for a new world of freedom and happiness, and the reality of Taiwan is far from their ideal.

At one time in the past in the process of their desperate struggle, the Taiwanese sought help from China, a kind of help that we neither should have sought nor could have relied on. Living as we do under the Kuomintang rule, we have learned it in the hardest way.

We Taiwanese are seeking helping hands from the free camp to rid ourselves of the oppressive rule of the Kuomintang. Whenever the Taiwanese speak of the free camp, the first thing that crosses their mind is Japan. A young Taiwanese appeals, thus:

"Having forced the Taiwanese to call Japan their motherland, pay taxes to the Japanese government, sacrifice and abandon hundreds of thousands of lives for its sake, how does Japan look upon the destiny of Taiwan?

At the zenith of its imperial military and naval forces, Japan would have dumped in the Taiwan Strait anything that threatened the interests of the Taiwanese, but now Japan sits back and nonchalantly declares: 'We have abandoned Taiwan; its status is undecided.'

The least Japan can do, whenever the Taiwan problem is up for discussion at the United Nations, is to speak up for the Taiwanese who have no right to speak up and to pay respect to the views of the Taiwanese. Japan ought to contend that it is injustice and inhumane to discuss Taiwan without the presence of the Taiwanese.

If Japan could only show its good faith this way, tens of thousands of Taiwanese youths who died in the South Seas might rest in peace in their graves. My own dear brother was among those who were called by the Emperor to fight for Japan and died in Manila. The dead never come back to life; then, why not in the least that much offering to those left behind?" [1]

The present political atmosphere in Japan is such that there is no knowing how far articles such as this should have any meaningful effect.

However, we Taiwanese shall never give up; we believe someday justice will be done and stir the soul of every man of conscience. So long as the Taiwanese stand steadfast and keep on fighting, the time will come when we win the laurels of victory. Down through the history of man, none of those who had fought for independence ever failed to attain the goal—no matter how long it takes.

Now the both camps confronting at a standstill, it is absolutely impossible to switch allegiance from one to the other. It is far easier to seek change, from under the Kuomintang rule to sovereign independence, within the free camp into which Taiwan is woven today.

The free camp chose to support the Kuomintang at the expense of Taiwanese' freedom and happiness for the grand cause of anti-communism. But then, as discussed at the end of the previous chapter, the Kuomintang's anti-communism is dubious and far from trustworthy.

Some argue that unless the Kuomintang stays intact the overseas Chinese in the Southeast Asia cannot but support Communist China

1 Extracted from "My Idea of Independence" by Nan Chen in the *Taiwan Youth* No.27, February, 1963.

to the detriment of the free camp. This is an absurd, politically disoriented argument with no thought for the psychology of the overseas Chinese.

To begin with, most of the overseas Chinese are no longer Chinese and live in respective countries of their choice. This is a natural consequence of the way they link their interests with those of the land of their residence, just as the Taiwanese gave preference to Taiwan's interests.

The overseas Chinese, therefore, never positively profess support for either China or Taiwan; their clamors of support are all propaganda phrases cobbled up by either side.

Taiwan's independence should help the overseas Chinese assimilate into the host countries and can hardly work against their interests in any way.

As observed so far, support for the Kuomintang is irrational and the Taiwanese appeal to the free camp never to support it. The moment the free camp ceases to support the Kuomintang, the Taiwanese will immediately rise and fight against it.

We must then challenge the free camp to first reduce and eventually cut the support for the Kuomintang. That is why our propaganda maneuvering is most vital.

First, we should see to it that the Kuomintang give up the notion of "Counterattack on the Mainland" and cease to be the "Republic of China". Then, the 2 million Chinese refugees will be thrown into an abyss of confusion and division leading to a coup or major riot. Lastly, the Taiwanese move in to aim at a breakthrough in the situation.

Better still, the Kuomintang can, though most unlikely, give up the whole idea of "Counterattack on the Mainland" and cease to run the Republic of China on its own initiative. The Kuomintang could

then have its military capabilities reduced and the central government and all legs of its machinery; a new process of democratization would then get started in Taiwan—a substantial process toward independence in Taiwan.

Let it not be misunderstood here that the Taiwanese wish the least to continue nursing a hatred toward the 2 million Chinese refugees. Once Taiwan attains independence, we shall let them decide on their courses of action: those who wish to return to the mainland will be offered necessary help; those wishing to stay in Taiwan can either apply for citizenship or remain aliens and enjoy every convenience and protection granted them.

Luckily enough, Taiwan has never been the stage of any war like in Korea and Vietnam. True, Taiwan like these countries is destined to confront communist powers but there is no need to give priority to military maneuvering. By spreading its roots of liberalism and democracy deep into the soil, Taiwan can be a genuinely stable nation.

The old wounds the Kuomintang has left over time must be healed quickly and rationally. A host of problems await us: reduction of the armed forces, demobilization, merging of government organizations, maintenance and improvement of education system, language policy, caring the Chinese refugees, reorganization of various industries, control of population increase, renovation of public morals, etc. etc.

Only after the Taiwanese have endured through the heavy load of obligations can Shangri-La be a genuine reality in Taiwan.

The History of Taiwan since 1970 Onward

ONG MEIRI

This short thesis takes over the history of Taiwan as it was left by my father Ong Iok-tek in his book *Taiwan: A History of Agonies* which was revised by himself and published in 1970. Taiwan has gone through over these 45 years a dramatic period of transition at home and abroad. In 1990, Mr. Takayuki Munakata, a member of the WUFI, co-authored with Ong Iok-tek a book titled *New Taiwan* with an added account of history since 1970. (Ong Iok-tek passed away in 1985.) As political changes since 1990 are equally worthy of note, this thesis briefly traces Taiwan's history from 1970 down to 2014.

Put in a nutshell, major changes in Taiwan since 1970 boil down to two happenings, namely Taiwan's isolation in the international community and its transition at home from a one-party dictatorship to a democratic nationhood.

Taiwan Youth (October 1985), memorial issue for Dr. Ong Iok-tek

Political Changes

I shall hereinafter try to chronologically trace the events in Taiwan, but, to

prelude it, I shall sort out details of elections that took place in Taiwan during that time.

In 1945, the Chinese Nationalist Party (Kuomintang, hereinafter KMT) placed Taiwan under its control and made it a Chinese province named Taiwan Province. In 1949, having lost the civil war against the communists, KMT relocated into Taiwan with two million refugees together with the entire body of government machinery, complete with the whole band of bureaucrats and parliament members as well as provincial government members.

The members of the Legislative Yuan and National Assembly continued to sit in their seats elected to back in 1947 in mainland China and eventually to remain perennial members without election. Should any be deceased, his runner-up in the 1947 election would move up to take his place.

The Taiwanese were restrained in their political activities. On the national level, they were allowed to elect only the portion of the seats allotted to the Province of Taiwan as against the entire Republic of China (hereinafter ROC), and on the local level the Taiwanese were able to elect their members into the Taiwan Provincial Assembly, leaders of prefectures, cities, small cities or towns, and respective assembly members. In some of the contests brave non-nationalists were seen challenging Kuomintang candidates. That had an effect of giving vent to the Taiwanese' political malcontent and eventually of familiarizing them to the election system, paving way to the democratic election that would take place in Taiwan half a century afterwards.

1970-1980: Taiwan's Isolation in International Society

In the 1970's, as the People's Republic of China (hereinafter PRC) opened diplomatic relations with various countries of the world, Tai-

wan was deprived of its diplomatic hands and shut out of international organizations. Ever since then up until this day, Taiwan has survived 40 odd years in total isolation in the international scene.

In October, 1971 the UN Assembly passed the motion of Albanian Resolution and the PRC replaced the ROC (Taiwan) in the UN Security Council. Chiang Kai-shek paid no heed to the advice from Japan and the United States to stay within the general assembly and walked out of the United Nations. That added to Taiwan's international isolation as not only the United Nations but also UNESCO, WHO and all major international bodies had their doors closed to Taiwan.

In the process of all the world's countries recognizing and opening diplomatic relations with the PRC, the Chinese communists instituted the so-called "One China" policy and asked them to close their diplomatic ties with the ROC. The Chiang regime stuck to its fiction of being the "legitimate Chinese government". The countries succumbed and forsook the Chiang regime. Thus, Taiwan was internationally isolated and her people victimized by the strife between the Chinese in the mainland and the Chinese who had fled into Taiwan.

The United States played the game the best way they knew how. They opened, on one hand, diplomatic relations with the Communist China while closing ties with the ROC while, on the other, enacting a domestic law called "Taiwan Relations Act" to keep Taiwan within the family of democratic states. The Taiwan Relations Act respects the governing authorities on Taiwan and obligates in clear terms the United States to defend the people in Taiwan in time of emergency. In other words, the act constitutes the legal basis for the United States' defense of Taiwan.

At home, the reins of government passed from Chiang Kai-shek to his son Ching-kuo but one-party dictatorship persisted and martial

law was there to stay on. But, the KMT had visibly lost its prestige in the face of the rising presence of the PRC and some signs of change began showing in the domestic affairs in Taiwan. The United States, for one, had its human rights drives gradually affecting the Taiwanese populace and the Taiwanese began making their voices heard on various occasions.

Then in August, 1977, the Presbyterian Church in Taiwan issued a Declaration of Human Rights demanding the KMT regime to rebuild Taiwan into one independent state. Such a move would have cost the Church its life, but the KMT dared not suppress it out of consideration for the church's international bondage and critical eyes of the world's countries.

In November 19th that year, a riot, known as Chung-li Incident, broke out amid a local gubernatorial election in Taoyuan Prefecture when an election fraud engineered by the KMT defeated a sure-to-win anti-KMT candidate. The rioters confronted the police; troops were mobilized to control them. Eventually, the soldiers pulled out without firing at the rioters. The KMT would never since resort to the military against public movements.

In August 1979, extra-party (non-KMT) activists inaugurated a Formosa Publishing House in Taipei and published a *Formosa Magazine*. The magazine sold like hotcakes and the publishing houses installed service centers across the island. These centers hosted political meetings.

On December 10, the Human Rights Day, the Formosa Publishing House hosted a memorial rally in Kaohsiung City. Over thirty thousand Taiwanese attended the assembly and the police and military-police units moved in and closed in on the demonstrators. The rally turned a stage of rioting, the police ruthlessly tear-gassing the

demonstrators. Two days later, the authorities arrested over a hundred of those associated with the rally.

The eight most prominent leaders of the rally were tried in military court; one was sentenced to life imprisonment and the rest to 12 to 14 years. The terms were far lenient as the court was held in the open under pressure from the United States where critical voices were heard over the court proceedings. Some ten or so Presbyterian churches people were arrested on charge of hiding the leaders, but they too had to be tried in an open court in deference to churches across the world.

It is worthy to note that from among those associated with the Kaohsiung Incident and out of those who defended them as their lawyers emerged latter-day leaders of Taiwanese politics, namely Ch'en Shui-bian, Hsieh Ch'ang-t'ing, Su Chen-ch'ang, to name a few.

But, then Taiwan needed another decade to become a full-fledged democracy. In a desperate effort to survive its life in isolation in the international community, the KMT put on a show of their "sense of freedom" by freeing passage for the inhabitants and granting the Chinese, who came to Taiwan in post-war years, visits to their old homes in the mainland, while "dealing with" anti-Kuomintang activists in darkness.

On February 28, two months after the Kaohsiung Incident, a brutal incident occurred while Lin I-hsiung, a lawyer and Taiwan provincial assemblyman, was in detention. His mother and twin daughters were massacred and his eldest daughter severely injured at home supposedly under 24-hour police surveillance. The authorities claimed to know nothing about it and no arrest was made. It was no doubt a blood-smeared warning against anti-government movements.

In the mean time, the Taiwan Independence Movement was gaining momentum abroad. A group of Taiwan independence activists

"Taiwan Youth", set up in Tokyo earlier in 1960 by the author of this book Ong Iok-tek and Ng Chiau-tong and other Taiwanese students, had come in contact with various activist groups in the United States, Canada, Europe and Taiwan (underground) and was about to merge in the World Union for Formosan Independence in 1970. These overseas-based movements operated to draw attention to Taiwan problems of not only the Taiwanese in respective host countries but also local sympathizers, thus serving to prepare ground for Taiwan' democratization.

Incidentally, during the two decades from 1960 through 1979, only 6,200 of as many as 52,613 overseas Taiwanese students returned home, according to the Executive Yuan, 1981.

1980-1990: Budding of Democracy

Twelve people who had been arrested on charge of their involvement in the Kaohsiung Incident ran in the by-elections of the Legislative Yuan and National Assembly in December, 1980, and all of them were elected. Never since the end of the war had the Taiwanese public laid hand on politics for fear of being subjected to arrests, imprisonment, and death penalties, but now they dared openly support political prisoners as their heroes.

Yet, the authorities never ceased to suppress anti-government movements nor stopped terrorizing democratic activists. In 1981, Dr. Ch'en Wen-ch'eng, assistant professor of mathematics at Carnegie Mellon University, was killed in the campus of the Taiwan University while homecoming; in 1984, Mr. Chiang Nan, a Chinese American, the author of *Biography of Chiang Ching-Kuo*, was murdered in California. Chiang Ching-kuo's son, Chiang Hsiao-wu, alias Alex Chiang, was found the ringleader and the incident led to the Chiang

family abandoning assuming presidency.

In 1985, in a "traffic accident" the wife of Ch'en Shui-bian, lawyer associated with the Kaohsiung Incident was heavily injured. It was a terrorist assault in disguise that drove the US government to step up its surveillance on the tyranny in Taiwan.

In 1982, a Formosan Association for Public Affairs, FAPA, was established by US-resident members of WUFI to seek building broad support for Taiwan Independence. The association was instrumental in promoting lobby activities in the United States. At the hearing in June 1982, the Foreign Affairs Committee Asia Pacific Ocean subcommittee demanded the Chiang regime to lift martial law. Since then the US turned quite outspoken in their views on issues of human rights and the future of Taiwan. The trend naturally spurred calls for democratization within the island of Taiwan.

The wind began blowing to radically change the political climate in Taiwan. In September, 1986, a political party, later known as the Democratic Progressive Party (hereinafter DPP), was formed in defiance of restrictions under martial law. And subsequently in 1987, Chiang Ching-kuo lifted martial law after 38 years (Taiwan and Pescadores only, excluding Kinmen and Matsu). Democracy activists, workers and students frequently staged demonstrations; the waves for democratization accelerated at a dramatic pace.

In January 1988, Chiang Ching-kuo died abruptly and his deputy Vice President Lee Teng-hui took over. A Taiwanese assumed the post of Presidency for the first time.

In the twelve years to follow until 2000, President Lee Teng-hui accomplished a miraculous feat of turning a one-party dictatorship to a democracy. At the point he was inaugurated President, the political reins were still very much in the hands of Chinese in the KMT. The

43-year-old dictatorial machinery was hard to die built on five legs, namely the Kuomintang, government, military, police and secret service networks. President Lee Teng-hui took cautious time to build up power his way through personnel reshuffling and other such means.

But it was not that the nature of politics under the KMT over the past several decades changed in anyway. The Temporary Provisions Effective During the Period of Communist Rebellion which had sustained martial law-based machinery had to wait till 1991 to be removed entirely. The Taiwan independence activists continued to be treated as subversive elements till the revision of Article 100 the Penal Code was revised in 1992.

In December, 1988, Cheng Nan-jung (*TeN Lam-long*) was charged with mutiny for printing "Draft Constitution of the Republic of Taiwan" by *Khou Se-khai*, a member of the WUFI in the journal *Freedom Era Weekly*. Cheng Nan-jung burned himself to death, encircled by the police force. He voiced aloud "I am TeN Lam-long, I support Taiwan independence." His death is still talked about as a dramatic symbol of the cause.

Apart from that, more lives had to fade, including an anti-Kuomintang politician Yu Teng-fa in 1989 and Wan K'ang-lu chief-secretary of the WUFI, in 1993, before democracy finally reached Taiwan.

1990-2000: Democratization under Lee Teng-hui

Martial law lifted and a Taiwanese president sworn in, Taiwan was now a welcome home for many Taiwanese students abroad. An air-choked Taiwan was now a breathing land of hopes with an inflow of many outstanding Taiwanese; Taiwan began marching forward in strong strides towards democratization.

In 1991, President Lee Teng-hui launched an ambitious "Six-Year

Plan for National Construction" to improve pubic livelihood. There arrived an unprecedented era of combined endeavor by the government and the people towards political reform and economic growth. In 1994, Prof. Li Yuan-che, the first Taiwanese Nobel laureate in Chemistry in 1986, returned to Taiwan and was appointed president of the Academia Sinica. (retired in 2006)

The year 1990 saw the outburst of a large-scale student movement known as the "Wild Lily Movement", the first of its kind ever staged in the island in Taiwan. The students made a four-point demand including to have the National Assembly dissolved, the Temporary Provisions Effective During the Period of Communist Rebellion abolished, a national conference, later called the National Affairs Conference convened, and the presentation of a Time Table for Polico-economic Reform. President Lee Teng-hui was quick to react. He met the students in person, heard them out and strode on with his idea of social reform.

The members of the Legislative Yuan and the National Assembly elected 44 years before in the mainland retired in 1991; the day had come for Taiwan to have the first public election ever held. In 1992, the emergency war-time system was terminated; the notorious "Article 100 of the Penal Code" which had restricted dissident movements was now revised and all political prisoners freed.

The DPP in opposition revived. Inside the KMT pro-Lee factions gained strength. A full-scale Taiwanization was underway. China-minded KMT members created a new political party, the New Party, in 1993.

President Lee Teng-hui professed a new concept of "New Taiwanese" and proposed his idea of coalition with new generations of Chinese-Taiwanese or the Chinese who had come to Taiwan after the war who accepted Taiwan as the country of their own.

In 1996, Taiwan staged its first universal suffrage. Communist China fired missiles off Kaohsiung and Keelung to intimidate the Taiwanese electorate. The attacks ended up only awakening the Taiwanese to their national identity. The US aircraft carrier "Independence" was rushed to the scene to demonstrate its readiness to defend Taiwan in crisis. President Lee Teng-hui was reelected by an impressive margin.

After he was elected by direct election in 1996, President Lee Teng-hui went on introducing administrative changes. In 1998, he nullified the administrative machinery of Taiwan Province. The 50-year dual system of Taiwan Province under the framework of the Republic of China since 1949 thus ended.

Meanwhile, the communists kept on mobilizing missiles annually targeting Taiwan and by 2014 some 1500 or 2000 are reportedly installed. China stuck to the One-China and steadfastly opposed to Taiwan's independence. China faced squarely against President Lee Teng-hui with the slogan of "Attacking with words; Intimidating with arms". China resorted to economy to encircle politics and utilized civilians to pressurize the government in an effort to pave the way for unifying China and Taiwan through closer economic and trading ties.

To counterbalance China's "One China" President Lee stated at an interview in 1999 with foreign newsmen that Taiwan's relation to China is one between two states or at least the relationship of one special state with the other. A concept of the so-called two-state theory; special state-to-state relationship emerged. Speaking of the cross-strait relations, some within the authorities said of Taiwan's talk with China as more a relationship of two states than that of two political entities of equal standing.

China countered back, stressing that Taiwan was part of China and any move toward its independence or any allusion of "Two Chi-

nas" or "One China, One Taiwan" will be strongly opposed.

Reference is often made to the "'92 Mutual Agreement" in recognizing the China-Taiwan relations. This is an agreement reached in the course of the talks between the Straits Exchange Foundation of Taiwan and the Association for Relations Across the Taiwan Straits of China. The agreement was not made public until immediately after Ch'en Shui-bian was picked to succeed presidency in 2000 when the minister of the Mainland Affairs Council of the Executive Yuan of the KMT made reference to its content.

The agreement was interpreted by Taiwan as meaning One China on either side subject to respective understanding on either side and by China as meaning One China on both sides. The former presidents Lee Teng-hui and Cheng Shui-bian deny the presence of the agreement itself, but the KMT's Chief Lien Chan made reference to the " '92 Mutual Agreement" in the communiqué made out after his meeting with Hu Jintao, General Secretary of the Communist Party of China in 2005.

As decreed by himself, President Lee Teng-hui left presidency in two terms and did not run in the 2000 election. The 2000 presidential election was a contest among three candidates: Lien Chan, KMT, Sung Ch'u-yu who had left the KMT, and Ch'en Shui-bian, DPP. A democracy activist and the former Mayor of Taipei, Ch'en Shui-bian collected 39.3% of the votes cast and won the election to be the first president ever elected from parties other than the Kuomintang.

2000-2008: The DPP under President Ch'en Shui-bian

Taiwan saw the birth of its first native president elected by its own people in a democratically administered election free of colonial rule by the Kuomintang of China. It was a major historically significant

happening. It proved at home and abroad that Taiwan was now a home of democracy—that democracy was here to root in Taiwan. The wave of democracy that had risen in the days of President Lee Teng-hui now culminated in a bloodless revolution in a manner the entire international community valued in the highest esteem.

Nevertheless, the election was an event that took place within the Republic of China and Ch'en Shui-bian was no more or no less than a president of the Republic of China. President Ch'en Shui-bian battled with his hands and feet bound within the system and his administration suffered in every inch of its way. The Ch'en Shui-bian administration was in fact a band of paratroopers descended in an enemy land. All government bodies—Legislative Yuan, justice, bureaucracy, military, police, media, and all—were glued tight to the Kuomintang, so tight that Ch'en Shui-bian as president could not lead politics at his will.

The people of Taiwan abode by, hoping that following the ground work in the first term of four years would come a dramatic period of revolutionary changes in the second term. The people hoped that would mean termination of the system of the ROC. The people of Taiwan foresaw in his image the arrival of a new Taiwan, a full-fledged nation state acknowledged by the international community.

In 2002, Ch'en Shui-bian said Taiwan and China are two different entities—one country on each side. China was quick to rebuff. Having claimed over years its sovereignty on Taiwan, China began applying pressure from all sides on Taiwan's move towards independence. In order to isolate the DPP, China made approaches to other political parties and dominated financial circles to exert further pressure on the Ch'en administration. China stepped up its program to deploy missiles targeting Taiwan and in 2005 enacted the Anti-Secession Law. The law stipulated that should subversive elements in Taiwan attempt

to separate Taiwan from China, China would resort to non-peaceful means to counter such a move. China openly warned against any move by the Ch'en administration to alter the name of the country, to enact a new Constitution or to expedite Taiwan's independence.

Meanwhile, a forerunner in support of Taiwan's democratization, the United States was heavily involved in Afghanistan and Iraq and was signaling to Taiwan not to create fictions in the China-Taiwan relations. Another power sympathetic towards Taiwan, Japan, was too far neck-deep in its trade with China to be of any political importance to Taiwan. The Ch'en administration was thus left high and dry in the international community.

During his eight years in presidency, Ch'en Shui-bian made a piece of contribution: Name Rectification Campaign or commonly Taiwanization. The movement initially budded in 2001 in Japan. Foreign residents in Japan are required by law to carry the Alien Registration certificate bearing the countries of origin. The Taiwanese were then classified Chinese, and there arose a movement among them with the support of the Friends of Lee Teng-hui in Japan to rename from China to Taiwan all Taiwan-related matters and bodies across the board. The movement was quick to disseminate in Taiwan, where in 2003 a major movement arose in the name of "Name Rectification". It was not a drive to merely change names but a significant drive to determine the identity of the Taiwanese.

Mayor Ch'en Shui-bian of Taipei had changed the Chief-shou Road, or "Long Live Chiang Kai-shek" running by the Presidential Office Building, to the Ketagalan Boulevard, after an indigenous tribe who inhabited in the vicinity. A few other names were rectified likewise, including:

2003 The word "Taiwan" was added on the front page of the passport.

2006 The Chiang Kai-shek International Airport was renamed the Taoyuan International Airport.

2007 The Chiang Kai-shek Memorial Hall was renamed the Taiwan Democratic Memorial Hall, and renamed back in 2009 as the Kuomintang restored power.

2007 The Chunghwa Post Co., Ltd. was renamed the Taiwan Post Co. but reversed after the return to power of the KMT in 2008.

Another unforgettable event took place under the Ch'en Shui-bian administration: educational reform. The high school textbook "Understanding Taiwan" was published as part of Lee Teng-hui's policy of promoting education on Taiwan and the policy was taken over by Ch'en Shui-bian. The notation "Chinese Continent" was removed from the "Map of the Republic of China" in the classroom. Taiwanization was gradually underway in Taiwan then unthinkable under the former Kuomintang administration. The children at school in those years were educated a new sense of Taiwanese identity, apart from those taught deep in the China-oriented environment.

However, China's hostility against Taiwan knew no limit. Already a few friends of Taiwan shied away from Taiwan under pressure from China. (As of late 2014 the ROC maintains diplomatic relations only with 22 countries of mid- and south America.) Ch'en Shui-bian applied for UN membership in the name of Taiwan in 2007 but was turned away at the door.

China kept aloof toward the Ch'en Shui-bian administration. In 2005, China invited Chairman Lien Chan of the KMT to a summit

talk in Beijing.

Taiwan had its share of the international economic recession at that time and it was most telling on its economy. The KMT blamed the DPP for the downturn of Taiwan's economy, and gradually a combined sense of discontent and anxiety permeated in the mind of the Taiwanese public and many began drifting away from Ch'en Shui-bian and his DPP administration.

Overly idealistic since the opposition days, the DPP opted with confidence to switch the constituency system from middle to small and halved the total number of parliament members to 225. As a result, the Kuomintang made the best of their strong local connection and registered a landslide victory in the Legislative Yuan election in 2008.

Thus, in March 2008, the Kuomintang and its candidate Ma Ying-chiu won the presidential election; the DPP regime was ousted in meager eight years.

2008-2015: Era under Ma Ying-chiu

The Kuomintang had cunningly modified its standing in favor of Taiwanization and forged a public impression that they had grown Taiwanese, while constantly looking forward to recapturing the reins of government. Ma had purposely made speeches in Taiwanese and often canvassing far into remote villages of indigenous people no key politicians had ever visited. He toured deep into the south daring to challenge highly Taiwanese populace. Ma stressed the KMT knew better how to manage Taiwan and would be sure to improve relations with China.

However, no sooner had President Ma been inaugurated and the Kuomintang stabilized its political position with a clean majority in the Legislative Yuan than the tide for Taiwanization quickly began

fading as some names reversed and the curriculum in favor of Taiwanization abruptly suspended.

Now, Taiwan is regarded interlinked with China, neither as in a special nation-to-nation relationship as prescribed by Lee Teng-hui nor as Ch'en Shui-bian's concept of "One Country on Either Side". China was quick to react. China refriended Ma and his administration and opened doors for dialogue. Ma took measures to remove the barriers between both sides and expressed readiness to activate encounter. Thus opened dialogues in all forms between China and Taiwan.

China, of course, intended to remove the barriers between across the strait to open ways to annex Taiwan. In 2010 an agreement was signed. The Economic Cooperation Framework Agreement or ECFA was a de facto FTA and was supposed to mutually benefit both sides.

Taiwanese companies advanced into China with a full pack of technologies and China exported to Taiwan mere farm produce and foods in return. What resulted was a series of hazards that backfired in Taiwan. Taiwanese industries were hollowed out and the labor market aggravated. Starting salary rates dropped and the unemployment rate soared. Elsewhere, direct flights increased in number and in came a flood of investment and financial cooperation projects. Then followed a huge inflow of media staff, students, immigrants, brides.

Further in March, 2014, the Ma administration cut short debates in the Legislative Yuan to enact the Cross-Strait Service Trade Agreement. That induced a huge student movement known as the Sunflower Student Movement. The students occupied the legislative floor for three weeks long. Citizens joined them in the cause and criticized the government. The protesters argued the influx of cheap labor from China would eventually endanger Taiwan. A keen sense of crisis of being "sucked" into China had motivated the students no doubt. In other words, that

is a crystal-clear denunciation of Ma's stance to side with China and a clear denunciation of China's design of annexing Taiwan.

The rising political consciousness in the minds of students and citizens was clearly felt in the local elections in November, 2014, when the Kuomintang suffered a fatal loss and the DPP and non-affiliates made a major leap forward.

2016 and after: The years under President Tsai Ing-wen

A tail wind blown by the so-called "Sunflower Student Movement" in 2014 and the successful outcome of unified local elections jointly brought the Democratic Progressive Party (DPP) a welcome victory in the presidential election in January 2016, which led them to take over the government. The student movement chanced to reveal the identity of the Taiwanese, which in turn drove the people to choose DPP in favor of KMT (the (Chinese) National Party = Kuomintang). The leader of DPP, Tsai Ing-wen, assumed Presidency to run afresh a government of the Taiwanese by the Taiwanese for the first time in history. The regime grabbed a large majority of the Legislative Yuan. Thus, the earnest wish of the author of this book, Ong Iok-tek, was finally realized after the lapse of 50 years.

The Tsai Ing-wen administration opts to strengthen amiable relations with the US, Japan and European states toward joining international bodies such as WHO, while remaining firm in maintaining the conventional position vis-a-vis China.

The Tsai Ing-wen administration lost no time in handling matters that had never been dealt with by the previous regimes, which invited repellence from KMT and conventional interest groups, eventually leading to a substantial loss in approval rating. First and foremost, Tai-

wan's social system itself was put to scrutiny: the preferential pension system for the servicepersons, teachers and public servants reformed and the Labor Standards Law revised. KMT's illegally acquired party assets were fast frozen, and Commissions were installed to promote "Transitional Justice" and dig into the realities of the 228 Incident and White Terror involving cases of human rights and massacres.

By way of diplomacy, the Tsai Ing-wen administration was quick to further mature Taiwan's democratic society, thereby to establish firm ties with the US and Japan. The Trump administration fully supported her regime and so does the current administration under President Biden. The US is firmly committed to Taiwan in its policy, installing necessary acts, sending government officials to Taiwan and effecting in several times sale of arms to Taiwan.

On the contrary, China is adamant in reducing Taiwan's international position, demanding such states as have thus far had diplomatic relations with Taiwan to cut off ties in return of aid. Such states numbered 7 in the years from 2016 to 2020.

The Tsai Ing-wen administration consistently stands against unifying with China, steadfastly eyeing for Taiwan's independent entity. China has further attempted to damage it in many a way, notably banning individual visits to Taiwan, heavily investing in Taiwanese mass media to voice in favor of KMT, amply spending to back up KMT candidates by collecting funds and manpower. etc.

Strangely enough, the ages-old foes joining hands to rob the Taiwanese of their politics – the Chinse communists and the Chinese nationalists!

In the unified local election in November 2018, the KMT candidate, Han Kuo-yu, was elected mayor of Kaohsiung, an undisputable fortress of DPP and, furthermore, KMT won mayorship in three of

the six major cities against DPP with only two.

On January 2, 2019, in an attempt to apply further pressure on Tsai Ing-wen, Xi Jinping spoke to have her accept China-Taiwan unification and the so-called "One Country, Two Systems "scheme. He even said he wouldn't hesitate use of arms. Tsai Ing-wen was quick to furiously respond against any of such threats. The incident chanced to enhance Tsai Ing-wen's reputation for her strong leadership.

What followed in Hong Kong against the democratic movement that had begun in spring that year and China's relentless oppressive measures to nullify the "One Country, Two Systems" gave the people of Taiwan a grave sense of caution against China.

For fear of treading a way to unification with China, should KMT return to power, the Taiwanese opted to reelect Tsai Ing-wen in the presidential election in January 2020 with a margin unprecedented in history. Younger generations played a vital role in raking up votes to make that happen.

In combatting Corona virus (Covid-19) since January 2020, Taiwan was quick to take an efficient government-led quarantine measure to control infection virtually nil and to maintain the social and financial lives of the nation. Corona recession was non-existent in Taiwan; the national economy picked up on the contrary. At the end of the day, Taiwan demonstrated what it means to be the world's most successful nation in combatting the pandemic.

In 2020 and 2021, Taiwan experienced a major shift in international environment with China visibly anxious in its attempt to invade and unify Taiwan. Taiwan's security has come to pose a matter of international concern; meanwhile, Taiwan's success was highly acclaimed in sustaining a stable nation in a system quite contrary to

that of China.

The Japan-US meet of heads of state in April 2021 and the G7 Summit in June issued communiques stressing on the importance of maintaining peace and stability in the Taiwan Strait. That proved a powerful message for Taiwan obviously prompted by the following factors:

* Taiwan's geopolitical values: Taiwan is indispensable for the security of the Asian region; military threats are immeasurable, should Taiwan be made part of China, suggesting the importance of Taiwan's strategic values.
* Taiwan is a full-grown democracy sharing sense of values with the other advanced nations.
* Taiwan has crucial industries of semiconductors, etc.
* China's hegemonistic advance and its militaristic ambitions have come to invite distrust from among the other nations to the extent of supporting Taiwan in a design to contain China.

However, China's provocative military moves seem to have no limit, as Chinese military aircraft fly beyond the intermediate line of the Taiwan Strait, military vessels cruise past Taiwan into the Pacific Ocean more frequently than ever. The Tsai Ing-wen administration is steadfast in dealing with China lest China should ever find pretext for invasion. Thus far, it is managing the situation without a flaw.

Changes in Taiwan's Economy

Here, a few paragraphs may be due to outline economic changes that took place in Taiwan since 1960s to this day.

In the 1960s

Up until the 1950s Taiwan's economy was basically agriculture-oriented but into the 1960s onward Taiwan grew fast to be an industrial nation. Inducing investment from the United States and Japan and subcontracting Japan along the way, thereby building itself into Japan's economic machinery, Taiwan eventually transfigured itself into a stable exporter of industrial products. Raw materials were brought in from all over the world, machinery and technology came from Japan, and the end products were exported to the United States. That's the way Taiwan expanded its economy at a rapid pace.

In the 1970s

In the 1970s Taiwan developed petrochemical industry with imported petroleum, manufactured chemical fibers and plastic goods and exported them in larger scales. Small businesses grew along the way and Taiwan soon achieved a high economic growth, amassed trade surpluses and eventually became a debt-free, super economy. At the decade's end Taiwan was now one of the Asia NIES to vie equally with South Korea, Singapore and Hong Kong. Taiwan was now one of the leading exporters of industrial products.

Alone and isolated in the international community without diplomatic ties with major nations in the world including Japan, Taiwan turned to building civilian contacts and economic interchanges. Barred from the IMF, Taiwan was driven to find its own way around. Self-sufficiency motivated Taiwan to build a debtless, stable, self-sup-

porting economy.

The government at last gave up "attacking the mainland" and turned inward placing more emphasis on building infrastructures. Airfields, highways, industrial complexes and ironworks were constructed in a series of building plans e.g. "Ten Major Constructions Projects" and "Twelve-Point Construction Plan".

In the 1980s

The 1980s continued to enjoy economic growth as Hsinchu Science and Technology Industrial Park was opened in December, 1980 to induce high-tech industries.

The main pillar of Taiwan's industries in that decade was machinery industry producing computers, computer software, precision machines, home appliances, etc. High economic growth, however, brought about currency appreciation, pay increase and substantial rise in management cost. Living standard rose and the higher-educated shied away from heavy labor or the filthy jobs, and that induced an inflow of workforce from Southeast Asia. Ever-rising production costs drove many manufacturers to seek lower-cost labor in the Southeast Asian countries.

China was aware of such changes in the industrial climate in Taiwan and economic interchanges with Taiwan visibly increased at that time. China obviously had a grand design going to activate economic ties with Taiwan.

No sooner had the diplomatic relations been opened with the United States in 1979, and Taiwan forced into international isolation, than China made a statement, "Note to the Taiwanese" to declare that China would now shift from "liberating Taiwan with arms" to "peaceful unification of Taiwan". China called for personal exchange,

economic contact and cultural interchange based on the principle of "One China being the People's Republic of China only" and "peaceful unification of China and Taiwan". It was about that time when China shifted to an open-reform policy to induce foreign investment and opened special economic zones and economic and technological development zones.

China adopted preferential measures providing Taiwanese corporations with low-cost labor and land. That was a stone to kill two birds using Taiwanese capital to sustain Chinese economy while building a bridgehead for China-Taiwan unification.

In the outset Chiang Ching-kuo rejected China's interchange proposal but could not fight the flux of time. While no free interchange allowed under martial law, Taiwanese companies advance in the Chinese market via Hong Kong after low-cost labor. And in 1985 the government relaxed restrictions so as not to interfere with transit trade while forbidding direct trade contacts. In 1987, martial law was lifted and Taiwanese tourists were permitted to travel China bound. In 1988, Chiang Ching-kuo passed away and Lee Teng-hui took over presidency and the policy as well.

In the 1990s

Martial law lifted and Lee Teng-hui, the first Taiwanese ever to assume presidency, inaugurated, many Taiwanese high-tech experts began leaving America homeward. Taiwan now emerged a home of new-born high-tech industry. The US-trained Taiwanese brought home one big asset in common: their close personal link with Silicon Valley. In no time Taiwan was leading the world in high-tech industry producing computers and peripherals.

Meanwhile, unaware of China's intention to promote economic

interchange for the sake of the unification of China and Taiwan, Taiwanese small businesses kept on stepping up investment in China and large companies were all anxious to follow suit. Aware of Taiwan hollowing out of industry and its growing dependence on China, President Lee Teng-hui came up with a set of two policies to prevent all that from happening: "Advance Southward" and "No Haste, Be Patient".

By "Advance Southward" Lee Teng-hui tried to shift investment from China to the Southeast Asian countries but of little or no avail in the face of China making every tiny offer available for Taiwan's industry and funds to flow into China through. China was undoubtedly an attractive market for investment. The other leg of his policy, "No Haste, Be Patient" proved powerless to block the tide.

2000-2007: Era under DPP Regime

President Ch'en Shui-bian was inaugurated in 2000 and he implemented his pledge of the "Three Small Links", postal, transportation and trade, which China had been asking for since 1979 and Taiwan had refused to comply all along. The decision more or less had to be made as economic inflow had grown to such an extent that these links were now a necessity. Direct trade and transportation links were restricted only to Kinmen and Matsu on the Taiwanese side and Amoy across the bay.

In the midst of economic globalization Taiwan applied for GATT membership in 1990, but the application was suspended. Then in November, 2001, WTO that had succeeded GATT approved Taiwan's application. Taiwan took that opportunity to propose a new policy to promote "active opening and effective management" to replace the former policy of "No Haste, Be Patient". Taiwan lifted re-

strictions on direct investment to China and on the item and amount of investment.

Taiwan's investment to China skyrocketed. Excessive economic dependence on China was risky as it was obvious that China was eyeing on eventual unification. Funds and skills flew out of Taiwan, industries hollowed out, unemployment rate boosted and pay rates fell. That meant a social unrest.

Then in 2006, Ch'en Shui-bian shifted from "active opening and effective management" to "active management and effective opening" in an attempt to reinforce control. The policy shift did not work and Taiwan's trade and investment continued to grow and Taiwan's economic dependence on China accelerated further on.

2008-2015: Era under the Kuomintang and Ma Ying-chiu Regime

In 2008, Ma Ying-chiu was inaugurated. Once again back in power, the KMT set out to expand economic interflow with China. Restrictions on investment were further relaxed, charter flights increased in number and more Chinese tourists rushed to Taiwan. Ma Ying-chiu promoted measures to lower the fence for non-economic sectors as well.

As mentioned in the previous section on politics, ECFA was signed in 2010 to further expand economic ties between Taiwan and China. However, ECFA was just another pipeline where through Taiwan's industrial juice leaked out at a rapid pace. Taiwanese industries would operate in China with Chinese labor and the unemployment rate in Taiwan continued to rise and the lowest income sector grew in proportion.

All this amounts to one remarkable phenomenon of China hav-

ing fed over the past two decades freely on Taiwan's funds, skill and equipment, manpower and all to gracefully modernize itself, to the point that Taiwan is now only left with China to live on by.

On the other hand, pro-Taiwan independence Taiwanese businessmen, however outstanding, have no access to decent business unless they give up supporting moves for Taiwan independence. It is a genuine sample of an "economy and civil life first; politics afterward" slogan beautifully at work.

In a nutshell, Taiwan sets economy and politics apart and China has always in mind that economic interchange is a mere prelude to unification. Presidents prior to Ma Ying-chiu had sought economic gains but avoided being sucked in politically. But on the contrary Ma Ying-chiu has his eyes wide open in promoting his door-opening policy on the clear assumption of unification ahead.

However, economy rests on sound politics. Dignity supersedes economy in any nationhood. Seeking economy at the expense of dignity is like choking a chicken about to lay golden eggs. The recent Sunflower Student Movement over the Cross-Strait Service Trade Agreement is one clear expression of discontent of the Taiwanese public with Ma Ying-chiu and his excessive pro-China stance.

When analyzing Taiwan, one can never discriminate economy from politics.

2016 Onward: Era under DPP and Tsai Ing-wen Regime

Despite the Ma Ying-chiu administration's conciliatory policy adopted toward China, Taiwan's trade dropped by 20% in 2015 both in export and import and the gross GDP fell to as low as 1%.

The Democratic Progressive Party led by Tsai Ing-wen took over the reins of government in 2016. Apprehensions were widespread

then on a downturn in Taiwan's economy as China would inevitably step up pressure toward Taiwan. Quite on the contrary, Tsai Ingwen's series of policies bore fruits instead to bring home a substantial growth rate of 1.05% in GDP, an up hike in the minimum wage of some 5% for the first time in 5 years and eventually a wave of upward trends from 2017 through 2020 in gross GDP of as much as the latter points of 2~3%. Taiwan's export/import trade goes on marking record-high increases ever since.

The New Southbound Policy offered attractive incentives for those enterprises forsaking their business in China, provided funds to switch investment back home, etc. Thus, the total investment in China fast dropped and more enterprises returned home or turned to Southeast Asian countries, Japan, Australia, etc. for investment.

Meanwhile, as the US-China relations cooled off, more investors turned to Taiwan to evade investment risks. Further in 2019 and onwards, China's oppressive stance toward Hong Kong and a series of measures taken there to suppress democratic movements prompted more Taiwanese to leave China and those enterprises and individuals working in China to return to Taiwan.

In August 2019, China banned individual tourists to visit Taiwan in an attempt to damage Taiwan's tourism and inbound revenues. The attempt, however, didn't work out and China's design failed, as tourists from countries other than China increased instead. The outbreak of Corona virus in 2020 hardly affected Taiwan's economy and social activities. Banned to tour abroad due to the pandemic, Taiwanese tourists turned to tour within Taiwan to help revive tourism to a great extent.

The central pillar of the Taiwanese economy is the electronics industry which proportionally weighs heavy in the world economy. Tai-

wanese enterprises lead the world in the production of semiconductors. As of 2020, Taiwan's foundries account for 70% of the world's share, Taiwan Semiconductor Manufacturing Company (TSMC) alone claiming a share of as much as 50%. The spread of the pandemic in 2020 and onwards prompted the use of the internet to further boost the global demand for semiconductors and, as a result, the volume of Taiwan's export thereof.

Furthermore, Taiwan's successful countermeasures to fight Corona amid a worldwide pandemic helped safeguard social life and general economic activities, Domestic consumption faired steadily; the GDP in 2021 is expected to sustain an annual growth rate of over 5%.

Translator's Note
Here Speaks
an Extraordinary Man

SHIMAMURA Yasuharu

Here is a man, an extraordinary man who accomplished an extraordinary work at a most extraordinary moment in the history of his fatherland—Taiwan. Yes, the author Ong Iok-tek, a linguist, writer, poet and scholar all in one, demonstrates here the whole spectrum of his wisdom as a scholar-historian in a manner unprecedented in historical writings.

First and foremost, our readers ought to be reminded that Ong wrote this book not in his own mother tongue of Taiwan but in the tongue of its former suzerain state, Japan, and had it published in Japan unmistakably targeting Japanese readership. He lived his student days in Taiwan under Japanese rule; he mastered his way of writing in a language alien to him. Yet, when he first conceived writing this most serious historical account of his own fatherland, he must undoubtedly have wished to write it in his own mother tongue targeting his own people at home—had the current situation in Taiwan only allowed him to. It did not; he could not.

Ong Iok-tek, instead, wrote every phrase and sentence in a most refined Japanese writable only by native elite Japanese. His syntax is

intact, his vocabulary abundant and, above all, his style of writing faultless. His love for his homeland overflows between the lines and his manner of speech is so profoundly Japanese—so much so that the entire work definitely calls for a Japanese mind to get it translated. The pleasure is thus all mine as a translator to have engaged myself in rendering every line into English free of native proofreading for the simple reason of saving every sigh and outcry of the author so lively heard between the lines. Extra care was thus exercised to weave an English version out of the original texture in Japanese. For any slips and trips anywhere in the process I am totally to blame as a professional translator.

Again, I wish to mark how grateful I am to have had this opportunity to make available for the western readership one of the most outstanding works on the history of Taiwan ever published. My sincere thanks therefore go to Mrs. Meiri Kondo, the author's daughter, who dared the risk of entrusting me with the most vital portion of work—translation. Her untiring effort throughout the entire project made possible this translation and the entire publication project.

Last but not least, a few words of gratitude are due to my wife, Keiko, for her share of contribution in expediting the work by way of spurring and morale-boosting at trying moments, not to mention proofreading, editing and other trivial but essential clerical works.

CHRONOLOGY

12th century	The indigenes attacked the Fu-chien shore.
14th century	The Ming installed Inspection Office in Penghu.
15th century	The name "Taiwan" appeared for the first time in *The Record of the East Barbarian Lands* (東蕃記) written by a Ming author.
16th century **1544**	Portuguese ship sailing off Taiwan called the island "Ilha Formosa" (Beautiful Island).
1592	Japan failed to seek sovereignty over Taiwan then known as Takayamakoku in Japanese.
17th century **1604**	The Dutch sailed to the Pescadores to open trade with China. The Ming demanded to leave.
1609	Tokugawa Shogunate of Japan sent feudal lord Arima Harunobu to explore Taiwan.
1616	Nagasaki official Murayama Tou'an sent troops to conquer Taiwan but failed due to a storm.
1622	The Dutch occupied the Pescadores and abused the inhabitants. The Dutch demanded to open trade with China but the Ming court rejected.
1624	The Dutch moved to Taiwan and landed in An-p'ing District, Tainan. The Ming opened trade with the Dutch.
1625	The Dutch began construction of Fort Zeelandia.

1626	Spain occupied Keelung and built Fort San Salvador.
1628	The Spanish established a settlement at Tamshui and built Fort San Domingo. Japanese businessman Hamada Yahyoe went on an expedition to Taiwan and captured the Dutch Governor.
1629	The Dutch attacked the Spaniards but failed.
1630	Fort Zeelandia completed.
1642	The Dutch drove the Spanish out of Taiwan to assume sole ruling power over Taiwan.
1650	Fort Provintia completed.
1652	Rebellion of Kuo Huai-i (郭懷一).
1661	Cheng Ch'eng-kung (鄭成功) advanced to Taiwan and declared it the Eastern Capital of the Ming Government.
1662	The Dutch surrendered to Cheng Ch'eng-kung. Cheng Ch'eng-kung died suddenly at age 39.
1664	Cheng Ch'eng-kung's son Cheng Ching (鄭經) succeeded his father and renamed Taiwan to Tung-ning (東寧).
1666	Ch'en Yung-hua (陳永華) established a Confucian temple and school.
1667	The Qing Dynasty's official came to negotiate peace.
1670	The British began to trade with Cheng Ching.
1681	Cheng Ching died at age 40.
1683	The Kingdom of Tung-ning was defeated by the Qing Dynasty. The Cheng surrendered.

1684	Taiwan was included in the Qing Dynasty's administrative system; "Taiwan Prefecture" was established as a part of Fu-chien Province. People were prohibited to go to Taiwan.
1686	Hakkas settled in the Lower Tamshui River plain.
1694	*Taiwan Prefecture Gazetteer* was published.
18th century 1714	A Christian priest started surveying Taiwan island.
1721	Rebellion of Chu I-kui (朱一貴).
1723	Qing Government established Chang-hua County, Tamshui and Penghu sub-prefectures.
1729	Qing Government strictly forbad emigration to Taiwan.
1730	Settlers without families in Taiwan were ordered to return to the Mainland.
1732	Qing forces under the administration of the Yung-cheng Emperor suppressed Ta-chia-hsi (大甲西) indigenous rebellion.
1738	Lung-shan Temple (龍山寺) was erected in Wan-hua (*Ban-ka*), Taipei.
1740	Qing Government prohibited settlers from moving their families out of Mainland.
1748	Hakkas moved into Miao-li.
1760	Bans on travelling totally relaxed.
1782	Struggle between Ch'uan-Chous (泉州人) and Chang-chous (漳州人) from Fu-chien broke out in Chang-hua (彰化) to cause disturbances.
1784	The Port of Lu-kang (*Lok-kang*) opened.

1786-1788	Lin Shuang-wen rebellion (林爽文事件) was suppressed after nine months of constant battling.
1795	Ch'en Chou-ch'uan rose in revolt against Qing Dynasty.
19th century	
1805	Pirate Chu Feng (朱濆) attacks Tamshui landed and invaded as far as Su-ao (蘇澳) by 1807.
1806	Conflict between the Ch'uan-chous and the Chang-chous continues several months.
1809	Pirate Chu Feng is surrounded by the Qing navy and commits suicide.
1817	Tamshui Government sets up a Confucian school in Hsin-chu.
1823	Revolt by Lin Yung-ch'un (林永春).
1838	The British enter Tamshui to trade.
1841	English vessel comes to Keelung Harbor. More than 400 people on board are killed or taken hostage. (cf. the First Opium War 1839-1842)
1853	The Ch'uan-chous and the Chang-chous were hostile. The Chang-chous opened Ta-tao-ch'eng (大稻埕) in Taipei.
1854	Part of Commodore Perry's fleet landed to survey coal.
1858	Treaty of Tianjin was signed; Taiwan was forced to open its ports.
1860	Convention of Peking was signed; ports of Tamshui and An-p'ing were opened.
1862	Tai Ch'ao-ch'un rose in revolt against the Qing.

1867	The Rover (an American vessel) Incident broke out.
1868	A British attempted to settle in the eastern area. British vessels attack An-p'ing.
1871	Mu-tan Incident: 54 shipwrecked Ryūkyūan sailors killed by Paiwan indigenes. Qing government rejected the compensation demand from Japanese Government. The Qing commented: "This place is not under jurisdiction of the Qing Dynasty."
1874	Japan sent punitive expedition of 6,000 soldiers to Taiwan in retribution for Mu-tan Incident.
1875	Taiwan was divided into two prefectures, north and south. Bans lifted, emigration from the mainland to Taiwan encouraged. Development of eastern Taiwan promoted.
1876	The British began mining coal in Pa-tu-tzu.
1884	Keelung and Tamshui harbors were blockaded by the French Navy during the Sino-French War. The French occupied Penghu.
1885	The Sino-French War ended; the French troops retreated. Taiwan Province was separated from Fu-chien Province. Liu Ming-ch'uan (劉銘傳) was appointed the first governor.
1886	Bureaus for tax, telegraph, tea and mine were set up.
1887	The government began building railways. (~1893)
1888	Postal system was established.
1891	Liu Ming-ch'uan resigned; his successor reorganized the system.
1894	Sino-Japanese war broke out.

1895	
April 17	Qing China signed the Treaty of Shimonoseki ceding Taiwan and the Pescadores Islands to Japan after being defeated by the Japanese Navy.
May 25	Pro-Qing officials declared the Republic of Formosa in an attempt to resist the arrival of the Japanese. T'ang Ching-sung (唐景崧) was named president.
May 29	Japanese forces landed in Taiwan.
June 4	T'ang Ching-sung fled to China.
June 17	Office of Governor-General of Taiwan opened; first phase of anti-Japanese movement terminated.
1896	
January 1	Shizangan (芝山巖) Incident: six Japanese academic officials died on duty.
March 30	The Japanese Government promulgated "The 63rd Law".
1897	
May 8	Last day of two-year "grace period" under the Treaty of Shimonoseki (totally 6376 people chose to move to mainland).
1898	Fourth Governor-General of Taiwan Kodama Gentaro arrived. He appointed Gotoh Shinpei a Civil Governor.
1899	The Bank of Taiwan established to encourage Japanese investment in Taiwan. Taiwan yen was issued by the Bank of Taiwan with an exchange ratio on par with the Japanese yen. The Taipei Medical School was established. Taipei tap water and sewerage systems completed. Railway construction started to directly link Keelung (基隆) through Kaohsiung (高雄).

20th century	
1900	Public telephone lines opened in Taipei and Tainan. Railway between Tainan and Kaohsiung completed.
1901	Railroad between Keelung and Hsin-chu reconstructed. The Office of Governor-General of Taiwan promulgated the "Colonial Monopoly system" (camphor, opium and salt).
1902	Second phase of anti-Japanese movement terminated; 11,950 killed during 1898-1902.
1904	Taiwan bank notes issued.
1905	First population census. (First Provisional Taiwan Household Registration Survey) Arable land survey (rice paddy 316,693 ha; dry field 158,880 ha). Electric light in Taipei.
1906	Unified weights and measure.
1907	Pei-pu Incident led by Ts'ai Ch'ing-lin broke out.
1908	North-South (Western Line) Railway completed. Construction started at Port of Kao-hsiung (1908-1912).
1912	The Republic of China inaugurated in mainland China.
1913	Miao-li Incident (a series of armed uprisings).
1914	Itagaki Taisuke revisited Taiwan to inaugurate an assimilation body.

1915	*Ta-pa-ni* (Se-lai-an) Incident, the largest revolt in Taiwanese history; over 100 protesters killed by Japanese authorities. Se-lai-an Incident led by Yu Ch'ing-fang: Third phase of anti-Japanese movement ended. First middle-school institution for Taiwanese (台中中學校) was established.
1919	Taiwan Education Decree promulgated. The construction of Office of Governor-General completed.
1920	Taiwanese students' political reformation body "New Citizens Society" (新民會) was inaugurated in Tokyo with Lin Hsien-t'ang (林獻堂) as president. Magazine *Taiwan Youth* inaugurated.
1921	Taiwan Culture Society founded. "Petition to Establish a Taiwan Assembly" movement began.
1923	Crown Prince Hirohito (Later Emperor) of Japan visited Taiwan. *Taiwan Youth* grew into *Taiwan Minpou* (台灣民報).
1924	I-lan Line Railroad completed.
1925	Farmers movement happens.
1926	Hua-tung Line Railroad completed. Taiwan Farmers' Union established.
1927	Taiwan People's Party (台灣民眾黨) , Taiwan's first political party, founded.
1928	Taihoku Imperial University (now National Taiwan University) founded. Hsieh Hsueh-hung (謝雪紅) and others organized Taiwan Communist Party in Shanghai.

1930	Chia-nan Canal (嘉南大圳) completed by Hatta Yoichi. Wu-she Incident; Japan forcefully crushed uprising by the Atayal indigenes.
1931	Taipei Broadcasting Station opened in 1931 to start full-scale radio broadcasting in Taiwan. Taiwan People's Party disbanded. Manchurian Incident began.
1934	Ku Hsien-jung (辜顯榮) appointed member of Japanese House of Peers. Sun Moon Lake Hydroelectric Power Plant completed.
1935 **April 1** **October 10**	 Taiwan's first elections were held for local assemblies. Exposition to Commemorate the 40th Anniversary of the Beginning of Administration in Taiwan.
1936	Construction of Sung-shan airport in Taipei completed.
1937	Sino-Japanese War broke out. "Kominka" movement promoted. Second phase of Sun Moon Lake Hydroelectric Power Plant completed.
1939	Industrial production surpassed agricultural production.
1940	Campaign began promoting the use of Japanese names for Taiwanese.
1941 **April 1**	 Segregation of primary schools between Japanese and Taiwanese children ends.

December 8	The Pacific War began; Takasago volunteer soldiers joined Philippine front.
1942	Japanese Army adopted Special Volunteer System; Japanese recruited Taiwanese for "volunteer brigades".
1943	Compulsory primary education began. Enrollment rates reached 71.3% for Taiwanese children (including 86.4% for indigenous children) and 99.6% for Japanese children in Taiwan making Taiwan's enrollment rate the second highest in Asia after Japan. Naval Special Volunteer System adopted. Roosevelt and Churchill stated in the Cairo Declaration to return Taiwan to Republic of China after the end of war.
1944	Japan began drafting Taiwanese.
1945	American air force conduct air raid on Taiwan. Japan (then including Taiwan) was defeated in World War II, and signed Japanese Instrument of Surrender (September). The United States directs Japanese forces to surrender to ROC as per General Order No. 1 (August). Japanese rule in Taiwan came to an end. Ch'en Yi of the Kuomintang was appointed Chief Executive of Taiwan as the Republic of China proclaims October 25 as Retrocession Day. The Mandarin (Chinese language) was forced to Taiwanese as the national language.
October/	KMT army arrive in Taiwan.
November	Social confusion begins. (Food shortage, traffic paralysis, extraordinary rising prices)
December	The prices of rice and goods increased ten folds as compared to levels just at the end of the war.

1947	The Constitution promulgated on January 1 in mainland China. 228 Incident (Massacre in March); "White Terror" began. Ch'en Yi was recalled and Taiwan Provincial Government established.
1948	National Assembly of the Republic of China passes the Temporary Provisions Effective During the Period of Communist Rebellion. The Mandarin Promotion Commission was established and students who speak Taiwanese in school were punished.
September	Liao Wen-i (廖文毅) and others of the League for Re-liberation of Taiwan in Hong Kong sent an appeal to the United Nations.
1949	Martial law was imposed (20 May, lasting till 1987) and the White Terror (terror by the government) stepped up. The New Taiwan dollar was issued, exchangeable with old currency at ratio of 1 : 40,000. The land reform began with the "375 Rent Reduction". Kuomintang army was defeated in the Chinese Civil War and fled to Taiwan with 2 million refugees. The capital of the Republic of China (ROC) relocated from Nanjing to Taipei.
1950 **March 1** **June 25** **June 27**	Chiang Kai-shek resumed office as President. The Korean war broke out. President Truman proclaimed: "The determination of the future status of Formosa must await the restoration of security in the Pacific, a peace settlement with Japan, or consideration by the United Nations."

1951 **September 8**	U.S. aid program started. The Peace Treaty of San Francisco officially signed by 49 nations; Japan officially renounced claims to Taiwan, but without designating a recipient.
1952 **April 28**	The Peace Treaty of San Francisco came into effect; Japan renounces all right, title, and claim to Taiwan, but no "recipient country" was designated. Japan and the Republic of China signed Sino-Japanese Peace Treaty (Treaty of Taipei).
1955	Liao Wen-i established in Tokyo "Temporary Government of the Republic of Taiwan".
1958 **August 23**	Taiwan strait crisis. China shelled Kinmen. (last 20 years after this event)
1959	August 7 Floods: serious floods in central Taiwan.
1960	Taiwan Youth Society started Taiwan Independence Movement in Tokyo (February 28). Lei Chen, editor-in-chief of *Free China*, was arrested on charges of sedition. The first Central Cross-island road completed.
1962	Taiwan Television Enterprise began telecasting.
1964	Shihmen Reservoir completed. P'eng Ming-min was arrested on charge of drafting A Declaration of Formosan Self-salvation. France recognized Communist China and broke off diplomatic relations with Republic of China.
1965	Vietnam conflict escalates. Taiwan becomes a major supply station and relaxation destination for U.S. military. Liao Wen-i surrendered to Kuomintang.

1966	First Export Processing Zone opened in Kaohsiung.
1967	The "National Security Council During the Period of National Mobilization for the Suppression of the Communist Rebellion" was established.
1968	Compulsory education extended from six to nine years.
1970	World United Formosans for Independence (WUFI) established; P'eng Ming-min (彭明敏) left Taiwan with support of WUFI (Japan) and sought refugee abroad. Chiang Ching-kuo was attacked while touring the US by Taiwan independence movement activists.
1971	The People's Republic of China took over the seat for "China" at the United Nations Security Council from the ROC. (United Nations General Assembly Resolution 2758) ROC walked out of the UN.
1972	U.S. President Nixon visited the People's Republic of China; Japan opened diplomatic ties with PRC and severed relations with Taiwan.
1973	Premier Chiang Ching-kuo announced the "Ten Major Constructions" plan, with the proposal for the first nuclear power plant a year after.
1974	World oil crisis resulted in doubling of prices of consumer goods in Taiwan.
December 18	Nakamura Teruo (Sunion), a Taiwan-born soldier of the Imperial Japanese Army, was found at the Morotai Island in Indonesia after his struggle for 30 years after the end of war.

1975	President Chiang Kai-Shek dies. Yen Chia-kan assumes presidency until May 20, 1978, when Chiang Ching-kuo takes over as head of the KMT.
1976	The year of the Dragon: more than 430,000 children were born.
1977	
August	The Presbyterian Church in Taiwan issued Declaration of Human Rights.
November	Rioting in Chung-li (中壢事件) erupted after vote rigging was uncovered in elections for the Taoyuan County magistrate.
1978	Chiang Ching-kuo became President.
1979	
January 1	The United States established diplomatic relations with the PRC and severed relations with the ROC.
April 10	The United States passes the Taiwan Relations Act affirming US commitment to defend Taiwan militarily and treating Taiwan as a state for most purposes of U.S. law. (retroactively from January)
July	Western Line Railroad fully electrified.
November	The first nuclear power plant completed.
December 10	Kaohsiung Incident: Taiwan Garrison Command arrested the editors of *Formosa Magazine* and sequestered the magazine's facilities.
1980	Lin I-hsiung's (林義雄) family were murdered on the anniversary of the 228 Incident. Hsinchu Science Park founded.

1981	Ch'en Wen-ch'eng (陳文成) was murderd.
1982	Formosan Association for Public Affairs (FAPA) established in US.
1983	US Senate Committee on Foreign Relations resolved "Resolution on Future of Taiwan" (November).
1984 **March**	Lee Teng-hui (李登輝) appointed Vice President.
May	US Subcommittee on Asia and the Pacific demanded lifting of martial law in Taiwan.
June	US Senator Bell openly supported Taiwan independence.
July	Labor Standards Law enacted.
October	Assassination of Chiang Nan.
1985	A corruption scandal erupts at the Tenth Credit Cooperative, causing a run on the bank. Reagan administration urged democratization in Taiwan (August). Indigenous people demanded the right to use their traditional surnames instead of Chinese surnames.
1986	Democratic Progressive Party (DPP), the first oppositional political party, illegally formed. Yuan T. Lee won the Nobel Prize in Chemistry. An anti-Dupont march held in the town of Lukang marking the beginning of civic environmental protests. Legislative Yuan held; Democratic Progressive Party advanced (December).
1987 **February**	First assembly in memory of 228 Incident.
July	Martial law lifted.

November	Chinese-Residents in Taiwan permitted to visit relatives in China.
1988 **January**	Bans on publishing newspapers lifted. President Chiang Ching-kuo died; Lee Teng-hui assumed presidency.
May	520 Incident: A demonstration in Taipei by farmers from southern and central Taiwan was suppressed.
1989	Bans on establishing new commercial banks lifted. Cheng Nan-jung (鄭南榕) burned himself to death.
1990	Wild Lily student movement: the first major student movement.
1991	Legislative Yuan and National Assembly elected in 1947 were compelled to resign. Opposition parties legalized. South-Link Line Railroad completed. The Temporary Provisions Effective During the Period of Communist Rebellion lifted but WUFI remains a subversive organization.
1992	Fair Trade Law enacted. The first democratic election of the Legislative Yuan. The government published the *228 Incident White Paper*.
1993	Ku Chen-fu of the Straits Exchange Foundation (ROC) and Wang Tao-han of China's Association for Relations Across the Taiwan Straits held historic talks in Singapore.

1994	National Health Insurance began. Ch'en Shui-bian (陳水扁, DPP) elected mayor of Taipei.
1995	228 Incident monument erected; President Lee Teng-hui publicly apologized on behalf of the KMT. Lee Teng-hui visited US. China carried out missile exercise in retaliation over Taiwan Strait.
1996	
March 8	China launched four missiles offshore Taiwan.
March 9	US President Clinton deployed 2 aircraft-carrier fleets offshore Taiwan.
March 23	The first direct presidential election; Lee Teng-hui elected. "No Haste, Be Patient" policy Lee Teng-hui announced for the investment in China.
1997	
February	228 Memorial Hall erected in the Peace Park in Taipei.
March	Dalai Lama visited Taiwan.
1998	
December 5	Ma Ying-chiu (馬英九, KMT) elected mayor of Taipei.
1999	
July 9	Lee Teng-hui announced "Two-State Theory": Taiwan and China are in a relation of two states, at least of two special states.
September 21	Chi-Chi earthquake: a mega-quake of magnitude 7.3 in central Taiwan with a death toll of over 2300.

21ᵗʰ century	
2000	
January	Education of mother language made compulsory in primary school.
March 18	Ch'en Shui-bian, the candidate from the DPP, elected president by a lead of 2.5% of votes marking the end of the KMT's status as the ruling party. Voter turnout was 82.69%; the first peaceful transfer of power.
March 24	KMT chairman Lee Teng-hui resigned.
March 31	Sung Ch'u-yu (宋楚瑜) organized People First Party.
May 20	Ch'en Shui-bian pledged "Four NOs and One Without" in his inauguration speech.
October	Executive Yuan resolved terminating construction of the fourth Nuclear Power Plant.
2001	
January 1	Three mini-links between Kinmen, Matsu and the mainland of Fu-chien (Amoy) began.
August	Taiwan Solidarity Union under Lee Teng-hui inaugurated.
September	Serious floods caused by Typhoon Nari.
October	Saos formally approved as an indigenous tribe.
2002	
January 1	Entry into the World Trade Organization.

June	Monthly *Taiwan Youth* published by Japan Headquarters of WUFI ceased at 500th issue. (1st issue in 1960)
August	President Ch'en Shui-bian spoke "One country on Each Side".

The final issue of *Taiwan Youth* (2002)

2003

January 14	Kavalans formally approved as an indigenous tribe.
April	SARS broke out.
October 25	200,000 participated in demonstration for enactment of a New Constitution in Kaohsiung.

2004

January 14	Trukus formally approved as an indigenous tribe.
February 28	228 Hand-in-Hand Rally, organized by Lee Teng-hui and commanded by Ng Chau-tong (Chairman of WUFI).
March 20	President Ch'en Shui-bian re-elected by a margin of 0.228% votes.
August	Taiwan won first Olympic gold medal in Tekondo.
December 31	Taipei 101 becomes world's tallest building.

2005

March 14	The PRC passed an "anti-secession law" authorizing use of force against Taiwan if it should formally declare independence.
March 26	1.6 million people marched in Taipei against China's "anti-secession law".

April 29	Kuomintang chairman Lien Chan(連戰) visited China and met General Secretary of the Communist Party Hu Jintao.
April	President Ch'en was invited to the funeral of Pope John Paul II, the first Taiwanese president to visit the Vatican.
June 7	The National Assembly of the Republic of China convened for the last time to implement several constitutional reforms, essentially abolishing itself.

2006

May 31	Tucheng Line of Taipei MRT (subways) opened traffic.
November	First Lady Wu Shu-chen (吳淑珍) indicted on charge of bribery and forgery of official document.
December	Hao Lung-pin (KMT) defeated Hsieh Ch'ang-t'ing (DPP) in Taipei mayoral election.

2007

January	Sakizayas formally approved as an indigenous tribe.
March	Taiwan High Speed Rail (Bullet Train) opened for traffic to link Taipei and Kaohsiung in 90 minutes.
July	Taiwan applies for membership in the United Nations under the name "Taiwan", and is rejected.

2008

March 2	Presidential election: Ma Ying-chiu (KMT) won.
June 13	Taiwan and China resumed direct talk for the first time in 10 years; Chiang Ping-k'un, chairman of Straits Exchange Foundation of Taiwan, met Ch'en Yun-lin, chairman of Association for Relations Across the Taiwan Straits of China, in Beijing.
November	Wild Strawberry student movement. Former President Ch'en Shui-bian imprisoned on suspicion of corruption.

2009	
May	Taiwan approved to participate in WHO in capacity of observer.
August	Typhoon Morakot hit Taiwan (over 650 dead and missing). Ma's Government was criticized for delay in rescue operation for major flood damages in southern Taiwan.
	Dalai Lama visited Taiwan.
September 11	Ch'en Shui-bian sentenced to imprisonment for life and 200 million yuan fine; his wife Wu Shu-chen imprisonment for life and 300 million yuan fine.
December 5	17 prefectural and mayoral elections: KMT 12 (-2) by 47.8%, DPP 4 (+1) by 45.3%.
2010	
November 5	Mayoral elections: KMT 3, DPP 2. Percentages of votes against total poll: KMT 44.5% and DPP 49.9%, DPP outnumbered KMT by 400 thousand.
2011	
March 11	Taiwan sent contributions to the tune of over 20 billion yen for the relief of east Japan Mega-Quake.
2012	
January	Ma Ying-chiu (KMT) re-elected President.
2013	
April 4	Taiwan-Japan Fisheries Agreement signed.
2014	
March 18	Sunflower Student Movement.
March 30	Demonstrations in various cities across the island in support of students. Over half a million rallied in Taipei.

June	Kanakanavus and Hla'aluas formally approved as an indigenous tribes.
November 29	KMT soundly beaten by nationwide local elections. KMT barely won one of the six gubernatorial election; an independent caididate Dr. K'e Wen-che elected mayor of Taipei. Ma Ying-chiu resigned KMT chairmanship.
2015	KMT soundly beaten by nationwide local elections. KMT barely won one of the six gubernatorial election; an independent caididate Dr. K'e Wen-che elected mayor of Taipei. Ma Ying-chiu resigned KMT chairmanship.
November	Ma Ying-chiu and Xi Jinping met in Singapore.
December	Quarter-based growth rate dropped below zero.
2016	
January	Tsai Ing-wen of the Democratic Progressive Party (DPP) elected President; DPP won majority in the Legislative Yuan.
February	Earthquake in Southern Taiwan.
May	President Tsai Ing-wen inaugurated.
December	Labor Standards Law revised. Diplomatic relations with Sao tome and Principe broken off.
2017	
January	Tsai Ing-wen toured the USA and South America.
February	Interdiction passed to ban killing cats and dogs at protection facilities.
June	Diplomatic relations with Panama broken off. Pension reform bill passed.

September	Mayor William Lai of Tainan posted President of the Executive Yuan.
2018	
January	Taiwan Travel Act passed at US Congress to enable high-ranking officials' mutually visits.
May	Diplomatic relations with Dominica and Burkina Faso broken off.
August	Diplomatic relations with El Salvador broken off.
October	Puyuma express train derailed.
November	Nationalist Party (Kuomintang) advanced and DPP suffered a crushing defeat in unified local elections.
2019	
May	Same-sex Marriage Law enacted to legalize same-sex marriage for the first time in Asia.
August	China banned visits to Taiwan.
September	Diplomatic relations with Solomon Islands and Kiribati broken off.
	✳China's oppressive posture to rigorously control democratic movements in Hong Kong that rose in March has come to extensively affect the Taiwanese.
2020	
January	President Tsai Ing-wen of DPP re-elected, defeating Kuomintang's Han Kuo-yu.
January~	Taiwan launched an epidemic prevention framework to fight Wuhan pneumonia that won the nation a worldwide acclaim as being the most successful nation in epidemic prevention.
	Minister Chen Shih-chung led Central Disease Control Center to mark impressive results.

	Digital Minister Audrey Tang appraised for his leadership in mask-application development.
June	Takao City Major Han Kuo-yu duly recalled.
July	Former president Teng-hui Lee deceased.
December	Taiwanese stock market kept on boosting, marking the highest on record on December 30th.
	＊High US government official(s) and Czech chairman (president?) officially visited Taiwan.
	＊US government sold weapons to Taiwanese government six times annually, to the tune of $5.8 billion (¥600.5 billion)
2021	
April	Former US Secretary of state Armitage visited Taiwan.
	The importance of peace and security of Taiwan Strait explicitly spelled out in Japan-US Summit Joint Declaration.
	The importance of peace and security of Taiwan Strait stressed at G7 Summit.
May	Wuhan epidemic spread. Taiwan controlled nationwide spread of the epidemic to nearly zero since last year, but the number rocketed to ten thousand in a month's time. Rigorous countermeasure proved effective to bring nationwide spread back to zero at the end of August.
July~	Japan, US, Lithuania, etc. supplied vaccine to Taiwan.

INDEX

Names

A-tek-kau-jiong　阿德狗讓
88

Akashi Motojiroh　明石元二郎
160

Andoh Rikichi　安藤利吉
161

Andoh Sadayosi　安東貞美
160

Arima Harunobu　有馬晴信
51, 75, 330

Beise Laita　貝子賴塔
100

Ch'en Ch'eng　陳誠
227, 231, 258, 270, 286

Ch'en Ch'iu-chu　陳秋菊
166, 171-174

Ch'en Chao-chun　陳朝駿
149

Ch'en Chen-hsien　陳振賢
192

Ch'en Chi-t'ung　陳季同
144

Ch'en Chieh-sheng　陳捷陞
174

Ch'en Chou-ch'uan　陳周全
119, 333

Ch'en Chung-he　陳中和
192

Ch'en Chung-kuang　陳重光
291

Ch'en Feng-yuan　陳逢源
191, 195

Ch'en Hsin-fu-tzu　陳心婦仔
120

Ch'en Hsin　陳炘
120, 221

Ch'en K'un-lun　陳崑崙
199

Ch'en Kuo-fu　陳果夫
231

Ch'en Leng　陳稜
50

Ch'en Li-fu　陳立夫
231

Ch'en Shao-yu　陳紹禹
200

Geographical names

Other items

★第一本站在台灣人立場的台灣島史

★戒嚴時期讓海外台灣人「一面哭一面讀」的真史

【定價400元】

在白色恐怖的禁忌時期，流亡日本的王育德先生以生命為賭注，奮力完成這部石破天驚的台灣史名著。本書是頭一次站在台灣人立場，以完全的台灣史觀濃縮、概述台灣千年來的脈絡軌跡，依循歷史視野追溯台灣的特殊性，並為台灣獨立提出了有力論證。

本書於 1964 年先以日文版在東京問世（弘文堂出版），立即成為日本台灣研究界鳳毛麟角的參考工具書之一，漢譯本於 70 年代同樣先問世於日本，再流傳美、加各地的台灣僑界。無數台灣熱血青年「一面哭一面讀」，終於理解台灣母土的「苦悶」身世，讓本書成為台灣史必讀經典。

漂泊的台灣人格者

王育德博士是世界語言學界公認的台灣語言學權威，也是出類拔萃的歷史研究者、評論者、創作者。他不但啟蒙無數台灣熱血青年，更是受到日本學界及台灣人社會敬重的「人格者」。

一個「昭和」生的台灣青年，見證了什麼樣的戰前台灣景象與命運？他的思想與視野如何養成，又如何迎接國民政府來到台灣之後的歷史轉折？本書由王育德博士親筆自述其成長經歷與半生，另收錄數十幀王育德及家族於日治時期及戰後所攝寫真圖集，引領讀者看見一代台灣知識分子的身影，以及與台灣命運牽繫的亡命生涯。

台灣總督府

一台湾総督府一

黃昭堂 著

黃英哲 譯

台灣經典寶庫
修訂新版

黃昭堂 著
黃英哲 譯

Taiwan Governor-General Office
台灣總督府

日本帝國在台殖民統治的最高權力中心與行政支配機關。

日本帝國在台殖民統治的
最高權力中心與行政支配機關。

本書是台灣總督府的編年史記,黃昭堂教授從日本近代史出發,敘述日本統治台灣的51年間,它是如何運作「台灣總督府」這部機器以施展其對日台差別待遇的統治伎倆。以歷任台灣總督及其統治架構為中心,從正反二面全面檢討日本統治台灣的是非功過,以及在不同階段台灣人的應對之道。

前衛出版
AVANGUARD

台灣
經典寶庫
Classic Taiwan

2013.08 前衛出版 定價350元

南台灣踏查手記

原著｜ Charles W. LeGendre（李仙得）

英編｜ Robert Eskildsen 教授

漢譯｜ 黃怡

校註｜ 陳秋坤教授

2012.11 前衛出版　272 頁　定價 300 元

從未有人像李仙得那樣，如此深刻直接地介入 1860、70 年代南台灣
原住民、閩客移民、清朝官方與外國勢力間的互動過程。

透過這本精彩的踏查手記，您將了解李氏為何被評價為「西方涉台
事務史上，最多采多姿、最具爭議性的人物」！

節譯自 *Foreign Adventurers and the Aborigines of Southern Taiwan, 1867-1874*
Edited and with an introduction by Robert Eskildsen

C. E. S. 荷文原著

甘為霖牧師 英譯

林野文 漢譯

許雪姬教授 導讀

2011.12 前衛出版 272頁 定價300元

被遺誤的台灣 *Neglected Formosa*

荷鄭台江決戰始末記

1661-62年，
揆一率領1千餘名荷蘭守軍，
苦守熱蘭遮城9個月，
頑抗2萬5千名國姓爺襲台大軍的激戰實況

荷文原著 C. E. S. 《't Verwaerloosde Formosa》(Amsterdam, 1675)
英譯William Campbell "Chinese Conquest of Formosa" in 《Formosa Under the Dutch》(London, 1903)

回憶在滿大人、海賊與「獵頭番」間的激盪歲月

Pioneering in Formosa

歷險
台灣經典寶庫5
福爾摩沙

W. A. Pickering
(必麒麟) 原著

陳逸君 譯述 ｜ 劉還月 導讀

19世紀最著名的「台灣通」
野蠻、危險又生氣勃勃的福爾摩沙

Recollections of Adventures among Mandarins,
Wreckers, & Head-hunting Savages

前衛出版
AVANGUARD

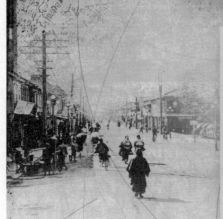

福爾摩沙
紀事
From Far Formosa
馬偕台灣回憶錄

福爾摩沙
紀事
From Far Formosa
馬偕台灣回憶錄

馬偕博士 原著

林晚生 漢譯
鄭仰恩 教授 校註

19世紀台灣的
風土人情重現
百年前傳奇宣教英雄眼中的台灣

前衛出版
AVANGUARD

台灣經典寶庫
譯自1895年 馬偕 著《From Far Formosa》

TAIWAN: A History of Agonies (Revised and Enlarged Edition)
© 2021 by **ONG Meiri**. All rights reserved

By **ONG Iok-tek**
Translated by **SHIMAMURA Yasuharu**
Edited by **ONG Meiri**
Proofread by **Chou Chun-nan, and YANG Pei-Ying**

First Edition 2015.
Second Edition 2021.

Distributor
Avanguard Publishing House
4F-3, No.153, Nong-an St., Jhongshan Dist., Taipei 104, Taiwan.
Tel: (886-2)2586-5708
Fax: (886-2)2586-3758
http://www.avanguard.com.tw
e-mail: a4791@ms15.hinet.net

Printed in Taiwan
ISBN 978-626-7076-11-8